This volume is one of a series devoted to the art and technology of photography. The books present pictures by outstanding photographers of today and the past, relate the history of photography and provide practical instruction in the use of equipment and materials.

LIFE LIBRARY OF PHOTOGRAPHY

Photographing Nature

Revised Edition

BY THE EDITORS OF TIME-LIFE BOOKS

TIME-LIFE BOOKS, ALEXANDRIA, VIRGINIA

For information about any
Time-Life book, please write:
Reader Information, Time-Life Books,
541 North Fairbanks Court,
Chicago, Illinois 60611.

TIME-LIFE is a trademark of
Time Incorporated U.S.A.

Library of Congress Cataloguing in Publication Data
Main entry under title:
Photographing nature.
 (Life library of photography)
 Bibliography: p.
 Includes index.
 1. Nature photography. I. Time-Life Books.
II. Series.
TR721.P48 1981 778.9'3 81-5346
 AACR2
ISBN 0-8094-4160-8
ISBN 0-8094-4158-6 (retail ed.)
ISBN 0-8094-4159-4 (lib. bdg.)

ON THE COVER: In a swamp near
Copenhagen, Danish wildlife
photographer Arthur Christiansen found
a graylag goose racing over the water for
takeoff. Christiansen panned his camera
to follow it and, with a shutter speed of
1/1,000 second, froze all motion except
the furiously beating wing tips.

Contents

When this volume was first published in 1971, photographing the natural world was becoming a popular activity. Amateurs were discovering nature on photographic field trips, and at botanical gardens and zoos. A few professionals were producing picture stories for the national magazines and a handful of scientists returned from field trips with photographs of esthetic merit. In the decade that followed, nature photography came of age.

The 66 new picture pages that appear in this revised edition for the first time indicate just how much progress has been made. The introduction of new equipment—cameras with truly automatic exposure control, fast color film, automatic electronic flash units, close-focusing macro lenses—in turn have led to alterations in style. Whereas portraits of an animal were once the photographic goal, now pictures of action—in color—dominate. And not just any action. The new photographs show aspects of animal behavior never before recorded, such as the combat of Spanish stallions *(page 33),* hyenas' hunting *(page 38),* a shark drowsing *(page 156)* and dragonflies reproducing *(page 125).* And an entirely new picture essay on the intimate lives of birds appears on pages 56-69.

Though styles and equipment change, and the number of nature photographers has grown, the subject of this book remains the same as it was when it was originally published. It shows the natural world in all its variety. There are pictures here from exotic locations—some were taken from the air and some from underwater—but there are also pictures made in zoos and aquariums, in nearby woods and in home studios.

The Editors

Animals, Vegetables and Minerals 1

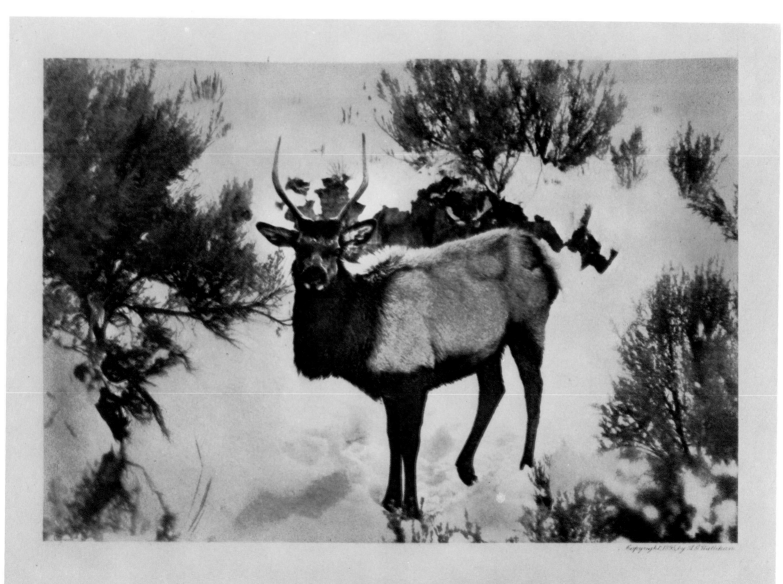

Portrait of an Elk.

Photographed from life by A. G. Wallihan.

A. G. WALLIHAN: *Portrait of an Elk,* 1895

The Lure and the Lore of Nature Photography

One of the most pervasive human interests is a fascination with nature. From the child's collection of beetles to the latest photographs of jungle creatures, from amateur deep-sea diving to microscopic research of single-celled plants and animals, there is an eternal appeal about nature that is tied to the central truths of life itself.

Today that natural interest is compounded by nostalgia. Defeated by the cities, sheltered from the elements, divorced from the earth, the urban dweller daydreams of unpolluted streams, unpopulated woods, the freedom of birds and fish. Nature photography is a postcard from and an homage to an age of innocence. In an era concerned with ecological preservation, pictures of nature are visible reminders of what is worth preserving.

Nature photography is at once an art, a science and a sport. As an art, it can make the ordinary remarkable, discovering intricate beauty in a snowflake, in a rain-silvered cobweb or in humble dandelions. And at many points the search for beauty blends with the search for scientific truth. The photograph depicts the beauty of the savanna and its inhabitants—and simultaneously reveals what the naturalist had not seen before.

Most nature photographers, however, are primarily neither artists nor scientists, but sportsmen armed with cameras. Disdaining the rifle, these hunters prefer to bag their quarry on film. The camera safari is replacing the big-game expedition, and a color photograph of a leaping gazelle, rather than a stuffed lion's head, hangs over the mantel.

When photography was born in the 19th Century, the nature photograph was born with it. One reason for this early fascination with nature was the era of Romanticism. The popular taste at the time turned toward the exotic, the extraordinary, the superlative. Music lost its formal, measured accents and became turbulent with passion. The balanced couplets of Alexander Pope were displaced by the sensuous imagery of Byron. The titled aristocrats of the salon gave way to the noble savages of Rousseau. Even the way in which nature itself was perceived underwent a transformation. Mountains were no longer regarded as obstacles that impeded the traveler but rather as marvels that thrilled the human spirit.

So the photographers of the last century scaled the Alps, sailed to the Orient, flocked to America's great West. And they brought bizarre sights back to the cluttered Victorian drawing room. During the 1850s the stereoscope was introduced to the public, and between 1854 and 1858 the London Stereoscope Company sold two and a half million views of the Canadian woods, the Alps, the Nile and other spectacles of nature.

A second great cultural force that influenced nature photography was the burgeoning interest in science. Johann Wolfgang von Goethe took time out from his poetry to write a treatise on granite and to propound a theory of color

A negative print of botanical specimens was made in 1839 by William Henry Fox Talbot, pioneer of the negative-positive process. The image was made directly, without a camera, by placing the specimens on a piece of photosensitized paper and exposing it to light. To make a positive print, Talbot discovered, such a negative image could be placed on a second sheet of photographic paper and re-exposed. Talbot called this kind of work photogenic drawing, which he explained as being "the process by which natural objects may be made to delineate themselves without the aid of the artist's pencil."

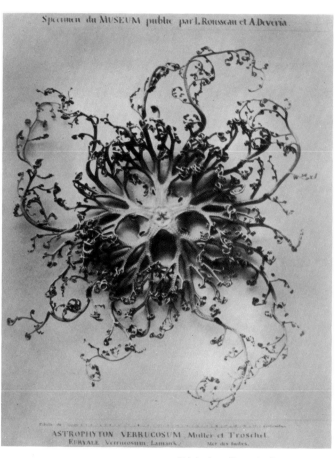

This intricate illustration first appeared in 1853 in Photographie Zoologique, a nature encyclopedia published in Paris. The printing plate was made by exposing the image onto a light-sensitive metal surface. The picture is of a sinuous relative of the common starfish, and was taken by the Bisson brothers, best remembered today for their photographic ascent of Mont Blanc.

(which proved to be inaccurate). An American painter named Samuel F. B. Morse became more famous by inventing the telegraph. Oliver Wendell Holmes speculated on visual perception. Henry David Thoreau studied animals in their natural habitat around Walden Pond. Alfred, Lord Tennyson attempted to reconcile the new theory of evolution with Christianity in his long poem *In Memoriam*. Nature photography satisfied the scientific vogue as well as the craze for romantic exotica, although many Victorians would have been hard pressed to delineate which taste they were indulging at any given moment.

In the earlier decades the chief subject of nature photography was scenery, mostly because it did not move. The long exposures required by both the daguerreotype (introduced in 1839) and the collodion wet-plate process (1851) gave the nature photographer little choice. Yet he was ready to brave any hardship in order to capture a striking picture. In 1861 the French photographer Louis Auguste Bisson — and 25 porters carrying a virtual factory to prepare and develop wet plates — scaled 16,000-foot Mont Blanc. At that dazzling snow-clad height Bisson had to erect a dark tent where he could coat his glass plates with liquid collodion and bathe them in silver nitrate. After the plate was exposed, snow had to be melted over a lamp to provide water for the development process. At the end of one arduous day the triumphant little army descended with three photographs — two of them good — and returned to the French border town of Chamonix, where their success was celebrated with a fireworks display. Soon Louis Auguste and his brother, Auguste Rosalie, were selling thousands of their Alpine panoramas. Bisson *frères* became so famous that Napoleon III invited them to record his ascent of the Alps. Perhaps the Emperor's choice arose as much out of an interest in his hobby as in historical record: Napoleon had become an amateur photographer, and had himself ordered a fast lens from England. It was mounted in silver and engraved with the imperial arms.

Later Alpine photographers even took along models on their ascents. When a 19th Century German photographer, Theodor Wundt, climbed the Alps in 1893, he was accompanied by a young lady mountain-climber who posed demurely beside the frightening precipices. Her name was Jeanne Immink, and she described her experience as follows: "He was standing right next to a vertical drop and wanted to photograph me. My God, you should have seen him. The ledge where he was standing was only a foot wide, but he didn't give it a thought. In an instant he had opened his tripod and ducked behind his black cloth. 'The left hand a bit higher, please, still higher. Good. Put your left foot forward. Fine.' You had to be there to see how he twisted and turned in order not to knock the camera over the cliff. The whole thing was unbelievably dangerous and could easily have ended

in disaster, but he shouted, '*Achtung!* Now, please, smile and look down into the abyss.' "

In America photographers had discovered a landscape as wild as any in Europe. In 1853 the daguerreotypist S. N. Carvalho wrote to the editor of America's *Photographic Art Journal:* "I succeeded beyond my utmost expectation . . . on the summits of the highest peaks of the Rocky Mountains with the thermometer at times from twenty degrees to thirty degrees below zero, often standing to my waist in snow, buffing, coating, and mercurializing plates in the open air." There spoke the ultimate nature photographer — slightly mad, full of enthusiasm and standing in snow up to his waist. Most of Carvalho's friends — and the editor of the *Journal* — told him he was courting failure; but Carvalho replied, "I am happy to state that I found no such word in my vocabulary."

Landscape photography made a major advance when the wet-plate process came into general use in the 1850s. The new process had many advantages over the daguerreotype. A photograph could be looked at from any angle, whereas a daguerreotype had to be held exactly so to catch the light. Moreover, a wet-plate negative could produce countless positives, while the daguerreotype *was* the picture. Still, wet plates required that the photographer take a darkroom with him everywhere.

One journeying cameraman, Charles Savage, fitted out a huge wagon for his tour through the West in 1866. He described it as "about nine feet long and six feet high in the dark room, leaving three feet of space in front for carrying a seat and provisions. The sides are fitted with grooved drawers for the different sized negatives, and proper receptacles for the different cameras, chemicals, etc." Thus equipped, he took the first photographs of such scenic wonders in Wyoming as South Pass, Devil's Gate and Independence Rock.

After the Civil War scores of photographers poured into the West to take pictures of the region's mountains, rivers, falls, deserts, canyons and unusual flora and fauna. Many of them accompanied geological surveys that were backed by the government or the Smithsonian Institution. Some of these photographers, like Alexander Gardner, worked alongside crews laying track for the transcontinental railroad, producing pictures with such imaginative captions as "View embracing twelve miles of prairie" or "The extreme distance is five miles off." Others took off on their own and never returned. One brief newspaper account in 1866 read: "Mr. Ridgway Glover was killed near Fort Phil Kearney on the 14th of September by the Sioux Indians. He and a companion had left the Fort to take some views. They were found scalped, killed and horribly mutilated."

There were less lethal but still annoying enemies of the early adventurers. Timothy O'Sullivan, one of the most famous photographers of the West,

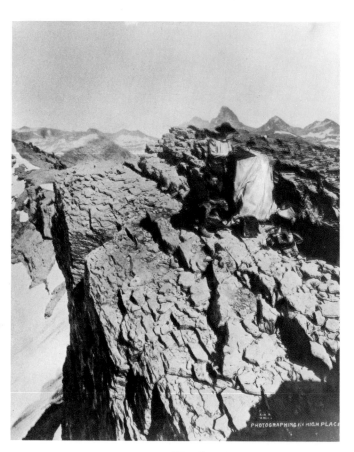

William Henry Jackson, shown on location in Wyoming's Grand Tetons in 1872, was one of the most famous among an enterprising and courageous band of frontier photographers. Their work, circulated mainly as stereoscopic views, familiarized Americans and Europeans with the splendors of the great American wilderness, luring sportsmen, adventurers and tourists into the wilds to see at first hand the grand vistas they had already viewed on film at home.

made an expedition to the Humboldt Sink of Nevada, and wrote: "It was a pretty location to work in, and *viewing* there was as pleasant work as could be desired; the only drawback was an unlimited number of the most voracious and particularly poisonous mosquitoes that we met with during our entire trip." Despite such harassments, more and more photographers entered the new territory.

William Henry Jackson took the first pictures of Yellowstone in 1871. John K. Hillers photographed the Grand Canyon. L. A. Huffman recorded on film the last herds of buffalo that still roamed the open range. Today such names as Jackson Canyon in Wyoming and Mt. Hillers in Utah commemorate these pioneer photographers.

Other nature photographers were meanwhile pioneering in the somewhat less dangerous but equally adventurous field of photographing animals in the wild. By the 1890s even amateurs were taking pictures of birds on the wing and gazelles on the run. In the interval several important inventions had appeared. Dry gelatin plates had come onto the market in 1880. Unlike wet plates, they did not need to be prepared or developed on the spot, and they were so much more light sensitive that exposure time was reduced to less than one second.

More important, roll film was soon being manufactured. Roll film could be loaded into small, hand-held cameras that were easily carried on field trips. Faster shooting was made possible when high-speed shutters were produced in 1890. Other innovations especially important for nature photographers were telephoto lenses, panchromatic "all color" film and lens filters with which black-and-white photographs could more accurately record the vast range of color in the natural world.

Technology not only gave nature photographers the equipment to take "instantaneous" pictures, as they were promptly called, but it also provided a process for widely reproducing the prints in books and magazines. By 1893, after nearly 40 years of experimentation and partial success, a method of cheap but accurate photographic illustration had been devised. It was the "half-tone process" (because the illustrations faithfully imitated the intermediate shades of gray in black-and-white pictures), and is still in general use. This process was an immediate boon to such pictorial journals as the *Illustrated London News, Illustrierte Zeitung* (Leipzig) and *L'Illustration* (Paris). In the United States general magazines like *Harper's Weekly,* as well as specialized ones like *Outing* that were devoted to nature and sports, began to print reproductions of photographs. At last photographers had found a mass market. It would shortly become even larger than the market developed by the fad for stereoscopic slides.

Armed with their new "instantaneous" cameras, nature photographers

15

pursued wildlife with all the terrifying energy they and their predecessors had directed toward mountains and lakes. They set about studying the habits of their subjects. An article in *Outing* magazine, in 1900, printed photographs of a butterfly emerging from its chrysalis. The helpful accompanying text explained that the butterfly "rests quietly for about an hour to enable its tissues to harden preparatory to flight. . . . Place it where you will, and it will pose for you to your heart's content." The article also pointed out that wasps and bees rest quietly under flowers on rainy days, sometimes in such a dormant condition that they can be taken into the studio.

In the 1890s Mr. and Mrs. Allen G. Wallihan were so successful in catching animals in their natural surroundings in Colorado that they photographed a veritable portfolio of them, using the dry-plate process. This indefatigable couple hid for hours behind rocks and cedars beside deer trails. On one occasion, spotting deer while on horseback, they dismounted and, as Mr. Wallihan wrote, "The tripod is up quick as a wink, and the camera follows, the lens is attached, plate-holder inserted, and just as I draw the slide, they come out right in front of me, within twenty-five yards." On occasion, Mr. Wallihan could attract the animals' attention by whistling, breaking a stick or "bleating like a fawn."

The Wallihans' efforts led to excellent pictures but questionable zoological observations. On the subject of elks *(page 11),* Wallihan wrote, "I think they use their tusks or 'ivories' as a warning, by producing a squeaking sound with them." Evidently the elks did not squeak on one lucky day when the Wallihans were able to photograph a herd of 200 of them. ("The photo does not show near all, as they covered the plate, and quite a good many off at each end," he noted.)

By the 1890s the animals could not escape the photographers even at night. A Pennsylvania conservationist and congressman, George Shiras III, invented a gun that fired a magnesium flash, enabling him to illuminate his quarry in the dark. Shiras' nocturnal pictures of deer won first prize at the Paris World Exposition in 1900 and provoked a French aristocrat to exclaim, "How happy I would be to place these splendid pieces in my hunting castle." Soon Mr. and Mrs. Wallihan were hunting deer at night with a flash lamp, Mr. Wallihan remembering that after the blinding light was fired the deer scattered so wildly that "You laugh at their confusion until your sides ache."

Modern nature photographers know that birds are shy of strange movement but generally will continue their normal activities if human beings are out of sight, inside a canvas blind. Earlier photographers, however, felt they had to hide in fake trees or under piles of hay. One description of bird photography at the turn of the century was printed in a book titled *Wild Life at Home: How To Study and Photograph It,* by the English photographer Rich-

ard Kearton. Kearton made his blind by wrapping green cloth around a frame and arranging the top to represent a storm-snapped trunk. "My wife painted the whole to represent bark," he explained, "and when it was dry my brother glued small pieces of moss and lichen to it, and I fastened a number of pieces of strong thread to the wire inside and passed the ends through to the outside. With these we tied on a number of sprays of ivy, which we stripped from the trunks of trees. . . . The device, it is pleasant to relate, answered our highest expectations upon the very first trial."

Such undeniable advances in technology prompted armies of photographers to go to every corner of every land, and even underwater *(Chapter 4).* The explorer and naval officer Robert E. Peary took a camera with him on an Arctic expedition; but he complained that the monotony of the Greenland ice cap provided little to photograph, and that "the interesting subjects for the camera figure down practically to the dogs."

The most celebrated photographers of nature went to Africa. Mr. Wallihan had predicted: "In the future, the literary hunter will tell you of his emotions while arranging his camera, how he felt as he looked into the eyes of the advancing animal . . . and prospected the chances of a good negative." Titled and untitled rich men traveled through the jungle with safaris of as many as 130 porters. Books were published with titles like *Camera Adventures in the*

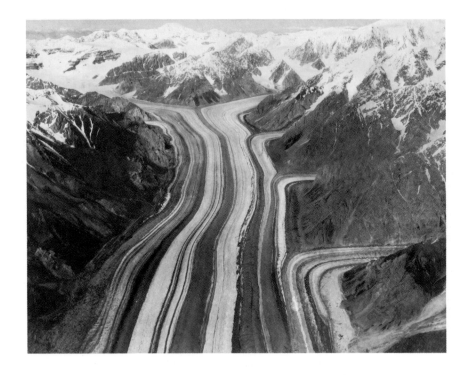

The forbidding, stunning reaches of desolate Barnard Glacier in Alaska's Wrangell Mountains, near the Canadian border, were taken with an aerial camera by explorer-photographer Bradford Washburn in 1938. Besides their undeniable esthetic quality, the patterns of this photograph graphically reveal the inexorable march not only of the main glacier, but also of the many lesser ones that contribute to its massive size and flow.

African Wilds and *Flashlights in the Jungle*. Among the most famous nature photographers in Africa were Martin and Osa Johnson, an American husband-and-wife team who made a very good business of photographic safaris. On their 1933 trip to Africa they took along 50,000 dollars' worth of lenses, innumerable cameras and two airplanes, his and hers. The Johnsons wrote books about their trip and their text was frequently as colorful as their pictures. One book, *Over African Jungles,* describes a lion: "He was one of the handsomest lions I ever saw . . . and I can't think of a better way to describe him than to quote Osa. 'Why, Martin,' she whispered, still with her hand on my knee, 'he's a perfectly beautiful platinum blond.' " Their safaris were not without danger. Martin Johnson wrote of one instance in which he and Raymond Hook were photographing a female leopard from a blind: "Before I realized what was happening she sprang squarely through the too-large opening in the blind, and struck the camera behind which I was standing, sending it back against my face. That in itself half stunned me, but then, with such a crash in my right ear as made me think that the sky had fallen, Raymond's gun exploded in her very

eyes. She was clutching at the camera not eighteen inches from me, and suddenly I felt her hot blood splash across my cheek. I still was too astounded to realize just what had happened, but then I saw her hold on the camera relax, and in another moment she fell limp, her head and body dangling down among the legs of the tripod of the camera . . . her hind legs supported by the lower edge of the opening in the blind."

Similarly, an English author, Marius Maxwell, warned his readers in 1924 of the dangers of photographing wild elephants: "Face-to-face meetings are at all times nasty incidents, and particularly speculative at close quarters." Such confrontations could be avoided, he went on, by learning to decode elephant sounds. With a confident knowledge that might disconcert a zoologist, Maxwell listed 11 different elephant sounds, including "a low squeaking sound" signifying "contentment or pleasure," and the elephant's danger signal, "a continued rumbling noise" indicating that "the members of a feeding herd are about to be alarmed." When dealing with a charging rhinoceros, Maxwell warned, "a sidestep in the nick of time is possible, but requires agility, and remains at all times a risky performance."

Today the nature photographer may still have to beware of the charging animal, but most of the technical photographic problems that bedeviled his predecessors have been solved. A few lenses, or perhaps one, a variable focal length, or zoom, lens, a 35mm single-lens reflex camera with a built-in light meter, and high-speed film enable the modern photographer to become a lightly burdened explorer. He has superb underwater equipment at his disposal, strobes for better lighting outdoors and in the studio, and a motor drive on his camera that allows him to take as many as 10 frames per second of a bounding tiger or galloping zebra, and even an electronically controlled camera that can set correct exposure automatically.

But although most of the technical problems may have been solved, the excitement has not gone out of nature photography. The photographer must still find his subjects. He must observe when flocks of migrating ducks descend on a pond each season or where a prairie dog is likely to pop up out of his hole. Even more challenging is the problem of taking a new picture of an animal or a landscape that has been photographed many times before.

That, of course, is the real problem: vision. In the Seventh and Eighth Centuries a Buddhist painter in China would stare at a flower or a monkey for days before lifting a brush. Finally he would dash off an ink drawing with a few strokes. The flower was not seen as an object of sentimentality; the monkey was not comical; for the first time a flower or a monkey had been focused on and fully *seen* on its own terms. The good nature photographers are in the same tradition: it is precisely this sort of clarity of vision that distinguishes their work at its best.
—*Edmund White* □

The World of Nature

Nature photographers may safari in African game parks, hike the wilderness to record on film the flora and fauna that survive in its harshness, or dive beneath the sea to capture the eerie beauty of life underwater. Or they may discover equally dramatic pictures in more civilized settings: a cardinal on a city window sill or a snowflake on a hat.

Whatever and wherever the subject, photographs open the world of nature to reveal with memorable clarity phenomena that men seldom have the opportunity, or the patience, to observe for themselves. Nature photographs preserve all the bustling life on the planet in all its colorful complexity. The best such photographs possess a quality of loveliness that lends them added importance as examples of a special kind of art.

Some of the most celebrated nature photographers have also been scientists, whose pictures benefit greatly from their special knowledge, and whose science has been advanced by their cameras. Increasingly, field naturalists find themselves picking up the camera as an indispensable tool of their work out of doors, and producing with it pictures that often go far beyond the merely documentary.

"There has been a change in nature photography," said Hans Kruuk, a behavioral biologist who made the haunting picture of hyenas at work that appears on page 38. "It has come closer to research, and many photographers are making a determined effort to portray the actions of nature rather than merely animals or plants." Ornithologists in particular find photography useful, because their feathered subjects are eternally in flight or perched warily on some distant branch and thus are especially difficult to study. (A picture essay devoted to the photography of birds begins on page 56.)

What constitutes an outstanding nature picture today is well illustrated by the example at right, made by zoologist Mattie Jarman, who, with her husband, Peter, studied impalas in the Serengeti for three years. This result of her research is first a remarkably elegant portrait of animals. But it also records the details of a classic confrontation between two impalas, a patriarch and a younger male.

Such work by scientists who are not professional photographers has set a new standard of excellence for all who make pictures of nature. Most photographers of nature, of course, are simply people from other walks of life, who are eager to record in their pictures the fleeting, the hidden, or the awesome scenes that are everywhere available in nature, and who, along with Thoreau, feel "we need the tonic of wildness."

Timidly, a younger male impala (right), his neck rigid with anxiety, his ears meekly forward in a show of subservience approaches an older, dominant male impala in a Tanzania preserve. The dominant animal permits the upstart to come near—but only to sniff the gland at the base of his forehead in an act of submission. The photographer steadied her camera on her Land Rover window frame and used a telephoto lens to record the encounter, which had never before been photographed.

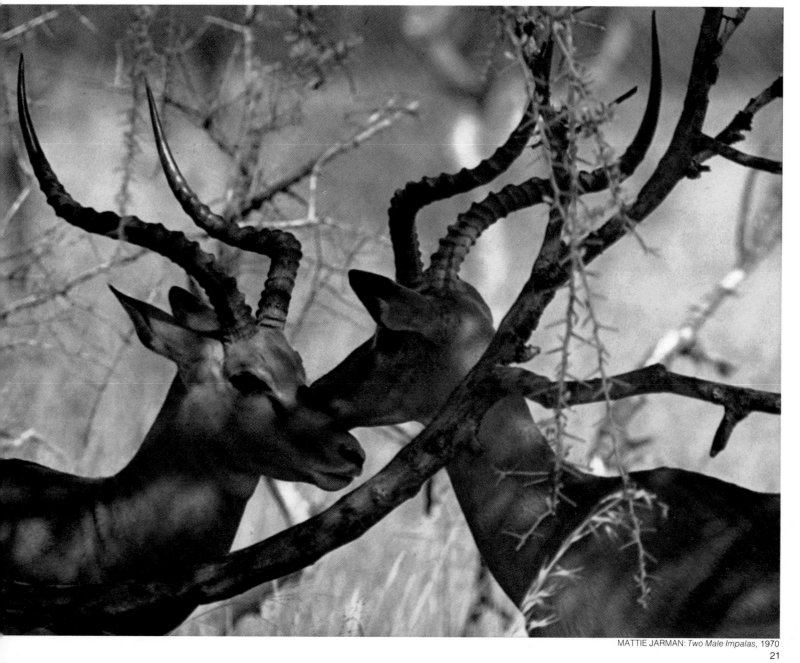

MATTIE JARMAN: *Two Male Impalas*, 1970

The Camera as Bird Watcher

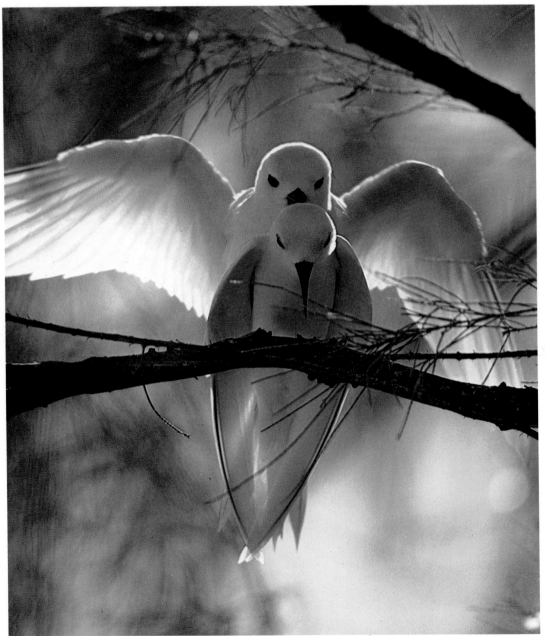

Although modern high-speed color film, fast and lightweight zoom lenses and motor drives can help transform a skittish bird darting through a shade-dappled forest into a memorable photograph, the most important of all the photographer's tools is the same one used by Audubon: watchful, knowledgeable observation.

Keen and patient viewing can move bird photography beyond static portraiture to rarely seen glimpses of the private lives of birds. To obtain the examples reproduced here, the photographers relied heavily on the fact that birds, although shy and elusive, are also creatures of instinct and habit, appearing in the same places at the same seasons every year, behaving in much the same manner at about the same time every day.

The ornithologist-photographer Robert Hernandez, aware that the excited fairy terns flitting through the trees were performing an aerial courting ceremony, patiently followed them until he was able to shoot the haunting picture of their mating shown at right.

For Teiji Saga, photographing whooper swans *(far right)* became a lifetime mission. Saga followed the swans each year to the frigid shores of Japan's Hokkaido island, where they winter. There, after nearly 15 years of studying them, Saga knew precisely when and where to try once again to achieve his lifelong aim, a picture that is "one with the swan in its pure, natural state."

Fairy terns mate in a tree in the Seychelles islands. The terns of the sparsely populated Seychelles, 657 miles northeast of Madagascar in the Indian Ocean, are unafraid of people, enabling the photographer to stand close enough with a 105mm lens—a popular portrait lens. He observed the terns' intricate ballet of flights and preening, realized it was a courting ritual, and waited for two hours to get this remarkable picture of their union.

ROBERT HERNANDEZ: *Fairy Terns,* 1977

Bedded down on the frozen surface of Odaito Jyoko, a bay on the northeastern coast of Japan's Hokkaido island, whooper swans double up for warmth as they wait out a blizzard. Some 13,000 whoopers winter in Japan, half on Hokkaido, crossing from Siberian breeding grounds. The photographer waited through the storm until the sun broke through and two of the big swans (center, right) looked up to bask in its warmth.

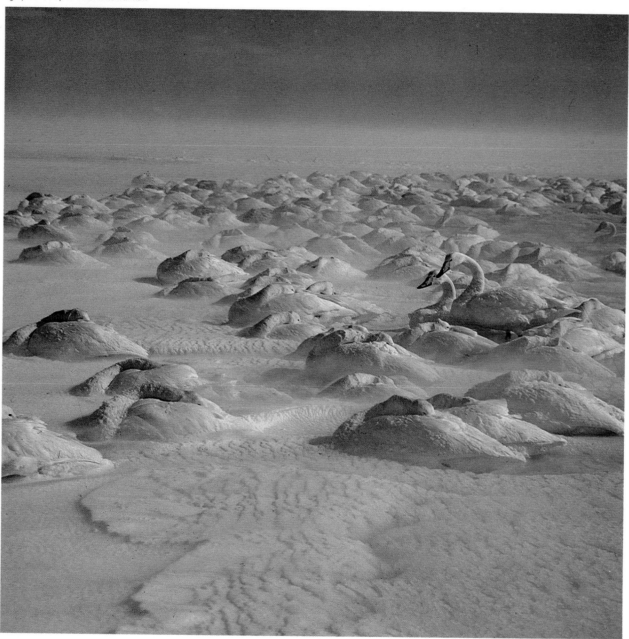

TEIJI SAGA: *Whooper Swans,* 1977

23

Split-Second Motion on Film

Some of the most remarkable sights in nature cannot be seen by man without special equipment because the actions occur faster than the human eye can detect. No one knew precisely how a fly landed on a ceiling or a leaf hopper took off, for example, until British naturalist-photographer Stephen Dalton succeeded in doing what no other photographer had ever done: obtain sharp pictures of insects in their natural airborne state.

In 1969, Dalton began to work on a shutter that would be fully open 1/450 second after it was triggered—on cameras like his 35mm SLR, the delay in shutter response, even for high-speed exposures, can be 1/20 second. Next, he needed a flash that had a duration of only 1/25,000 of a second, to freeze insect motion and the vibration of its wings, which beat from eight to 1,000 times a second. In addition, he had to devise an electronic-eye triggering device that was sensitive enough to be set off by the shadow of an insect's antenna. The device also had to work instantaneously to trip the shutter before the insect left the shallow depth of field of a prefocused 100mm macro lens.

With the aid of electronic scientist Ronald Perkins, Dalton spent 18 months assembling a winning combination of shutter and electronic flash capable of three time-delayed exposures. Dalton and Perkins also perfected an electric-eye triggering device, and heightened the likelihood that the insect would fly through the beam by arranging mirrors that reflected the beam in a crisscross pattern in the box that functioned as the studio. The only remaining step was to catch some insects and put them in the box—and when Dalton did so, the results were these astonishing pictures.

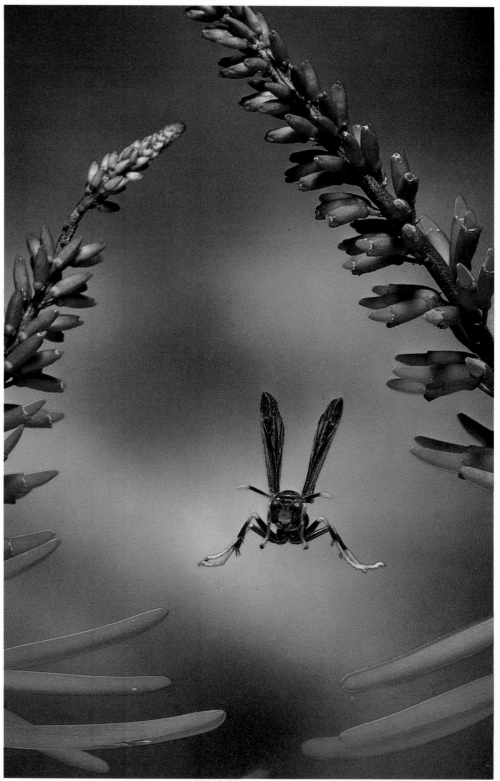

STEPHEN DALTON: *Paper Wasp*, 1973

◀ *A head-on shot of a paper wasp in mid-flight (left) catches it at one extreme of its crisp wing motion — the wings beat from exactly vertical, as here, to exactly horizontal, while antennae and legs remain outstretched. This picture is one of a series that for the first time revealed the pattern of wasp flight.*

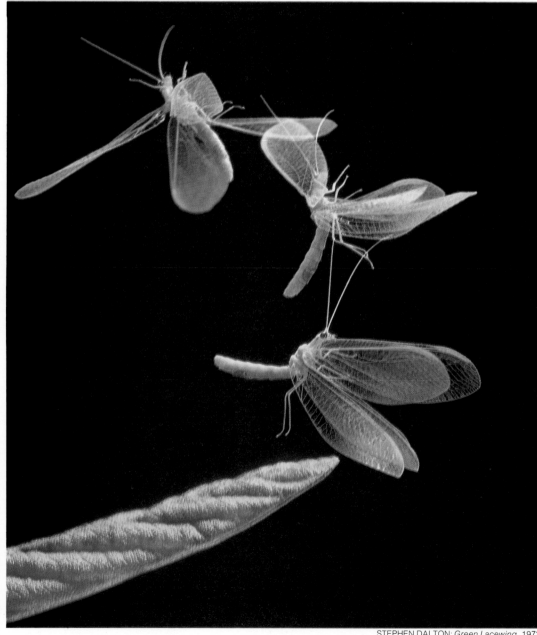

STEPHEN DALTON: *Green Lacewing,* 1973

A green lacewing executes a backward half-loop after making a vertical take-off from a hawthorn leaf. The lacewing, caught in mid-air inside a specially constructed mini-studio, triggered the camera shutter and flash, freezing images of the insect in three aerial positions. Some 900 exposures had to be made before this one recorded for the first time the lacewing's style of flight.

Revealing the Unfamiliar: Fire and Ice

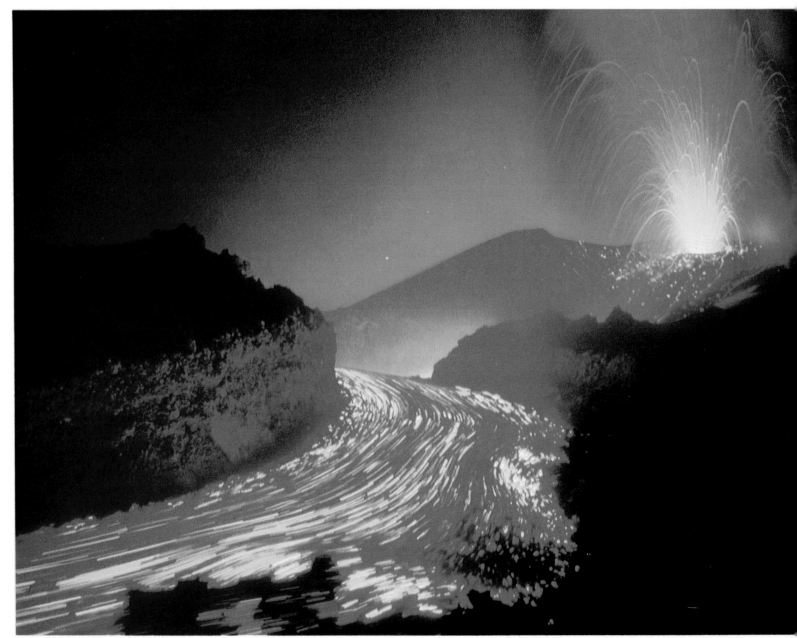

UNIDENTIFIED SOVIET PHOTOGRAPHER: *Mount Tolbachik Erupts*, 1975

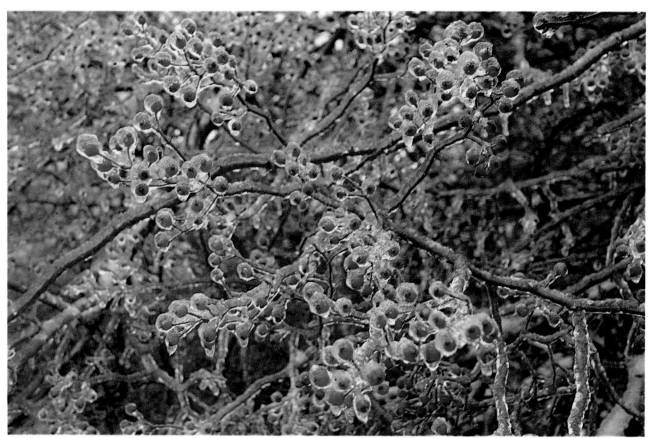

Wild rose berries, encased by ice after a winter storm, glisten in the overcast winter sun in suburban Connecticut. This picture is part of the photographer's personal project to photograph seasonal changes in the woods near his home.

Mount Tolbachik, a volcano on the eastern edge of the Soviet Union, erupts with a blast of flame, smoke and molten rock that denuded the Kamchatka peninsula for nine miles around the cone.

From the alarming grandeur of a flaming volcano to the beauty of wild rose berries sheathed in ice, the camera can discern all the surprises that are the true nature of nature. Mount Tolbachik in Kamchatka, a strategic Siberian peninsula only 442 miles from Alaska and dotted with missile bases, put man-made pyrotechnics in the shade on July 6, 1975, by blowing its craggy stack. Tolbachik, one of 22 active volcanoes on the peninsula, spewed tons of magma — liquid rock at a temperature of 1,800° F. or more — so upsetting the at-mosphere that electrical storms raged in-side the billowing volcanic clouds.

Western observers are kept away from the area by the security-minded U.S.S.R., but the world got a look anyway, after an unidentified Soviet photographer smug-gled his film out of the country.

On the other side of the world, in a setting close to his home in Wilton, Con-necticut, industrial photographer Bruce Ando came upon a quieter but equally startling spectacle, the delicate filigree of ice-shrouded wild rose berries.

Creatures in Ocean and Tank

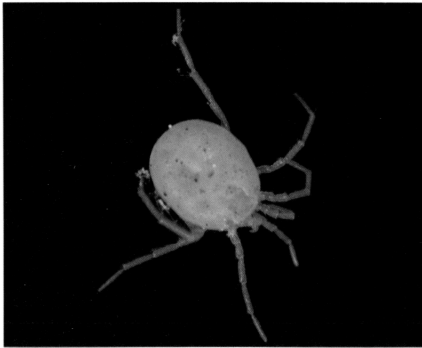

JOHN COOKE: *Water Mite*, 1969

Trapping a tiny water mite against the front of a tank, the entomologist-photographer mounted strobe lights on either side of it. He also set up adjustable mirrors that reflected the light at angles, adding dimension and texture to the mite's body with highlights and hints of shadows.

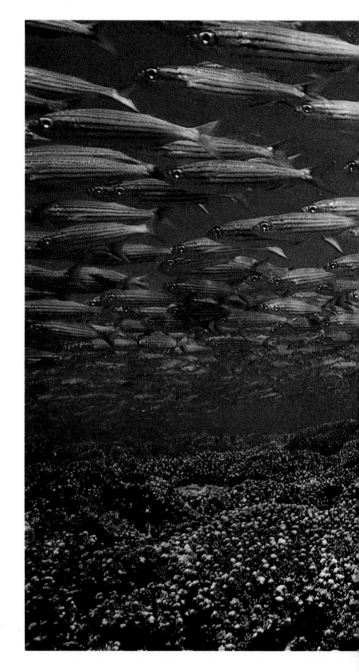

Without photography the sea would remain *aqua incognita* to all but divers and marine biologists. But today the proliferation of underwater photographers— from tourists with snorkels to professionals like those represented on pages 148 to 156—has made recognizable sights out of even such exotic undersea spectacles as the one at right.

Some creatures have to be brought into captivity before they can be photographed. The fresh-water mite above can barely be perceived by the naked eye. In order to take its picture, entomologist John Cooke placed it in a tiny tank of water. He then trapped it against the front of the tank with a glass slide that had a cavity in its surface. He used a 35mm camera with a four-inch extension tube to which a 40mm microscope lens was attached. The special lens provided clarity at short range—it was only two inches from the mite when the picture was taken—and the resultant photograph revealed every joint in the creature's almost microscopic legs.

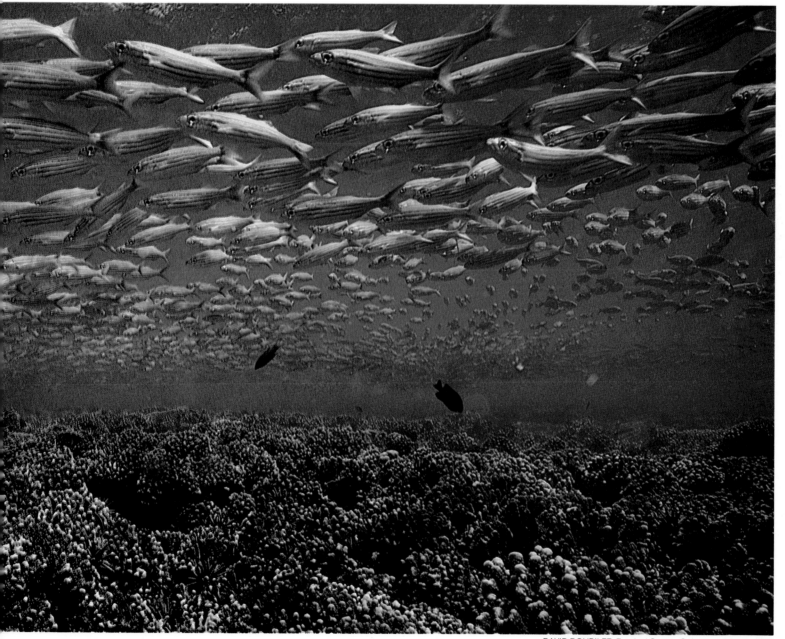

A school of grunts blankets a coral field in the Galapagos. The picture was shot with an 18mm lens through an optically corrected dome port. The glass of the port compensates for the way water bends light rays and gives the lens the same 100° viewing angle it would have above the surface.

DAVID DOUBILET: *Tropical Grunts, Galapagos Islands*, 1977

Subtle Colors That Add Impact

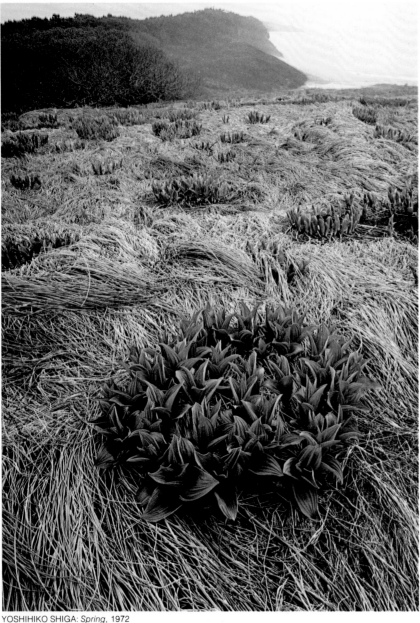

YOSHIHIKO SHIGA: *Spring*, 1972

Nature photography today is almost irresistibly color photography. And in some cases color film records even more than the eye does.

On a rainy day, when most photographers pack up their gear, more imaginative photographers use the rain itself to enhance the picture *(right)*. Particles of rain water diffuse the light and soften contrast. Water also reflects the blue light characteristic of an overcast afternoon onto the color film, which is more sensitive to blue than the eye.

At daybreak or sundown when light is too feeble for fast shutter speeds, it is often richest in dramatic possibilities. Early on a June day, when Yoshihiko Shiga made the picture at left, which he calls *Ikiru* — "to live" — the fragile scene was enhanced by a pale morning mist.

Spring shoots punch through the frozen surface of a mountain slope near an inland lake on Hokkaido island in northernmost Japan. The scene, which won Japan's Nendo Sho award in 1974, not only glistens with the rich green of the hellebore leaves and the straw of grass but glows in the delicate golden light of early morning.

In this picture of a forest grove at Yosemite ▶ National Park, taken with regular color film, the falling rain emphasizes the blue cast of a cloudy day. Everything seen in such weather conditions appears blue, almost as though it were being photographed — or viewed — under water.

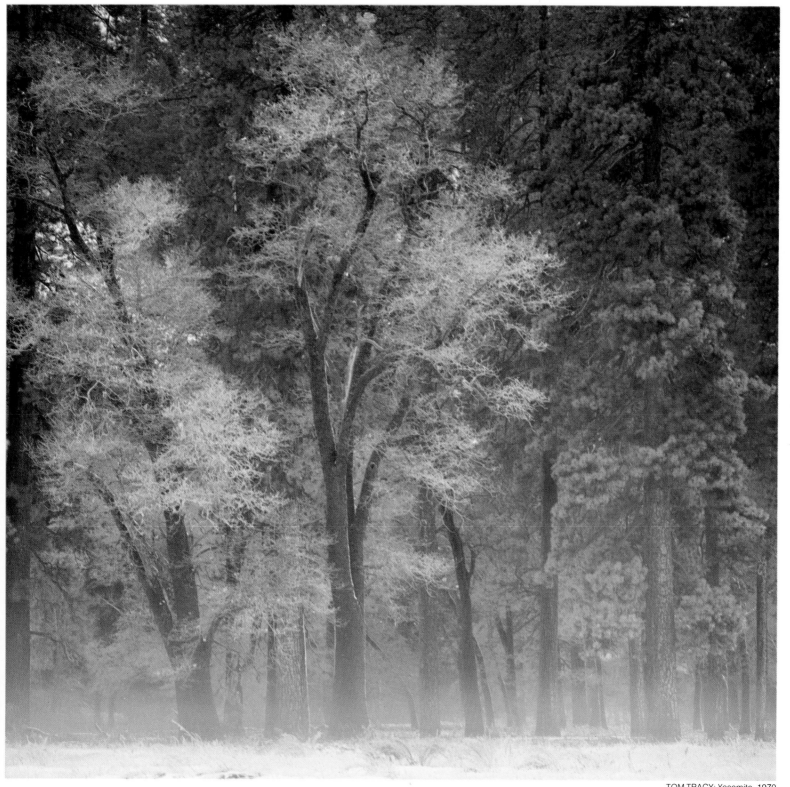

TOM TRACY: *Yosemite*, 1970

Catching the Unique Characteristic

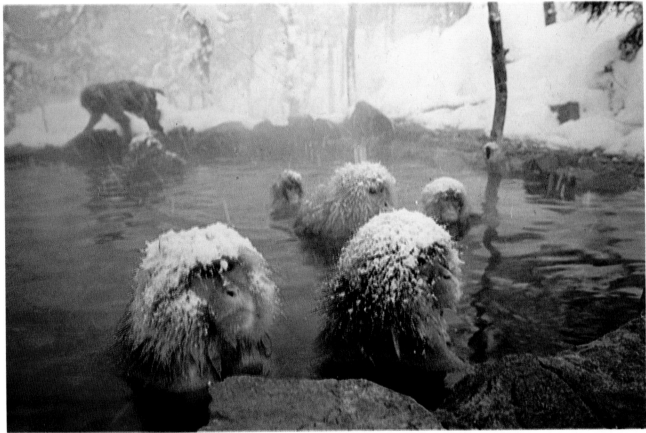

CO RENTMEESTER: *Snow Monkeys in a Hot Spring,* 1969

As does any narrator, the camera tells of nature by revealing its character through action. Capturing the action on film, however, requires inside knowledge of what is likely to happen, so the photographer can not only pick a ringside seat but bring along the necessary equipment.

Covering a wild-horse roundup in Galicia, Spain, David Alan Harvey knew that a fight was likely to occur when two rival stallions confronted each other in the corral. To work speedily, without having to adjust dials, and to catch the fast action once it began, Harvey preset a camera with automatic exposure control to ensure correctly exposed pictures at the fastest shutter speed the light permitted.

Similarly, when Co Rentmeester undertook to portray the lives of the snow monkeys of Japan, he heard of the monkeys' method of warming up after searching for food in the icy mountains — and thus staked out a popular hot spring for a crusty group portrait.

In a natural hot spring, Japanese snow monkeys find their own relief from the cold weather. The photographer caught the moment of humorous incongruity when the monkeys warmed all but their snow-encrusted heads in the steamy water.

Penned together during a wild-horse roundup, rival ▶ *stallions battle. The shot was made with a long-focal-length lens — its reduced angle of view filled the frame with action and its shallow depth of field yielded an out-of-focus background that further concentrated attention on the stallions.*

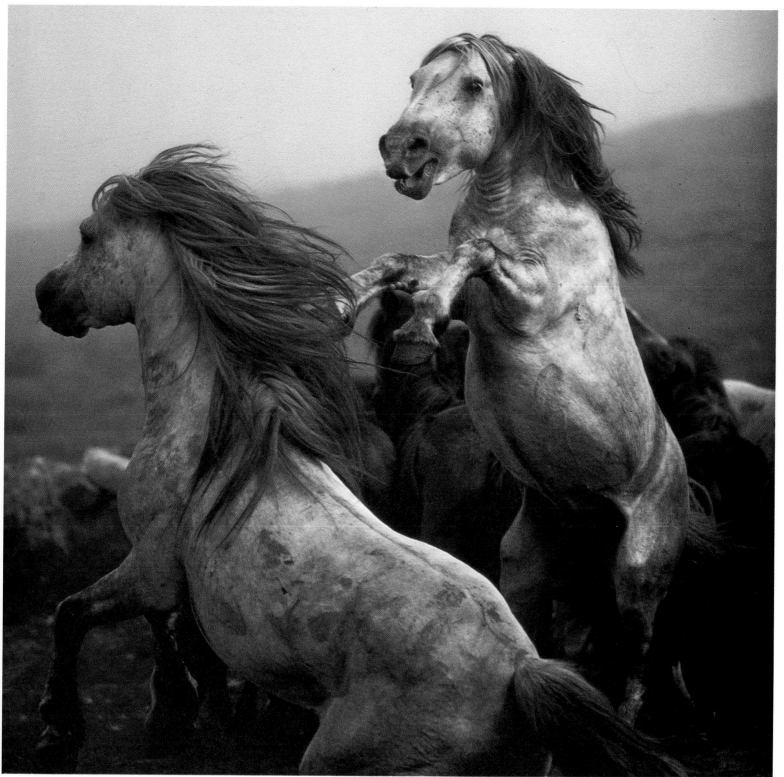

DAVID ALAN HARVEY: *Wild Stallions, Galicia, Spain,* 1977

Setting Up a Natural Situation

Sometimes the photographer has to move the natural habitat into an artificial—and more manageable—environment. The confrontation, at right, of an insect-eating South American marmosa (mouse-opossum) squared off against a tropical grasshopper its own size, was accomplished by transferring the two antagonists to a terrarium.

The result was not only a nature photograph that could not have been shot in the wild, but also a study that no artist could match. Only a photograph could convey the authenticity of the moment as the pugnacious little marmosa, with its bulging eyes and its an-ticipatory stance, realizes that it has met its match. (The grasshopper did prove too much of a challenge, and the marmosa backed off.)

While the camera is superior to the pen in capturing such fidelity to life, even less dramatic photographs serve as realistic evidence for the artist in his own work. And often the artist acts as his own photographer. The noted naturalist and illustrator Roger Tory Peterson has written, "In my studio, 35mm transparencies are projected on a Trans-Lux screen and then there is no question as to just how a duck holds its foot or how a leaf catches the light."

To make this picture of a showdown between an insect-eating marmosa and an insect its own size, an entomologist confined them in a 50-gallon terrarium that had been supplied with plants, sticks and rocks collected from the same spot in Panama as the animals. Using an SLR camera with a 50mm lens, the scientist-photographer lighted the scene with a strobe and reflector. Even in this small enclosure it was an hour before the two creatures met. But when they did, the photographer memorialized the scene on film.

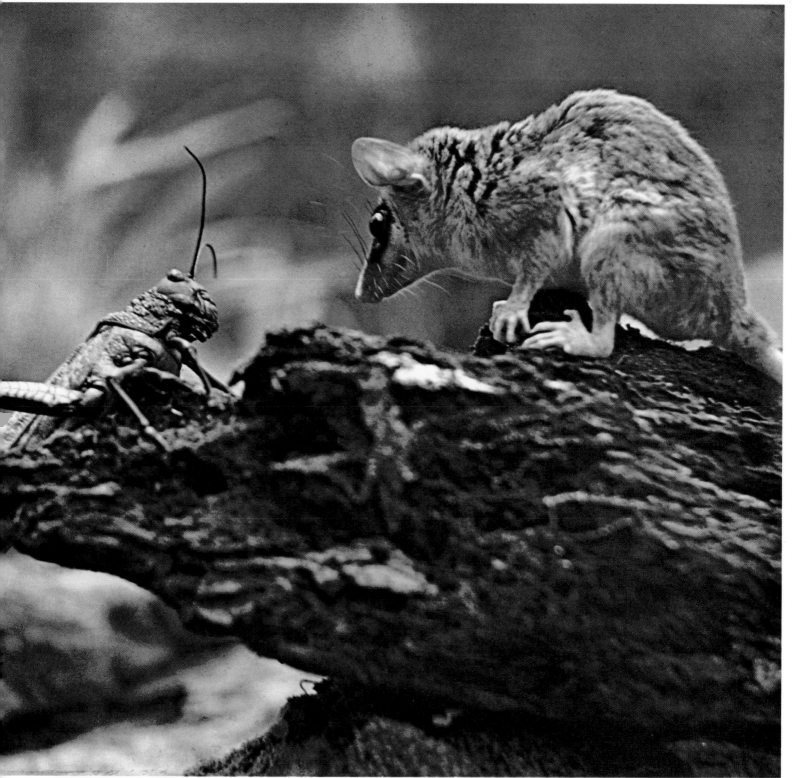

C. W. RETTENMEYER: *Grasshopper and Marmosa*, 1956

Bagging a Photographic Trophy

More and more photographers have found hunting wild animals with a camera instead of a rifle more humane, and better sport. There are no closed seasons, no forbidden species and no "bag" limit. Furthermore, each hunter can achieve a different photographic interpretation of the same animal.

A photograph of a running cheetah, like the one at right, taken by John Dominis, reveals more of the cat's essential grace than any dead specimen could show. The cheetah is built to run, and its long legs, narrow waist and small head invariably make it appear awkward in repose.

Photographing an animal requires as much courage as hunting it with a gun. The photographer may have to stalk his quarry longer and at closer range than the conventional hunter does. But the animal that the photographer pursues may be shot time after time, and suffer no fate worse than overexposure.

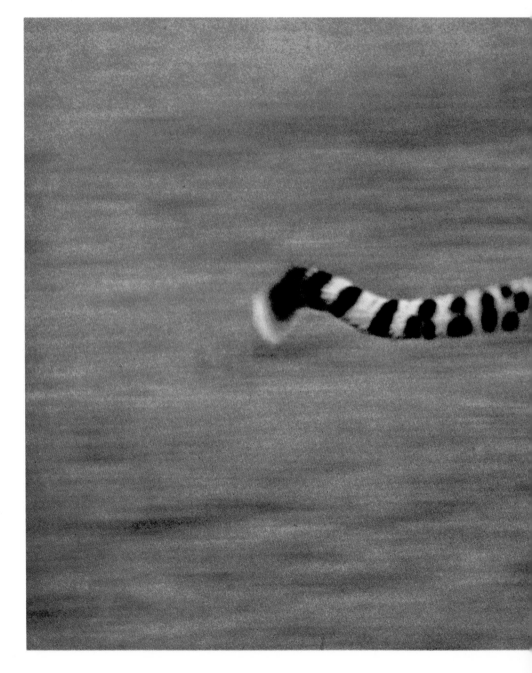

To portray the speed of the cheetah, an explosive runner that has been clocked at 60 mph for bursts of a quarter of a mile, the photographer panned as the cat streaked past his camera. The blurred background and legs emphasize the sensation of swift motion. The photograph also reveals a secret of the cheetah's running style that the naked eye could not detect: at full tilt the animal touches the ground with only one paw at a time.

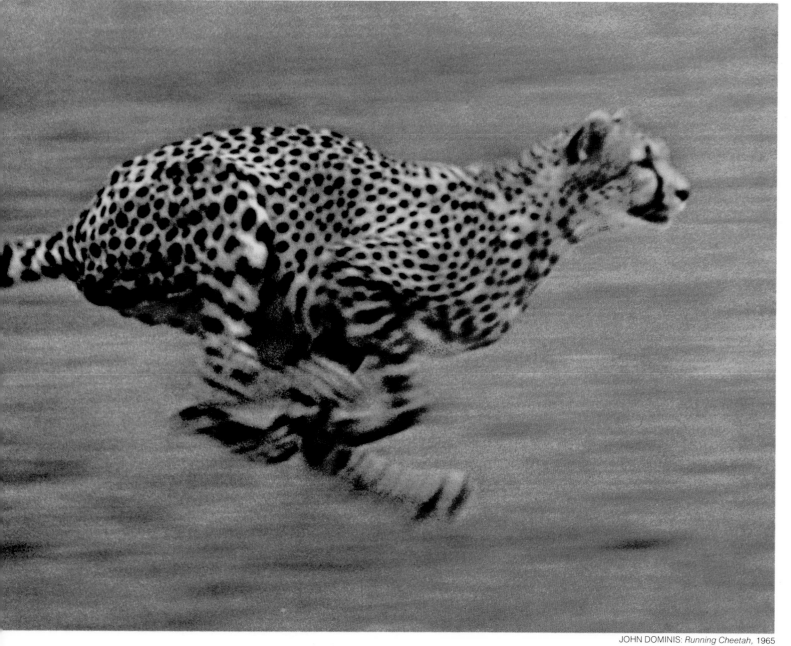

JOHN DOMINIS: *Running Cheetah*, 1965

Revealing Action After Dark

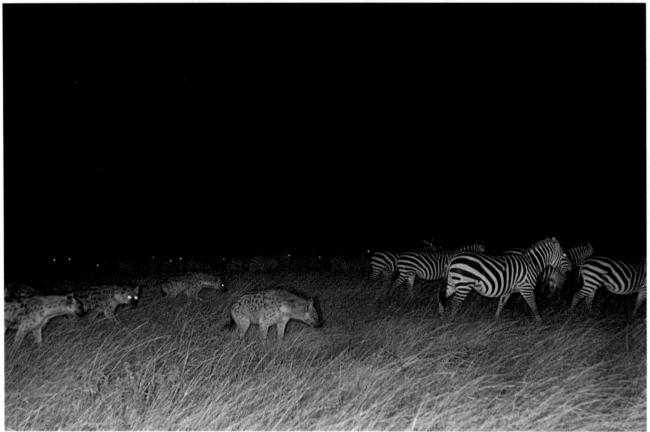

HANS KRUUK: *Hyenas on the Prowl, Tanzania,* 1967

Without the broad palette of daylight colors, the camera beholds nature at night as stark and surreal, the setting for eerie drama. Strobe lights, specially rigged, are almost essential. Some flash units fired in the dark automatically shut off when light reflected back from the subject indicates that there is sufficient illumination for correct exposure. Such a flash clamped on a jeep windshield and another on the camera enable zoologist Hans Kruuk to bump through pitch-black night after zebra-eating hyenas *(above)* and "concentrate on the action without having to fiddle with stops in the dark."

In contrast to Kruuk's method, Japanese nature photographer Manabu Miyazaki used flash units as part of an elaborate set-up he built for around-the-clock surveillance of the animal traffic on a forest path near his home in the Japanese Alps. Six cameras with automatic mechanisms to advance the film, four strobes, all weatherproofed and muffled so the clicks and whirs of the machinery would not startle the prey, were trained on a short section of the path.

All of this equipment was automatically triggered every time an object interrupted a beam of infrared light — invisible to animals — that spread across the path. Miyazaki returned only to change film, which revealed, when developed, a Lilliputian wonderland of animal activity — including the jumpy fly-by-night fellow in the picture opposite.

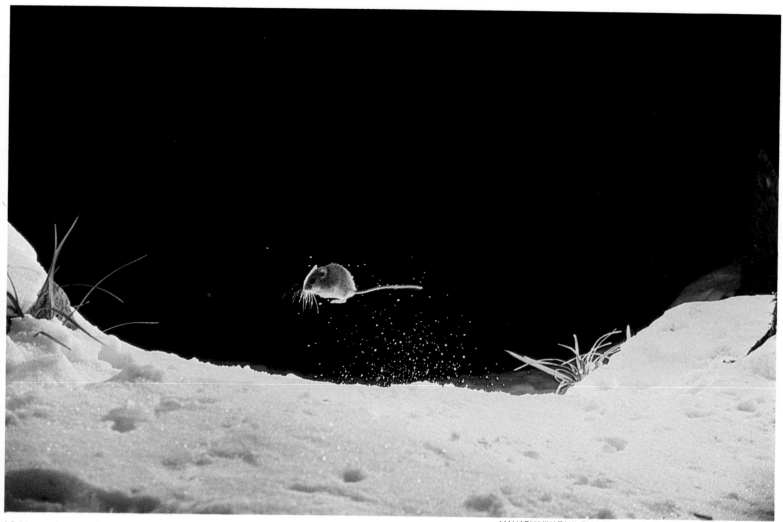

A field mouse bounces along a game trail at night in the Japanese Alps. The mouse took its own picture, interrupting an infrared beam that tripped the shutter release of a camera and electronic flash unit set up along the trail. The rig could run for 20 days by itself; all the photographer had to do was change the film.

MANABU MIYAZAKI: *Field Mouse on the Move, Central Alps, Japan,* 1977

Lasting Images of a Vanished Canyon

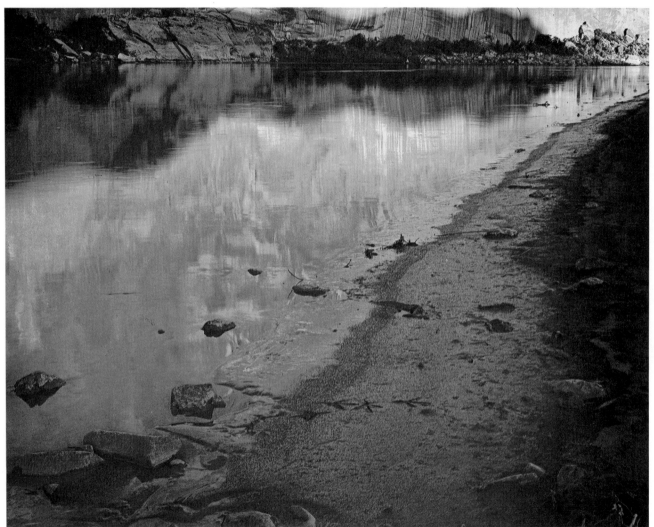

ELIOT PORTER: *Heron Tracks, Colorado River Shore,* 1961

Nature photography can provide an invaluable aid to history by preserving the look of scenic places doomed to disappear through human intervention.

In 1963 Glen Canyon, which extended 100 miles across the Utah-Arizona border, was flooded when the Colorado River was dammed as part of a hydroelectric and irrigation project. Before this scenic wonder disappeared from human view forever, Eliot Porter paid it a farewell visit with his camera. Porter's pictures, published by the Sierra Club as the book *The Place No One Knew,* acquainted the general public with the wonders of Glen Canyon for the first time—but only after it had been submerged. His pictorial record preserved forever the beauties of the canyon, which was soon to be drowned under a man-made reservoir. □

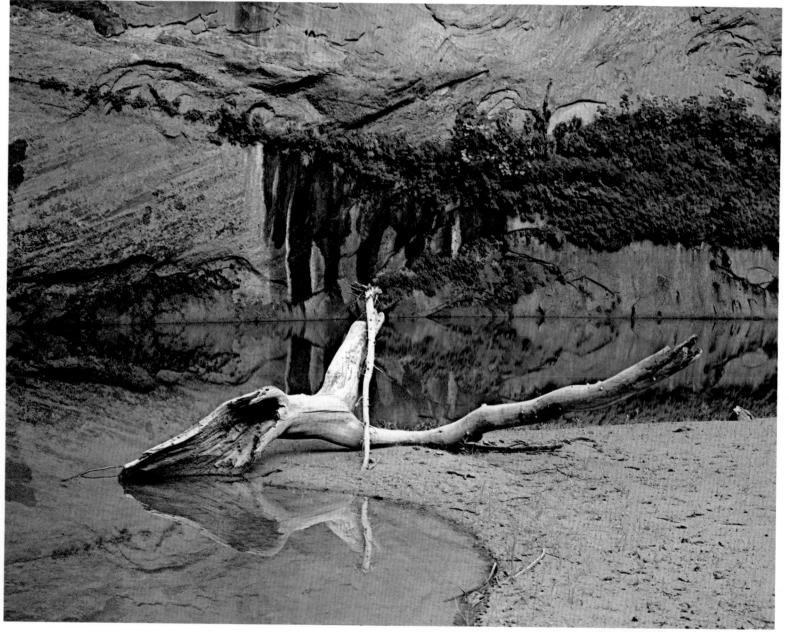

ELIOT PORTER: *Plunge Pool, Little Eden*, 1962

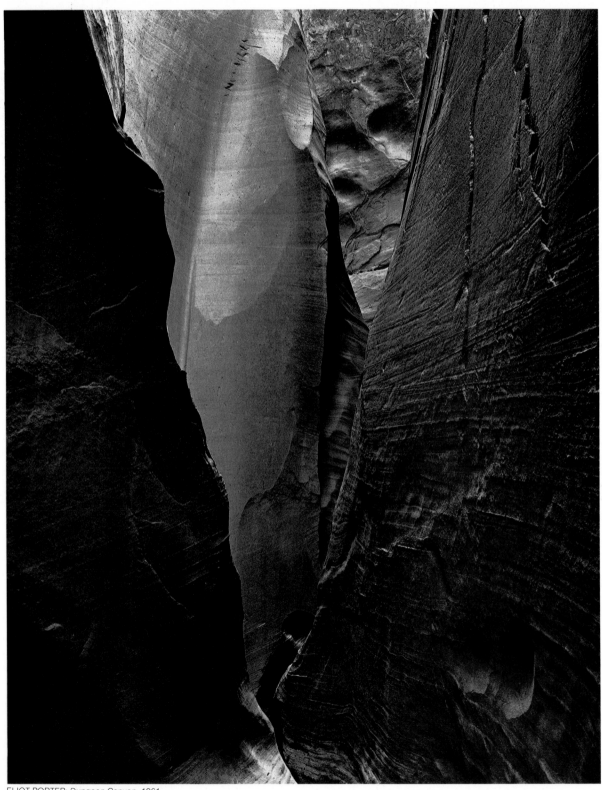

ELIOT PORTER: *Dungeon Canyon,* 1961

42

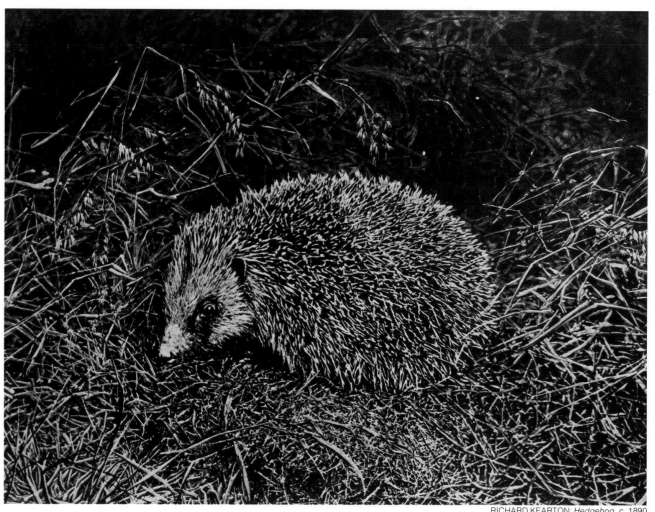

RICHARD KEARTON: *Hedgehog*, c. 1890

When to Go, Where to Go, What to Take Along

Outdoors is plainly the place for the nature photographer to spend most of his time: That is where his subjects are. And on his first or his hundredth trip to the field he will find pleasures offered by few other kinds of photography. Perhaps chief among these pleasures is the exhilaration of the hunt itself — the sheer joy of searching out subjects for pictures that will be in some measure unlike those anybody else has taken. A good example is the prickly portrait of a hedgehog on the previous page. The photographer may be sure of this variety because nothing in nature is completely predictable or subject to duplication. Few living creatures can be counted on to hold perfectly still. Many subjects in the field are so elusive as to be almost illusory. And the light is constantly changing, not only in amount and direction but in color as well. These variables are, to be sure, obstacles as well as opportunities. But the photographer who learns to cope with the caprices of nature will find an endless range of fresh and interesting pictures to take, and he may be sure that his excursions will never be boring.

Before venturing outdoors and into this world of infinite variety and challenge, the nature photographer must consider three basic matters: the best time to go out, where to look for his subjects, and what equipment to carry along with him. And if he will take the time to do a bit of homework on these questions beforehand, he will later find that his efforts have helped immeasurably to make any of his trips smoother and the pictures more successful.

When to go out depends to a great extent of course on what the photographer wants to photograph. He need not wait for a perfect summer's day if climate is not essential to the subject he is considering. The photographer of seascapes or sky will naturally welcome a brewing storm. The intricate structure of deciduous trees is most clearly delineated during the dead of winter, when the leaves are gone. Many small mammals are easiest to flash-photograph during their nocturnal foraging hours, if the photographer can determine ahead of time where to set his flash. The deeply saturated colors of wild flowers come out best on a bright but overcast day. In fact, many of the most striking and revealing nature pictures are those taken at the most unlikely-seeming moments.

There are, of course, limitations decreed by specific subjects. The man who wants to photograph honeybees, nesting birds or leaping salmon will have to fit his schedule to theirs. The timing and techniques for photographing some of these particular categories— birds, insects, flowers, big game animals, underwater life— will be discussed at some length in later sections of this book. But a good nature photographer soon finds himself developing the true naturalist's all-encompassing interest in the world around him, and thus he enlarges his expertise along with his repertoire.

Given this attitude, the nature photographer's "field" can extend from just

At their breeding site on the coast of South Africa, two adult gannets (foreground) stand guard in front of the dark-feathered young birds of the nesting colony. Because the area is near a guano mining operation, the gannets were accustomed to the sight of men. The photographer, Roger Tory Peterson, a famous ornithologist, was able to come within five feet without disturbing them. This made it possible for him to use a 35mm SLR camera with a 35mm lens. The wide-angle view and great depth of field of this lens brought out the detail of the nearest birds without losing the shapes of the other birds or even the cliff in the background.

outside his door to the farthest reaches of the wilds. There is, however, no question about where to begin: it is the nearest place that a plant can grow or a bird can perch. It may be a backyard or a nearby park or even, for a city apartment-dweller, a window box planted with wild flowers. Every photographer interested in nature can start by finding such an easily accessible place. Perhaps the most famous instance is that of Edward Steichen who, having taken pictures of just about everything everywhere else in the world, devoted long and loving attention to a single shad-blow tree on his farm in Connecticut, recording its aspect in every season, in every light and in every stage of bloom and dormancy. For the amateur even more, there is no better way to become familiar with the subtleties of nature, and to learn the capabilities of his camera equipment as well, than by concentrating in this way on one convenient and familiar subject.

This sort of close study will pay further dividends as the photographer begins to move around within the confines of his own small nature preserve. Even a modest yard offers an astonishing variety of subjects: flowers, grasses, vines, mosses. The plants attract insects, and these in turn bring birds and perhaps a frog or a snake. The enterprising photographer can help nature along with the judicious application of flower seeds or a bird feeder, being careful to let his handiwork show as little as possible.

If the convenience of the backyard nature setting is intruded on by civilization—in the form of manicured lawns, fences or telephone wires—the photographer then can move a relatively short distance farther afield: to the wood lot of an accommodating farmer or to a weekend retreat in the country. Even churchyards and ancient cemeteries in the middle of cities can be quiet places to work; many of them have beautiful trees and wild flowers that can be photographed—with or without their surroundings. Once again convenience and accessibility should be the prime considerations, since there is much to be gained by going back time and again to the same locale. All of the pictures on pages 78-84, for example, were taken over a 22-year period by freelance photographer Thomas Martin in a relatively small section of Palisades Interstate Park, which is a mini-wilderness located just across the Hudson River from the skyscrapers of Manhattan.

With his powers of observation and his technical prowess tested on familiar ground, the nature photographer is ready to extend his field still farther abroad. Many of the state and national forests, parks or seashores are within reasonable traveling distance of nearly any home. A number of them have been set up expressly to preserve particularly interesting forms of plant or animal life or geological formations. Sanctuaries for wildlife exist not only in distant Africa but in practically every country, particularly the United States. There are preserves for alligators in the Florida Everglades, for

47

whooping cranes on the South Texas coast, for bison in New Mexico, for mountain goats in Montana, and for migrating waterfowl all along the flyways from Canada to the Bahamas and Mexico. Special permission for taking pictures is required in some of these preserves, but it can usually be obtained. In fact, wildlife, in surprisingly natural surroundings, is as near as the nearest zoo. As the pictures on pages 181-196 demonstrate, superb pictures can be taken of exotic birds and animals under controlled conditions in habitats quite similar to those in the wild. Similar pictures can be taken in aquariums and in botanical gardens and arboretums; all offer the opportunity to observe and photograph rare specimens that would be impossible to find, much less photograph, in the wild.

The best camera for most field photography is the 35mm single-lens reflex with interchangeable lenses. It is by far the most popular and widely used camera for nature photography. It is not, of course, the only good camera for field work. Some of the other types (which will be discussed in turn) are more useful in certain circumstances. But for an all-around, reliable and practical nature camera, most photographers prefer the SLR.

The reputation of the SLR for this sort of work is based first of all on the camera's through-the-lens viewing and focusing system, which permits the photographer to see exactly what the camera sees. This is helpful when focusing on subjects at normal distances of a few feet or a few yards, at close-up range or for long-distance scenes when the subject is too far away to be seen clearly without the magnified view provided by a telephoto lens. Speed counts in the field, and the light meter built into most SLRs lets the photographer set aperture and shutter without taking his eye off the subject.

The SLR's versatility is enhanced by a broad range of special-purpose lenses, any of which can be easily and quickly attached or removed. Whatever lens is coupled to the camera, the SLR's viewfinder and meter keep right on working, showing precisely the image the camera will record, how sharply it is in focus, and what settings are required for proper exposure. For close-ups there are macro lenses specifically designed for this kind of work; alternatively, regular lenses can be used with the simple addition of a bellows attachment or extension tubes (pages 94-95). For broad views of subjects such as trees, large animals or landscapes there is a complete range of wide-angle lenses. The long focal length of the telephoto lens makes it possible to magnify distant (or dangerous) subjects such as animals (Chapter 5), to close in on one small portion of a nearby subject, or to blur out distracting backgrounds such as bars in a zoo cage or a fence behind a flower bed. Telephoto lenses are commonly available in focal lengths from about 90mm (with a magnifying power of about twice that of a normal 50mm lens), up to about 600mm (with a power about 12 times normal). There are more powerful lenses, but they are heavy

Perched in a Norway spruce on a winter day, a cardinal is softly illuminated by sunlight reflected from snow underneath the tree. The bird and its mate were attracted by birdseed on the ground. While one bird was feeding, the other kept watch, always from the same limb. The picture was taken from a window 15 feet away with a 35mm SLR and a 300mm lens with an extension ring.

and unwieldy; the 600mm is about the practical limit for normal field work. For focal lengths longer than that, many photographers use catadioptric, or mirror, lenses, which magnify an image just as some telescopes do, by bouncing the light back and forth inside the lens itself. Such lenses are tolerably compact and manageable, even those of 1,000mm focal length.

Although some nature photographers insist that conventional fixed-focal-length lenses are the sharpest, and, thus the only, lenses to use, others are finding the adjustable-focal-length zoom lens a convenient and versatile tool in the field. The zoom provides the photographer with a range of focal lengths — in effect, a range of lenses — in a single piece of equipment. By smoothly changing focal lengths, he can zoom in on a small detail within the scene, or pull back to encompass a broad panorama — all without moving or taking his eye from the viewfinder. This versatility makes zoom lenses popular with photographers who are willing to sacrifice lens speed (most zooms can open no wider than f/3.5) and some optical precision (zooms tend to bend straight lines near the edges of the frame).

A major advantage of the 35mm SLR in the field is its portability. A typical SLR with normal lens weighs less than two pounds, and its narrow, rectangular shape allows it to be carried easily on a neck strap or to be stowed in a gadget bag or hiking pack. Finally, it uses lightweight and relatively inexpensive film. A dozen rolls of 35mm color weigh only a pound and yield over 400 pictures.

While the compactness of the 35mm camera is one of its chief attractions, some photographers prefer a larger film size, especially for landscapes and are willing to sacrifice some convenience to get it. There are some excellent alternatives in a group of so-called medium-format SLR cameras. All use 120 film and take pictures 2¼ inches high and from 1⅝ to 2¾ inches long, depending on the camera. Most look like old-fashioned box cameras — but the resemblance ends there. Like their smaller brothers, the medium-format SLRs can be fitted with a wide range of interchangeable lenses, and the image comes through the lens as usual. It can be viewed either through an accessory eye-level prism finder, as in the 35mm version, or from above on a ground-glass screen. The ground-glass screen affords a flat, same-sized display of the exact area the exposed film will include, just as a view camera does, and so helps in composing the scene, especially with the use of a tripod.

Where careful composition and extra-fine detail are of prime importance, and the subjects are reasonably stationary — as in a pattern photograph of wild flowers or in a scenic vista — the ground-glass viewing offered by the medium-format SLR may make it the best camera. However, since the image is reflected in a single mirror before being thrown on the screen, it is a mirror image, i.e., reversed from left to right. This can be perplexing in some kinds of field work, particularly with active subjects: They appear to move in the wrong

direction on the screen. If the subject is moving left on the ground glass, the photographer must pan to the right to keep it in view. The accessory prism viewer turns the image back to normal.

The 35mm rangefinder camera opened the modern era of nature photography. It is the immediate ancestor of the 35mm SLR and the best ones have most of the SLR's best features—interchangeable lenses, a wide range of shutter speeds and other versatile controls, and the convenient 35mm film size. The only substantial difference is in the viewing-focusing system. Instead of seeing the subject through the lens, as with the SLR, the photographer looks through a separate window, which is coupled by a mirror arrangement with another window. This produces overlapping images of the subject seen from two slightly different perspectives. When the focusing ring is turned, the two images come together until the subject is in focus. The difference in perspective between the lens and the viewfinder is automatically corrected at normal distances, as with the twin-lens camera.

In a few respects the rangefinder has some advantages over the SLR, and some photographers carry both, one to supplement the other. The basic rangefinder is less intricate, lighter and more compact. It emits a discreet click rather than the more audible clunk sometimes caused by the SLR's swing-away mirror, and is therefore more desirable when the camera is used by remote control or in a blind very close to nesting birds or timid animals. Because the viewing window is entirely independent of the lens it is equally bright and sharp for all lenses. But because it is separate, it does not show the magnification or other perspective of the added lens without an accessory adapter.

Even a rangefinder camera that comes with only a single, fixed lens has many desirable features, and one with a good lens will produce marvelous nature pictures within normal viewing ranges. The fixed-lens rangefinder camera does, however, lack the versatility of a camera with interchangeable lenses, and tends to limit the field photographer's subjects.

The twin-lens reflex camera was long a favorite with nearly every professional nature photographer, and it is still fondly regarded by those who specialize in medium-range landscape photographs and portrait-type pictures of plants and animals—all of which it takes superbly. It provides 2¼ x 2¼-inch pictures with the attendant advantage of a large negative; and it also has a ground-glass viewing system—with its attendant disadvantage of the reversed image. (For the photographer who prefers eye-level viewing and a corrected image, an accessory prism viewfinder is available.) The subject is not seen through the camera lens as with an SLR, but through a twin lens of the same focal length just above it, and this means that the viewing-lens and taking-lens viewpoints are not precisely the same, thus introducing the problem of parallax error. Better twin-lens cameras adjust for this difference auto-

matically at normal and far viewing distances, but framing extremely near subjects becomes largely a matter of guesswork. Also, no matter what aperture is chosen for the taking lens, the viewing lens remains wide open and the photographer is unable to preview the depth of field at his selected f-stop. Another disadvantage is that twin-lens cameras, with few exceptions, do not have interchangeable lenses.

The view camera is the biggest gun of the photographic arsenal, with built-in advantages and disadvantages. For spectacular landscape pictures like those taken by Ansel Adams *(page 199)* or exquisitely detailed compositions *(pages 217-219),* the view camera has no peer. It has another invaluable asset, especially useful in taking landscape pictures: Its flexible controls permit the photographer to rearrange the scenery. The view camera also has a large ground-glass viewing screen and equally large film sizes (from 2¼ x 3¼ inches to 8 x 10 inches or more). For photographers reluctant to carry such cumbersome equipment, there are compact versions of the view camera designed for outdoor use. Known as field cameras, these portable models are considerably less bulky than studio view cameras.

What to take along with the camera or cameras you choose? A good selection of field photography equipment is listed on page 55. But at the very least, even for simple daylight photography with no extra lighting, you will want a selection of long, wide-angle or zoom lenses, and filters, a light meter (even if there is one on your camera), a tripod, a lens cleaner and fresh batteries.

The uses of various lenses for nature photography are described in the appropriate chapters. Each lens should be provided with a skylight filter to reduce haze and to protect the lens.

Your camera probably has through-the-lens metering or automatic exposure control, but an extra, hand-held meter is still a valuable back-up tool to have along in case an in-camera meter should fail. Moreover, hand-held meters are superior to in-camera ones in dimly lit situations because they can gauge lower light levels than most in-camera meters, and they can indicate extremely slow shutter speeds (several seconds or more), a feature needed for accurate time exposures. And most hand-held meters, unlike in-camera meters, can measure incident light—light falling on the subject rather than that reflected from it. Gauging exposure with incident light is helpful with such subjects as a strongly backlighted animal. It cannot be approached close to get a reflected light reading from the animal alone, and a reflected reading at camera position will be distorted by the backlighting. An incident light reading at camera position, on the other hand, will give the accurate exposure settings—if, as is usually the case, the illumination reaching the camera is the same as the illumination reaching the subject.

A tripod is essential for getting pictures under difficult lighting conditions,

where long exposures call for steady support, for anchoring long lenses or lenses with close-up attachments, and for careful framing of stationary subjects such as flowers and bird nests. The tripod also permits steady panning on a moving subject such as a running deer. It should have a double-jointed head that allows the camera to be pointed in any direction, and the center post should be reversible so that the camera can be mounted underneath when you are photographing objects close to the ground. If weight and size are primary considerations, as they are likely to be on a long hiking trip, a small table tripod that has a ball-and-socket head (both shown on pages 90-91) can be an acceptable substitute. An arsenal of monopods, shoulder pods, clamps and gunstock mounts is also available to steady cameras and lenses and to hold lights and reflectors in the field. With all such supports, sturdiness is an essential consideration. When a camera is mounted on a tripod, the shutter should be snapped with a cable release in order to avoid the slightest jar; otherwise the steadying effect of the tripod may be nullified.

The most often overlooked items for the field kit are first, spare batteries and second, something with which to clean the lens. Dust and grime are facts of life in the field, and nothing is more detrimental to a fine lens than trying to clean it with an already grimy handkerchief or shirttail. Gritty particles should first be whisked from the lens with a fine brush, and the lens polished with lens tissues. Distilled water is a safe cleansing liquid; in the field a convenient source of distilled water is condensed moisture from the breath. Extreme care must be taken not to get the slightest speck of saliva on a lens; the lens should be held above the mouth with the head tilted upward, and the breath exhaled slowly and softly onto the glass surfaces.

The above items make up the basic kit for the field photographer who wants to travel light and shoot only during the day. Such a photographer is understandably disinclined to take lighting equipment along with the rest of his gear. Yet extra illumination often can be nearly as helpful in daytime as at night. It can provide fill-in light, or stop the motion of birds' wings or the nodding of wild flowers in a strong breeze. New electronic flash units weigh but a few ounces and automatically regulate their own output for correct exposure. The illumination is truly packaged sunlight — the color of the sun at high noon — so no special filters or films are needed.

Another piece of special equipment not in every field kit is an air-pressure shutter release, a simple and inexpensive device that enables the photographer to take close-ups of skittish subjects from a discreet distance. It consists of a long plastic tube with a squeeze bulb at one end and a plunger that presses the precocked shutter button at the other end. For use when you need to get still farther away, electronic, radio-controlled and even infrared, or heat-activated shutter releases are available. For complete remote control,

and for the rapid-fire shooting needed to cover fast action, several types of motor drives are available, either as accessories or, in some cases, built into the camera. They advance the film automatically each time a picture is taken. And if *this* isn't discreet enough, the whole motorized camera can be enclosed in a soundproof housing called a blimp. Not many photographers will want or need to get quite so elaborate; but for those who do, the hardware to handle nearly any situation can be bought or specially built.

Almost as important as the equipment is how to get it there. The items in the checklist on page 55 weigh less than 25 pounds, and with the exception of the tripod, all of the equipment can be stowed easily in a medium-sized shoulder-strap bag. The tripod can be carried across the other shoulder as a counter-weight or, for long treks in rough terrain, a small tripod that can be carried in the bag will serve.

For most makes of cameras there are specially fitted bags available that have compartments for the camera and accessories, and built-in sockets to hold extra lenses. These are convenient but they tend to be bulky. Most photographers prefer to use an unfitted bag, working out their own most convenient stowage plan. Conventional camera gadget-bags are for sale everywhere, but equally good and often less expensive types of rugged field packs are available in sporting-goods and surplus stores. With any of these unfitted bags small slabs of foam plastic in different shapes and sizes can be used to cushion and separate the larger pieces of equipment.

For additional equipment, such as an extra camera body, special-purpose lenses and perhaps a complete line of close-up accessories, nothing can beat an aluminum or fiberglass carrying case. It resembles a small suitcase and is carried by a handle. Most of these carrying cases come packed with layers of foam plastic that the purchaser, using a knife provided with the case, carves into pockets for each piece of equipment. A good aluminum or fiber-glass case is waterproof and dustproof, gives excellent insulation (important in the field) and provides quick access to each item. Many photographers prefer this kind of case for all their equipment; it is undoubtedly the best bet for anyone who expects to take most of his pictures in a relatively confined area and does not have to walk too far to get there.

A small corner should be reserved in every carrying case for a handful of plastic bags—the kind sold in grocery stores for sandwiches. They are invaluable for protecting equipment from dust and lint inside the case, for covering cameras and lenses while working in snow or rain, for keeping film dry and for countless other uses. Also a sheet of thick plastic or rubberized material should be carried for kneeling on damp or dusty ground; this ground cover can be folded inside the carrying case or wrapped around a leg of the tripod and secured with rubber bands.

Modern camera equipment, when used knowledgeably, can refine the actual taking of a picture to an almost mechanical operation. The nature photographer should take full advantage of this fact because he needs to devote as much attention as possible to his subjects. Acquiring a good understanding of how—and why—the equipment works is the basic step. Dry runs at home and experience in the field will increase his prowess, and along the way he can pick up many profitable shortcuts in technique.

It also goes without saying that the nature photographer should be something of a naturalist. He should read every nature book he can find that describes the flora and fauna of the places he plans to visit. There are excellent field guides that tell where to find nesting birds, how to identify the various kinds of animals, trees and flowers, and generally what to look for in any particular locale. Classroom botany and biology text books contain a great deal of good basic information. Many national parks produce detailed manuals that describe the plants and wildlife to be found within their boundaries. For recommendations on clothing and other personal gear in the field, the photographer can make good use of the field guides that are published for hunters and for fishermen. One important note of caution, however: If the photographer plans to stalk the same quarry as the hunter, he would do well to wait until the hunting season is over; a camouflaged photographer creeping through the underbrush after a deer can be mistaken for the deer itself, with dire results.

Once afield, the novice photographer is tempted to snap away at everything in sight. The urge must be resisted. A great nature picture demands concentrated effort; hours or even days may be needed to get all the elements of a picture to come together—good lighting, an appropriate background, artistic composition, an interesting action or aspect of the subject. So it is necessary to stick to one subject at a time. By the same token, if a subject is worth so much effort it is worth spending some extra film to make sure of getting the picture. Each exposure should be bracketed: half a stop above and below the meter reading for color film, and a full stop in each direction for black and white. Finally, a careful record should be kept of each significant exposure: the subject and the date; the lens used; any attachments such as extension tubes and filters; the f-number and shutter speed. Only with such data can the subject be adequately described and the camera technique studied and improved.

Patience and perseverance are clearly two of the nature photographer's prime requirements. It is equally clear that he needs a good grounding in his subject matter and a certain amount of special equipment. Most of all, he must have abiding interest in all aspects of nature. Only then will he feel truly at ease taking pictures in the outdoors. □

A Checklist of Equipment for the Field

Equipment for general nature photography in the field can be divided into the three groups listed below. The basic equipment will give pictures of what the eye normally sees, plus moderate long-distance and moderate close-up pictures. The second group of items augments the flexibility of the basic list and adds the capability of auxiliary lighting. The third group includes accessories, mostly for further convenience. (Specialized equipment for close-ups and underwater photography is discussed in the chapters devoted to those topics.)

group 1: basic equipment

single-lens reflex camera with normal lens, and case

wide angle and long focal length, or zoom lenses *(text)*

front and rear caps and protective skylight filter for each lens

light meter

tripod

cable release

extension tubes for close-up pictures

film

carrying case

lens brush and tissues

batteries

group 2: supplementary equipment

table tripod

ball-and-socket tripod head

ground-level viewer

electronic flash unit

filter set *(page 212)*

air-pressure shutter release

group 3: accessories

pistol grip for lenses above 200mm

shoulder pod for photographing birds

extra camera body

accessory motor or motorized body

kneeling mat or ground cover

plastic food-storage bags

notebook

carrying case for additional equipment

The Flighty Subject

Of all nature subjects, birds are among the most tantalizing—and satisfying—for the field photographer. Their habitats range from remote icecaps to backyards. Some birds are exotically colored, others drab; some are relatively tame and approachable, others so elusive that they can be captured on film only with high-speed cameras and powerful lenses. All birds, however, have a common characteristic that endears them to nature photographers: They are creatures of habit.

Birds tend to do the same things over and over again in recognizable patterns. A given species may be depended on to perch or posture or soar in a certain way; feeding techniques seldom vary; nesting takes place at the same time every year and in predictable places. A knowledge of these repetitive activity patterns allows the photographer to find the bird he is after, to get within camera range and to show his subject behaving naturally.

The kind of camera equipment that is best for bird photography depends principally on how much the subjects move around. Any reasonably portable camera can be used for photographs taken at nests since the camera is set up close to the subject, prefocused and arranged so the shutter can be tripped from a distance with a long cable release or other remote-control device. Twin-lens reflex and rangefinder cameras, being quiet and compact, are good for this work.

Even an electronic flash unit can be used; the birds soon get used to it. And if the photographer wants to avoid returning to the camera to wind the film and reset the shutter for each new picture, he can use a motorized SLR camera (its mirror should, however, be locked up if possible in order to make it quieter).

The SLR, with its quick framing and focusing system, is also the best camera for virtually every other kind of bird picture, whether the subject is perching, roosting or on the wing. Long lenses are generally required to get a large enough image on the film because most birds are small and have to be photographed from a distance. And a motor drive, for shooting a series of pictures in rapid succession, is also very valuable for catching birds in flight.

Additional gear may be called for to suit the photographer's special requirements. Russ Kinne, who took the portrait of the pelican at right, has assembled an armory of equipment over more than 25 years of photographing birds. He even designed and hand-made a quiver to carry long lenses on his belt. But he needed only his keen eye and a telephoto lens to get the remarkable photograph reproduced here.

A white pelican, its head swiveled 180°, rests with its beak tucked deep in its own back feathers, eyes still drowsily vigilant. The photographer spotted the pelican while touring a bird sanctuary in Saint Petersburg, Florida. To avoid alarming the pelican he kept his distance and used a 300mm telephoto lens from about 25 feet away. The very long lens magnified the bird's feathers and eyes; its shallow depth of field blurred the background.

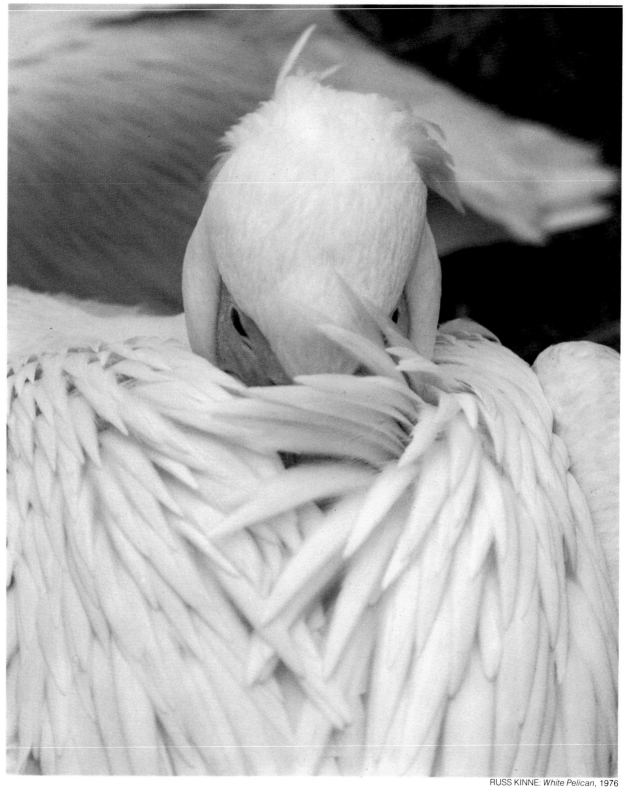

RUSS KINNE: *White Pelican*, 1976

Pageants of Courtship

Some of nature's loveliest moments occur when birds go through their elaborate rituals of courtship. These rituals are also among the most curious of bird activities, and many are so stylized that they can easily be recognized by a photographer familiar with bird behavior.

Thase Daniel had often photographed courting water birds in Louisiana and her home state of Arkansas, and her experience prepared her to catch the graceful vista at right on an Amazon expedition. She saw large numbers of great egrets flying in and out of a lagoon, and when she spotted their characteristic bending of knees and spreading of feathers, she knew their mating rituals were under way.

Hoping not to disturb the birds, Daniel approached the scene with caution. She walked slowly, making no quick movements and as little noise as possible; she kept foliage between her and the flock until she reached picture-taking range.

She watched and shot for two hours. "Patience," said Daniel, who has photographed birds for more than 20 years, "is the key. Sometimes I think I am going to faint from holding my breath for so long."

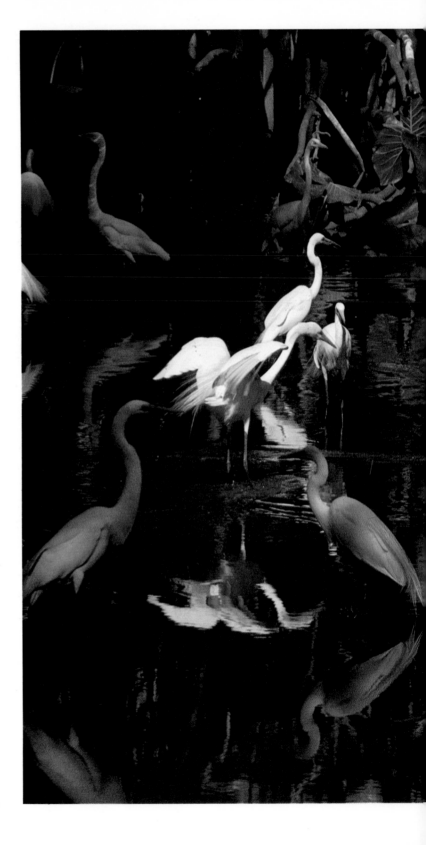

Deep in an Amazon swamp, great egrets perform their ancient ritual of courtship. Brilliant white males vie for mates, charging at each other with wings spread and beaks raised. The photographer used a motor drive on her 35mm SLR to shoot three frames per second while conditions were ideal.

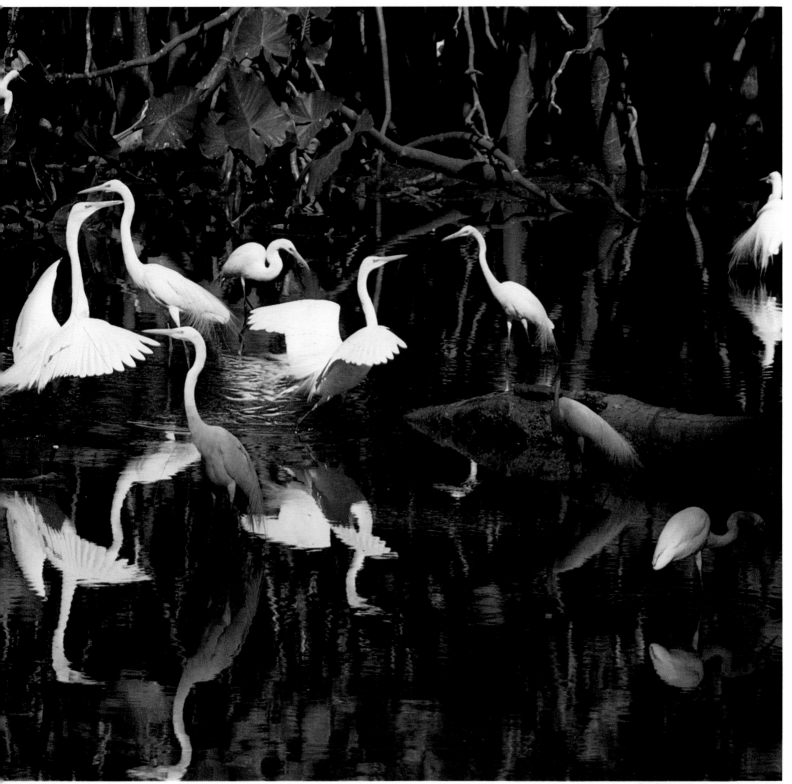

THASE DANIEL: *Courting Egrets,* 1974

In the Nest

A four-week-old bald eagle stares into the ▶
camera from its nest in the tidewater region around
Chesapeake Bay. For this portrait of the still-fluffy
fledgling, the photographer got up close, resting his
camera on the edge of the six-foot-wide nest,
and using a special 15mm ultra-wide-angle lens.

On Great Inagua Island in the Bahamas, a flamingo
rolls an egg between its legs with a deft nudge. The
rolling ensures that the egg will be evenly warmed
when the flamingo rests on it again. The close-up
was made from a discreet distance—30 feet—with
a 600mm lens on a tripod-mounted camera.

Life in the nest—the tender care exhibited by the parents, the antics of rapidly developing fledglings—is always rich in photographic possibilities. Locating the nests of some birds requires some ornithological knowledge and in some cases adventurous climbing. Once the nests are located, gaining photographic access to them can be tricky. Some birds, such as seagulls, owls and ravens, attack people who venture too close to their nests, and they can inflict real injury. Or the photographer may frighten adult birds away from the nest for long periods and their young can suffer as a result. With proper care, however, nests can be photographed safely and the rearing of a family recorded.

The simplest way to get close-up shots of nesting activity without actually getting so close to the nest as to disturb the birds is, of course, with a long lens. One was used to take the intimate view of the flamingo at right.

Sometimes, however, a long lens is not enough. To get the eye-level view of the baby bald eagle opposite, photographer Peter B. Kaplan first had to climb 75 feet up into the tree containing the nest, pulling up his camera behind him as the bird's mother circled menacingly overhead. Fortunately, the mother had become accustomed to biologists who had been studying threatened species in the area, and she flew off once she saw that her baby would not be harmed. Biologists checking the next day found her once again tending her offspring.

JEFF SIMON: *Flamingo Rolling Its Egg, 1980*

PETER B. KAPLAN: *Baby Bald Eagle in Nest*, 1979

Capitalizing on Food's Attraction

At feeding time birds are usually busy and not easily disturbed by a photographer. To assure his subject's cooperation, one part-time nature photographer — Herb Orth, Deputy Chief of the Time-Life Photo Lab — hit on a simple technique. He carried seeds or crumbs in his camera bag when going into the field to attract and occupy his quarry.

A fruit-bearing bush is a more natural attraction and a good site for setting up a blind and lights in the field *(right)*. Even a backyard bird feeder or a berry-laden garden shrub is a dependable magnet for birds, bringing different species as seasons change, and overlooking windows also make convenient blinds.

On the West Indian island of Trinidad, photographer Thase Daniel saw that a giant flowering shrub was a perfect location for a striking picture. Because the bush was 30 feet tall, Daniel asked the occupants of a nearby house for permission to shoot from their upstairs porch. She spent nearly six hours there, following her own advice for shooting wildlife: "If I stand here some more," Daniel repeats to herself, "something else might happen: I might get an even better picture!" The stunning photograph reproduced opposite rewarded her patience.

A dazzling orange-breasted sunbird sucks nectar from an Erica blossom on South Africa's south coast. Shooting from behind a cloth blind just four feet away, the photographer used a telephoto lens on a medium-format SLR to get this precisely focused image. Two separately mounted fill-in flashes enabled him to bring out the iridescent feathers around the bird's head and neck.

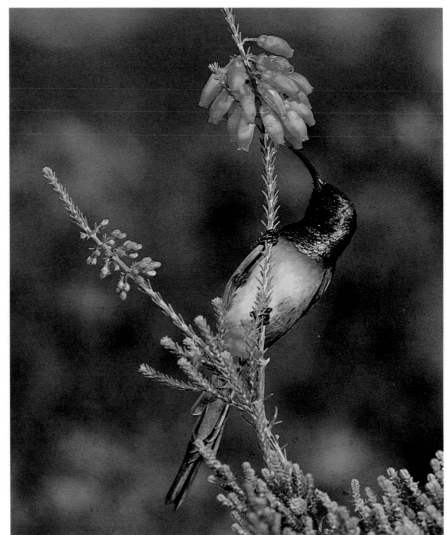

CYRIL LAUBSCHER: *Orange-breasted Sunbird, 1978*

Tiny bananaquits flutter over a schefflera shrub, pecking at the plant's plentiful fruit. A 400mm lens, steadied with a pistol grip, made it possible to fill the frame with just the top of the bush, and its shallow depth of field blurred the background.

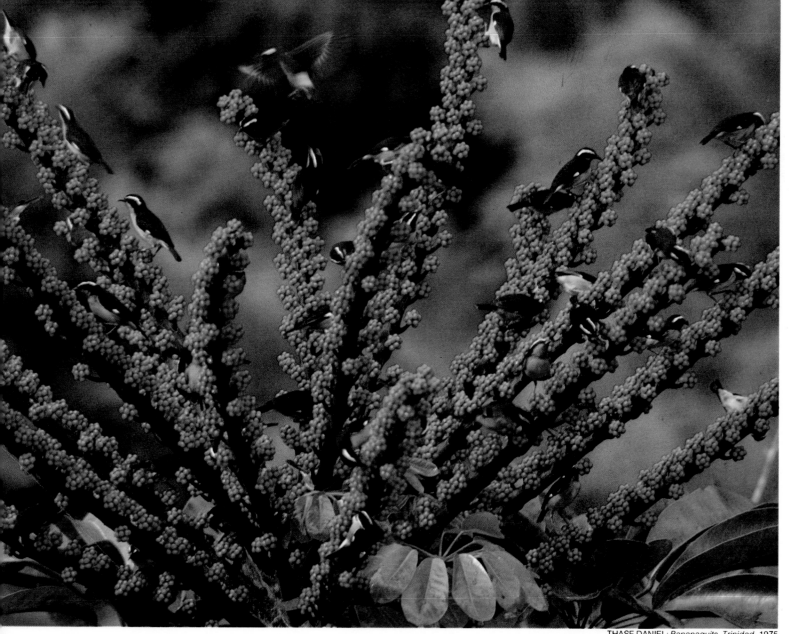

THASE DANIEL: *Bananaquits, Trinidad*, 1975

Encounters with Tough Hunters

Raptors—hawks, eagles and owls—are pound for pound among the most ferocious carnivores on earth, and a photograph of one of them catching or clutching a victim can be an image of nature at its most savage. But since the hunting area covered by these wary birds may range for miles, photographing predator and prey together is a challenge. A photographer can hide near a nest for a raptor returning with food, or he can track the bird with a long lens and snap it as it drops on a rodent or a fish.

But even the most skilled bird-watcher is more apt to get a good picture by setting out bait. Once, when working on a *Life* picture essay, George Silk made use of a kind of bait to get the dramatic shot opposite. He had learned of a rancher who was shooting ground squirrels and setting them out as food for a young golden eagle that was having difficulty surviving on its own. Knowing something of eagles' habits, Silk was able to position himself to catch the bird in mid-swoop. His best shot *(opposite)* was one of a sequence made with a Hulcher, a camera designed to take fast action pictures at 20 or more frames per second.

Often an extraordinary photographic opportunity arises when the photographer has no chance to set up for it. The picture at right came of just such a surprise occurrence, one that needed quick eyes and hands to capture the moment.

In a remarkable picture shot on the run, almost
by chance, a short-eared owl pauses on its way back
to its nest in the Galapagos Islands, holding in its
beak a freshly killed mouse captured as food for its
mate. The photographer, surprised during a walk
by noise of the kill, used a 135mm lens that was
mounted on her camera. The moderately long
focal length yielded an out-of-focus background that
is recognizably forested but does not distract
from the dramatic presence of the owl.

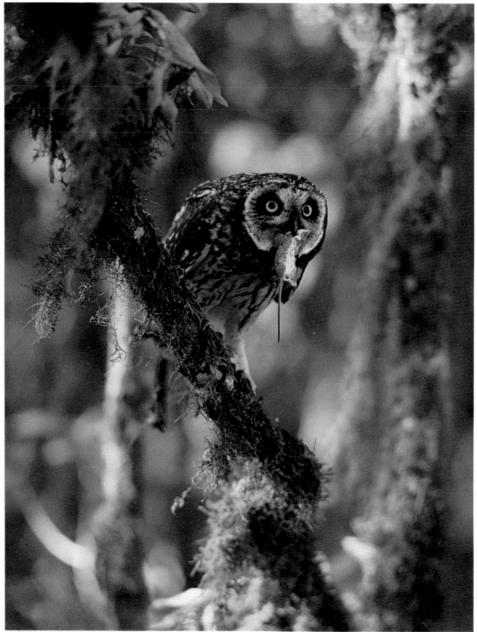

TUI DE ROY MOORE: *Short-eared Owl and Prey,* 1978

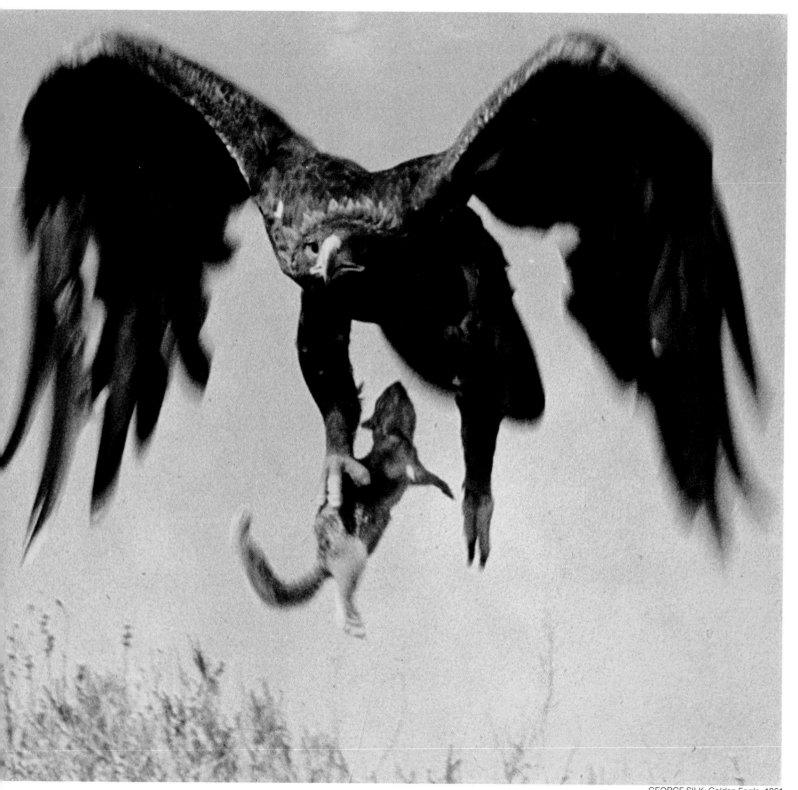

GEORGE SILK: *Golden Eagle*, 1961

Drama on the Wing

Now and then a single photograph can convey the soaring exhilaration of the flight of birds—but that one picture may be the fruit of many attempts. Aiming, focusing and setting exposure in time to catch a bird on the wing require extraordinary skills. One way to develop the necessary technique is to take pictures of birds flying to and from an accustomed place such as a nest, a birdbath or a feeder. But to capture all the grace of a soaring gull or a pair of migrating swans, the photographer must seek out certain locations: A seaside cliff that creates an updraft on which gulls can glide, for example, or a lake or river that serves as a stopover on a seasonal migration route *(opposite)*.

Long-focal-length lenses are practically essential for birds in flight, and a zoom lens can be particularly handy in adjusting the framing of the fleeting subject. An autowinder or motor drive permits the photographer to advance film automatically through the camera without stopping to cock the shutter, and a camera with automatic exposure control can help him concentrate on the action.

A brace of trumpeter swans flying south for the winter gains altitude over a wooded mountainside in Alaska. The picture, made in late afternoon beside one of the swans' favorite stopovers, a lake in the northern Rockies, required extra care in exposure. The in-camera meter indicated a setting correct for the generally dark scene but not for the bright white swans. To compensate, the final exposure—f/5.6 at 1/500 second—was a compromise between the indication for the scene and another measurement taken by pointing the camera at a white handkerchief.

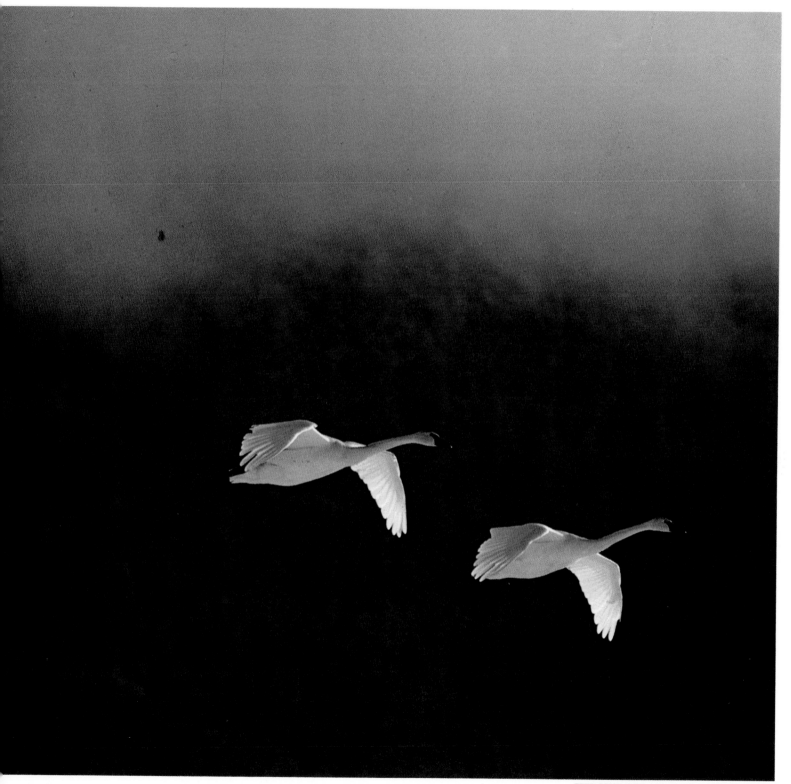

FRED BRUEMMER: *Migrating Trumpeter Swans*, 1973

Flocks in Formation

Geese float across an autumn sky in a great, orderly chevron; a flock of mallards splashes its way out of a pond in a confusion of spray and wings. For birds, such communal behavior provides protection against predators. For a photographer it offers powerful images of many individual birds — sometimes 10,000 or more — behaving with all the purpose of a single creature.

Action that dramatizes the interdependence of the flock is often fleeting. Flocking behavior varies from species to species, and knowing the distinctive calls and gestures that may trigger a mass movement like the take-off at right can help a photographer to anticipate such spectacles. Sound recordings of many species are available, but direct observation in the field is the best preparation.

Exposure is often a problem because dramatic flocking usually occurs at dawn or dusk when light levels are low. To record detail in the late-afternoon departure of the mallards in the picture at right, nature photographer Tom Blagden intentionally overexposed his picture. His in-camera meter, influenced by the glare of the setting sun on the water, indicated an exposure that would have rendered the birds as nothing but silhouettes.

With a frenzied flapping of wings, a flock of mallard ducks bursts from a pond in North Carolina's Pine Island bird sanctuary. The photographer studied the mallards' behavior for a week to be in the right position for the back-lighted take-off. He steadied his camera and its 500mm mirror lens on an unopened tripod, and used a motor drive to get several shots of the birds' rapid departure.

TOM BLAGDEN: *Ducks Taking Off from a Pond*, 1978

Odd Objects in Swampy Waters

With so many high, dry and comfortable places from which to take photographs, why would anyone risk becoming alligator bait in a bayou? The answer is staring out at you from the picture at the right: Many superb pictures lurk in the shallow waters of swamps, ponds and at the seashore. This environment is unlike either dry land or deeper water, and some of its inhabitants can be found nowhere else.

The fact that many photographers are fearful of getting their feet—or their equipment—wet is actually a good reason for going to these places: There is less competition. And it is possible to protect equipment as well as feet. Waterproof shoes for the shallows, or fishermen's hip boots for deeper water, are the only extra protection the photographer needs. Camera gear can be protected from moisture, mud and sand if it is enclosed in wire-tied plastic food-storage bags, which are available in rolls at any grocery store.

When shooting close to the water or when the wind is kicking up spray or sand, the photographer should keep the plastic bag on the camera, with only the tip of the lens uncovered; the controls can be seen and operated through the plastic. Most tripods are made of materials resistant to rust and corrosion, but the tripod should be cleaned thoroughly after each trip, with special care taken to remove grit from inside the threaded or sliding parts of the telescoping legs.

Locating animals is seldom more difficult in the shallows than in other places. As always, reading up on habits and habitats is the essential first step. Many of the creatures leave ample evidence to indicate their presence; beavers gnaw down trees and erect dams and lodges in the water; muskrats build burrows in the sides of pools and streams; otters construct mudslides down river banks; alligators build waterside nests that are all but impossible to miss—they may be six feet wide and a yard high.

To find smaller animals, such as the frogs and marsh birds that live in thick swamp grass or reeds, it is best to rely on sound. This is easiest if two people are along. Standing perhaps 30 feet apart, each person silently points to where he thinks the animal's sound is coming from. Then both move, slowly and quietly, a few feet closer and point again, keeping this up until they are close enough to catch sight of the quarry.

Be aware, however, that swamp creatures are descendants of some of the oldest and wiliest creatures on the planet, and they will have caught sight of a photographer long before he can spot them. Some, like the big fellow shown at right, are dangerous. For that reason, and because swamps can become labyrinthine mazes the moment dry land is out of sight, going in with a guide is the best assurance of a successful trip and good pictures.

An alligator, naturally camouflaged with duckweed, surfaces after an underwater foray in a pond in central Florida. A 105mm lens foreshortened and accentuated the creature's bulk, but did not have sufficient depth of field to keep its entire length in sharp focus.

JEFF SIMON: *Alligator*, 1979

Plants of an Uncertain Environment

Marshlands offer vistas seldom photographed and uniquely beautiful — shifting patterns of light, dappled shadows and overhead vegetation create scenes of eerily dimmed mystery. But a photographer venturing into such a half-water, half-land environment soon realizes why few have come before him. Simply finding a place to stand with a camera takes extra trouble.

Klaus Lang, a close-up specialist who took the photograph at right, carried a sheet of plywood into the jungles with him. He positioned the wood underfoot as a platform for his tripod. Then he was ready to use the relatively long exposure times in combination with small apertures that gave maximum depth of the field.

Another swamp specialist, James H. Carmichael Jr., relied on a boat and a guide to ferry him through a Louisiana bayou to a dry land vantage point for the cypress-filled panoramas opposite.

Carmichael, an anthropologist-turned-nature-photographer, did not use heavy boots for his swamp work, claiming that they impede walking. Instead he wore socks and sneakers, and kept a wary eye out for water moccasins.

KLAUS M. LANG: *Lily Pads*, 1971

Lily pads gleam on the murky surface of a pond in Floresta da Tijuca, a national park deep in the jungle of Brazil. The photographer used a tripod-mounted view camera to get this picture of leaves and flowers spotlighted by a beam of late-afternoon sun filtering through the overhead tangle of tropical foliage.

An autumn morning sun burns away the fog shrouding a corner of Louisiana's Atchafalaya Swamp, where an egret (upper left) perches amidst Spanish moss. The picture was made with a 35mm SLR fitted with a 100mm lens.

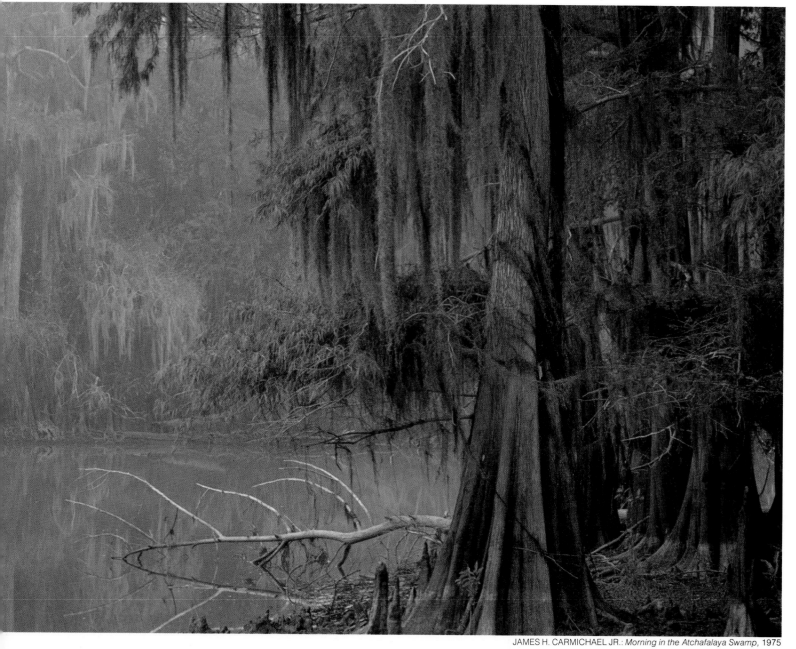

JAMES H. CARMICHAEL JR.: *Morning in the Atchafalaya Swamp*, 1975

Hard-to-Find Locations

The green back of a tiny Brazilian tree frog *(opposite)* blends protectively with vegetation, making it difficult for predators, or photographers, to pick it out from its surroundings. Equally difficult to spot, but for a different reason, is the frog orchid *(right),* so rare in the United States that it is on the endangered-species list.

The discovery of such hidden wonders may require more experienced eyes than those of most sometime swamp photographers. But conservationists, foresters, game wardens and park rangers can point out interesting plants, and areas that animals are known to frequent. They can also be helpful in scheduling trips because they know at what seasons and times of day specific plants and animals are likely to be at their most photogenic.

Even a master photographer must often depend on the advice of an expert. When Dmitri Kessel photographed the heartland of Brazil for *Life,* he was not given the opportunity to adjust his schedule to suit the subject; he had just two weeks to cover the vast Mato Grosso wilderness. Only by traveling on horseback with a young Brazilian naturalist, who was an expert on precisely what lived where, was Kessel able to find elusive but fascinating little creatures like the tree frog.

Similarly, M. Philip Kahl, though himself a trained naturalist, benefited from the guidance of the Audubon Society conservationists in seeking out rare marvels like the frog orchid for an essay on the Society's Corkscrew Swamp Sanctuary in southern Florida.

A five-inch-long frog orchid, so named for its resemblance to the amphibian, glows in the interior of Florida's Corkscrew Swamp. The rare flower, found only in Florida and in the Caribbean, has no leaves and grows on branches of small trees 10 to 12 feet above the swamp's watery surface.

M. PHILIP KAHL: *Frog Orchid,* 1975

A tiny green tree frog, only one and a half inches long, does aerial acrobatics among the reeds and grass in central Brazil. The frog's green back blends into the vegetation when it is resting, making it hard to see from above. The photographer and a young Brazilian naturalist guide were able to spot it only by crouching low enough to glimpse its bright underside when it moved.

DMITRI KESSEL: *Green Tree Frog*, 1958

Visitors to the Marsh

Swamps are by no means all tropical, jungly places. Coastal wetlands, for example, exist at practically all latitudes, as do inland bogs and marshes, some of them at high altitudes. And swamps are regularly visited by animals that are not necessarily swamp dwellers. In a single day, a marsh in the mountains of the American West might be a stopping-off place for deer, cranes, Canadian geese, coyotes, perhaps a bald eagle or two, and even a moose.

At Yellowstone Park, larger animals such as the moose spend most of the day roaming remote hills where they are difficult to find and photograph. But dawn often finds them feeding on the rich harvest of a bog or marsh, some of which are not far from park roads. This is where photographer Steven Fuller, a year-round caretaker at the park, caught the breakfasting moose at right. The dim light of dawn, Fuller believes, "reveals animals in their most primeval way. An hour later, the magic is gone."

Wading placidly through the mudflats at the edge of the Yellowstone River in Yellowstone National Park, a moose feeds on water weeds. The photographer, a park caretaker, matched a naturalist's knowledge of the animal's habits with his own preference for the quality of the light at daybreak to produce this stunning picture.

STEVEN FULLER: *Daybreak, Yellowstone Park*, 1978

A Natural Wonderland in the City's Backyard

An hour's drive from New York City is a small but wondrously varied nature preserve called Greenbrook Sanctuary. Almost within sight of the city's skyscrapers, birds nest in sylvan thickets, spiders weave, wildflowers bloom and shrivel.

The sanctuary comprises 150 acres of woods, streams, bogs and grassy glades atop the rocky Palisades that tower over the Hudson River in northern New Jersey. A semiprivate preserve, Greenbrook is available to anyone who applies—not unlike hundreds of other nature sanctuaries throughout the country.

In 1961, Thomas W. Martin, a master diemaker from Manhattan, began to devote his weekends and holidays to nature photography—and usually his destination was Greenbrook, where all the photographs on the following six pages were taken. Martin made himself familiar with every plant and creature on every acre. This knowledge enabled him to plan his expeditions ahead of time so that no time was lost deciding where and what to photograph. Like all experienced field photographers, though, he kept an open mind about his subjects. If, for example, he was planning to shoot back-lighted flower studies but the day became overcast, he switched to moss or mushrooms, which do not need bright sun.

To take the pictures that appear here,

a good deal of equipment was needed on every trip. For moving subjects such as birds and small mammals Martin used a 35mm SLR with a 400mm lens and bellows that focused from infinity down to an image ½ life size. For extreme close-up shots he used a 35mm rangefinder camera body with a through-the-lens reflex housing and bellows, mounted on a tripod. A 135mm lens attached to the bellows served for general close-up shooting and a 200-600mm zoom lens gave extra magnification for distant subjects.

The only piece of basic equipment that Martin did not carry with him was an auxiliary lighting unit; all of his outdoor pictures were taken with only the existing light, whether dim or bright. His single concession was the occasional use of a large rearview truck mirror on sunny days to concentrate a beam of sunlight on a shaded subject.

Although the work of a part-time photographer, Thomas Martin's pictures are not amateurish. They have been praised by both wildlife and photographic experts and have been published in many books and magazines. "I know it sounds corny," he said, "but when I look through my camera lens I can imagine how a violinist feels as he takes up his bow. The beauties of nature that I see are surely akin to great music."

Greenbrook

Dappled by a spring sun filtering through overhanging foliage, the stream that gives New Jersey's Greenbrook Sanctuary its name flows over the mossy rocks. The stream meanders through the wildlife preserve, forms a pond, then continues to the rocky cliffs of the Palisades, where it tumbles 300 feet into the Hudson River. For this medium close-up a 135mm lens was used.

Bullfrog

Up to its mouth in a New Jersey bog, a glint-eyed
bullfrog waits for an unwary insect to fly too close.
When one does, the frog, whose hind feet are
touching the bottom, will spring up and grab it.
Bullfrogs are generally complacent subjects if
the photographer avoids sudden movements. This
one was coaxed into position with the stem of a
bullrush, and the picture was taken with
a 135mm lens and bellows on a 35mm camera.

Greenbrook in Spring and Summer

Buttonbush Flower

Swallowtail Butterfly Wing

Northern Oriole

Wild Grass with Raindrops

From April through August, Greenbrook Sanctuary offers its widest variety. All these subjects were taken with a 135mm lens and bellows, with three exceptions: For the picture of the butterfly wing (top, second from left), Martin used a 35mm lens and bellows to magnify a section of the wing 9 times life size. For the red squirrel (bottom right), and the Northern oriole (bottom left)—two subjects whose timidity and skittishness required shooting from a distance—long lenses gave the needed image size.

Chanterelle Mushroom

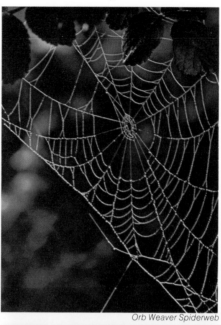

Orb Weaver Spiderweb

Crab Spider

Star Thistle

Red Squirrel

Greenbrook in Autumn

Catbrier Leaf

Butterfly Weed

With the coming of September, Greenbrook takes on a crisp and brilliant aspect. Martin employed the lower angle of the autumn sun to backlight many of his subjects, like the three plants above. This illumination enhances details such as the vein structure of the translucent catbrier leaf (which is glossy green and nearly opaque in summer), the silky seed-bearing pappus of the butterfly weed and—a sign that another year's life cycle is complete—the stark, empty seed pods of the milkweed. For all three pictures he used a 135mm lens with a bellows.

Milkweed Seed Pods

Autumn Debris

Leaves in Ice

Its waters depleted by a dry summer and fall, a sluggish stream is glazed with algae and decaying plant matter (top right). Later, at the edge of a pond (bottom right), November ice has encased other leaves. To capture highlights and avoid clutter, Martin focused on selected areas, using a 200mm lens for the top picture and a 135mm for the lower one. Sharpness was maintained by aiming almost straight down so that the entire field of view lies in the same plane.

Greenbrook in Winter

Sculptured by gusts of wintry wind, the surface of Greenbrook Pond is transformed into crystalline whorls of ice. The ripples and circles were caused by air pockets caught under the water as it froze.

Ice Patterns

S. R. MORRIS: *Venus's-Flytrap Devouring a Baby Frog*, 1972

Tools and Techniques of an Exacting Specialty

Nature is where you find it, and sometimes you find it in tiny samples. Then close-up photography is needed to get it on film. Taking close-up pictures can be one of the most fascinating enterprises in the whole field of nature photography— recording and clarifying everything from how a wasp flies to how a spider approaches its mate.

And close-up photography can even make the ordinary subject more intriguing, by revealing minuscule parts hitherto unseen by the unaided human eye. The photograph of a bird or an animal or a landscape is rarely a surprise unless, of course, it is a disappointment. But the close-up photograph of the interior of a flower can be an unexpected revelation.

What is a close-up photograph? It is a film image ranging from at least 1/10 the actual size of the subject to about 35 times life size. Special equipment is needed for this kind of photography since to obtain these larger-than-normal image sizes, the subject must be nearer the lens than the normal camera mounting will allow.

The size relationship is expressed as a multiple: 1x, for instance, means that the image on the film is life size; .10x means that the image is 1/10 life size. Images that are smaller than life size are expressed as decimals, nevertheless, they are still, in the context of photography, commonly called magnifications. Life-sized images (1x) and larger can be obtained with specially designed close-up lenses, or with regular lenses that are used with close-up attachments. A magnification of 35x is usually the limit that can be obtained with regular close-up equipment. For larger images, it is more practical to attach the camera to a microscope.

There are several different types of close-up accessories. (A comprehensive selection is shown on pages 90-91.) The simplest are supplementary lenses that fit onto the front of a regular lens. Another type consists of either bellows or rigid tubes that are inserted between the camera body and the lens. The third type is a specially designed macro lens. All of these devices permit sharp focusing at very close range; this produces large images according to an elementary rule of optics: By decreasing the distance between the lens and the subject the close-up systems increase the size of the image recorded on the film. A fourth way to increase image size is to use a tele-converter, a tube containing several lens elements. All these systems differ considerably in complexity, optical quality, degree of magnification and cost. The principal methods, as well as their merits and limitations, are discussed separately on the following pages so the photographer may determine which one of them will best serve his purposes.

Except for the supplementary lenses, which will work with any kind of camera, all of these close-up systems are designed for use with a 35mm or with a medium-format single-lens reflex camera that accepts interchangeable

lenses. There is a good reason for this: The SLR's through-the-lens view is essential in getting a close-up properly framed and accurately focused. Alternatively, the view camera, which also permits the photographer to see through the lens, can produce excellent close-ups under controlled studio-like conditions. In addition, all Leica 35mm rangefinder cameras can be converted to reflex operation. Fixed-lens cameras, including 35mm rangefinder and twin-lens reflex types, can be adapted for close-up work *(pages 110-111)* — though at the expense of some convenience and usually some accuracy.

Because so many nature close-ups are taken out of doors, and because many of the subjects are alive, the photographer must contend with the changeable light and sudden movement. These problems are literally magnified whenever an image is enlarged. Movement is increased proportionately; if a subject jumps or the camera jiggles, the photograph will be blurred unless extraordinary precautions are taken. Among the best preventives are a tripod, a cable release and a fast shutter speed. In some circumstances it may help to use the self-timer and mirror lockup. An electronic flash, which provides the effect of a shutter speed of 1/1,000 second or higher, can also stop motion *(pages 104-105)*.

Exposure is also a special problem. Close-up accessories that increase the distance from lens to film diminish the amount of light reaching the film. This means that the f-stop numbers engraved on the lens are no longer accurate indicators for exposure settings. A camera with a built-in through-the-lens light meter will adjust automatically for this loss of light because the meter gauges only the light that will actually reach the film. A camera with automatic exposure control governed by a through-the-lens meter will also compensate automatically for light loss due to lens extension. Sometimes, however, a through-the-lens meter and automatic exposure control cannot be used. If the light passing through the extended lens and the close-up accessories is too dim to register on an in-camera meter, the photographer must resort to a more sensitive hand-held meter. Sometimes flash is needed for proper illumination, and most meters — in-camera or hand-held — cannot gauge flash exposures. In these cases, and when using a camera that has no through-the-lens meter, exposures generally must be calculated with the aid of mathematical formulas such as those on pages 98-101 and 104.

The arithmetic involved is relatively easy, but much time can be saved by using the basic formulas to compile a simple chart, or guide, with figures that will apply specifically to the individual photographer's own equipment. A method for doing this will be found on page 101. Getting some of the brain-work out of the way beforehand will allow full concentration on the subject and will pay handsome dividends in a field of nature photography that is a novel world of its own. □

An Arsenal of Accessories

The equipment shown at right is neither a basic kit nor a collection of every accessory available for nature close-up photography. However, this assortment should cover most close-up situations a photographer is likely to encounter.

All cameras, lenses and extension devices must be compatible. Accessories made by the camera manufacturer will always work satisfactorily.

At the heart of these systems is the 35mm single-lens reflex camera. For most close-up work, photographers rely on macro lenses. These lenses have an extended focusing range that allows continuous focusing from infinity to ½ life size. The most common macro lenses have a focal length of 55mm (2). Longer focal-length macro lenses, such as the 105mm and 200mm ones shown here (3, 4), give maximum magnification at greater distances from a subject.

A macro zoom lens (5) offers great flexibility in both close-up and normal photography. Such lenses, however, are less sharp than fixed-focal-length macro lenses. In most cases, their maximum magnification is no greater than ¼ life size (.25x). This magnification can be increased with a tele-converter (6). A compact tube that has two or more lens elements, a tele-converter attaches to the back of any lens—including macros. It doubles or triples focal length without affecting the lens's closest focusing distance, and thus enlarges image size.

Adding close-up attachments—extension tubes, supplementary lenses, bellows—to regular lenses is the least expensive way to take close-ups, though there is some loss of sharpness around the edges of the image. The easiest way to adapt a regular lens to close focusing is by screwing supplementary lenses (7) into its filter-mounting threads. Better image quality results when extension tubes (8, 9, 10) or bellows (23) are fitted between the camera body and the lens. A threaded adapter ring (11) makes it possible to reverse any lens—a trick that places the lens elements that work best at short range nearest to the subject.

A right-angle viewfinder (15) is handy for looking down into a camera when photographing objects that are close to the ground. A plain ground-glass focusing screen (16) is easier to read than the split-image screens in most cameras. A hand-held meter (12) is often needed to extend the range of the camera's built-in meter. It should be adaptable for measuring very small areas; an attachment for metering flash (13) is also useful.

A ringlight (19) that fits around the lens provides direct frontal illumination. Other lighting effects can be obtained by using a single flash with reflectors or two flash units. The larger of the two shown here (17) generates enough light to permit small apertures for the greatest depth of field; the smaller one (18) has a remote sensor that can be clipped to the front of the lens for automatic close-up exposures *(page 105)*. For careful positioning, flashes or reflectors can be attached to lightweight stands (27); for mobility they can be put on a camera-mounted bracket (20). In either case, use a ball-and-socket joint for flexible angling. Ordinary white and black poster boards serve well for reflectors and shades.

A lightweight but sturdy tripod is essential for most close-ups; the most useful type (21) has legs that will spread extra wide to lower the camera near to the ground. Alternatively, a table-top tripod with a ball-and-socket head (22) can be used for low-level shooting.

1 **35mm camera with 50mm lens and lens hood**
2 **55mm macro lens**
3 **105mm macro lens**
4 **200mm macro lens**
5 **70-150mm macro zoom lens**
6 **auxiliary 2x tele-converter**
7 **supplementary lenses**
8 **27.5mm automatic extension ring**
9 **14mm automatic extension ring**
10 **8mm automatic extension ring**
11 **adapter ring for reversing lens**
12 **light meter**
13 **flash meter attachment for light meter**
14 **cable release**
15 **right-angle viewfinder**
16 **plain ground-glass focusing screen**
17 **automatic electronic flash unit**
18 **automatic flash unit with remote macro sensor**
19 **ringlight**
20 **camera bracket for two flash units**
21 **large tripod with wide-spreading legs**
22 **table-top tripod with ball-and-socket head**
23 **bellows**
24 **tape measure**
25 **clips for holding reflectors**
26 **two-way clamp and rod for reflectors**
27 **stands for lights or reflectors**
28 **white and black cardboard**

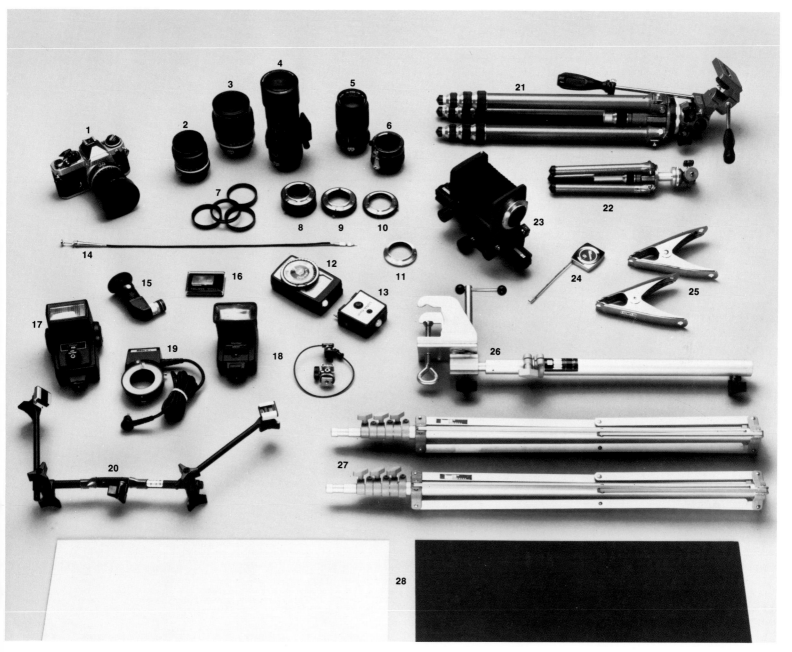

How to Use Supplementary Lenses

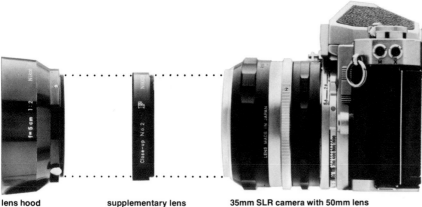

lens hood **supplementary lens** **35mm SLR camera with 50mm lens**

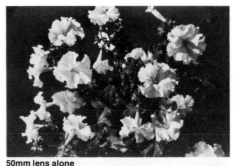

50mm lens alone

50mm lens and +1.5 diopter supplementary lens

50mm lens and +4.5 diopter supplementary lens

The simplest devices for making close-ups are supplementary lenses. They are magnifying glasses of varying powers, and are attached to the front of regular lenses. Supplementary lenses enlarge an image in two ways: They add their own power to that of the regular lens, and they change the focusing distance of the regular lens so that it can actually move closer to an object than it normally would.

The power of a supplementary lens is expressed in diopters, an optical term that is used to describe both the focal length and the magnifying power of the lens. Thus a 1-diopter lens (expressed as +1) has a focal length of one meter (1,000mm), and will focus on a subject one meter away. A +2 diopter focuses at half that distance (500mm) and magnifies twice as much; a +3 diopter focuses at 333mm and magnifies three times as much, and so forth. Lenses of varying diopters can be added to each other in order to provide greater magnification, as long as the stronger lens is attached to the camera first.

As the chart at right shows, when a supplementary lens is affixed to a camera lens set at infinity, the new focusing distance will be the focal length of the supplementary lens. This is true no mat-ter which camera lens is being used. For example, a +2 lens will always focus on a subject 500mm (19½ inches) away with a 50mm lens, a 135mm lens or any other lens—provided the regular lenses are set at infinity. However, the focusing distance will be reduced and the degree of magnification increased as the focusing ring of the regular lens is adjusted *(chart, page 93)*. The ultimate image size still depends on the focal length of the camera lens. This is because the degree of enlargement is determined by the diopter of the supplementary lens plus the magnifying power of the regular lens. Thus a +2 diopter gives a bigger image with a 135mm lens than with a 50mm lens.

Advantages: Supplementary lenses do not change exposure readings. They are small, inexpensive and can be used with any kind of camera, including the rangefinder models *(page 110)*.

Disadvantages: Because of their design, these lenses can provide acceptable sharpness only near the center of a picture and only when used with small apertures. Their surfaces, not bonded to the regular lens, may cause reflections and other aberrations. And overall sharpness of focus decreases at +5 diopters or stronger.

How supplementary lenses enlarge: The top picture shows a cluster of petunias as seen by a 35mm SLR with a 50mm lens. The lens, set at its closest focusing distance (about 18 inches) produces an image on the film about 1/10 (.10x) life size. (The pictures here are enlarged slightly above actual film size.) With a +1.5 diopter supplementary lens (center) camera-to-subject distance is reduced to 15 inches for a larger image, about .20x life size. With a +4.5 diopter lens the distance is 10 inches and the image of one blossom is enlarged to about .33x life size.

Data for Use with Supplementary Lenses

supplementary lens	focus setting (feet)	subject distance (inches)	approximate image magnification using 50mm lens	approximate area covered (inches) using 50mm lens	approximate depth of field (inches) at f/8
+1 diopter (1 m. focal length)	infinity	39	.05x	19 x 28	9
	20	34	.06x	16 x 24	6½
	10	30	.07x	14 x 21	5
	5	23¾	.08x	11 x 16½	3
	3	18¾	.11x	8½ x 12¾	2
	2	14¾	.14x	6½ x 10	1
+2 diopters (500mm focal length)	infinity	19½	.10x	9½ x 14	2½
	20	18¼	.11x	8¾ x 13	2
	10	17	.12x	8 x 12	1¾
	5	15	.14x	7 x 10½	1¼
	3	12½	.16x	5¾ x 8½	¾
	2	10½	.20x	4¾ x 7	½
+3 diopters (333mm focal length)	infinity	13	.15x	6 x 9	1
	20	12½	.15x	6 x 9	1
	10	12	.16x	5¾ x 8½	¾
	5	10¾	.18x	5 x 7¼	¾
	3	9½	.22x	4¼ x 6¼	½
	2	8¼	.26x	3¾ x 5½	⅜
+4 diopters (250mm focal length)	infinity	9½	.20x	4½ x 7	½
	10	9	.22x	4¼ x 6¼	½
	5	8½	.24x	4 x 6	½
	2	7	.30x	3½ x 4¾	¼
+5 diopters (200mm focal length)	infinity	8	.25x	3¾ x 5	⅜
	5	7	.30x	3¼ x 4¾	⅜
	2	6½	.33x	3 x 4½	¼
+6 diopters (167mm focal length)	infinity	6½	.30x	3¼ x 4¾	¼
	2	5¼	.38x	2¼ x 3½	⅛

This chart shows how supplementary lenses can be used. The columns showing image magnification and area covered apply only to a 50mm lens (or any lenses from 45 to 55mm used on a 35mm camera). The other columns are valid for camera lenses of any focal length. The chart is especially applicable for rangefinder and twin-lens cameras (page 110). Since the focusing mechanisms of these cameras cannot be used accurately at close distances, the "subject distance" must be measured with a tape. The figures refer to the precise distance between the subject and the front face of the supplementary lens.

The image magnification column indicates the relation between the image size on the film and life size; thus the number .10x means that the image on the film is 1/10 life size. The depth of field is given for an aperture of f/8. Accordingly, at an aperture of f/4, divide each figure in half; at f/16, double each figure.

How to Use Extension Tubes and Bellows

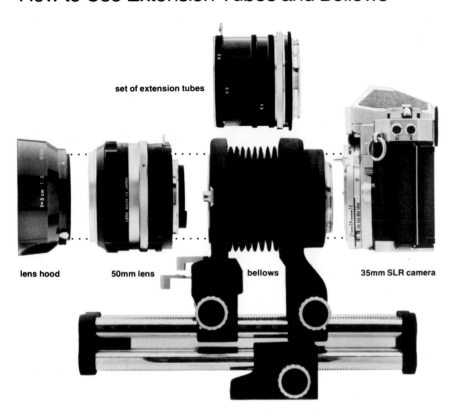

set of extension tubes

lens hood 50mm lens bellows 35mm SLR camera

50mm lens alone

50mm lens on full extension-tube set

50mm lens reversed on extension tubes

50mm lens on fully extended bellows

Extension tubes and bellows, mounted between camera body and lens, both help make close-ups by extending the lens nearer to the subject and farther from the film. This has a magnifying effect because the lens is focused on a smaller part of the subject but projects the image of the smaller portion onto the same area of film. The farther a lens is extended, the larger the image size on the film.

One major difference between tubes and bellows is the degree of versatility they offer. Tubes are rigid metal rings that extend the lens in steps. Bellows, on the other hand, are made of flexible material and provide continuous gradations of magnification over their entire range.

Another difference is that tubes can provide a useful feature not found on bellows. This is a mechanism that connects the lens to the camera to permit normal through-the-lens metering. Only the so-called automatic tubes have this mecha-nism. Without this link, the camera's built-in meter can still be used, but the meter must be specially set for a form of oper-ation known as stop-down metering. This requires that metering be accomplished with the picture-taking aperture, not the maximum aperture normally used. Be-cause the picture-taking aperture is usu-ally small, little light reaches the meter's sensing devices, which may no longer be responsive enough to react, and other means of setting exposure must be used.

Advantages: By permitting the use of regular or macro lenses, tubes or bellows maintain the optical quality of the camera system. They are the only attachments that will produce high-quality images that are larger than life size.

Disadvantages: Bellows and nonauto-matic tubes complicate the use of the in-camera meter. Bellows and long tubes may be unwieldly, and usually need to be mounted on a tripod.

Some different degrees of magnification obtainable with extension tubes and bellows are shown in the pictures at left. At the top is a view of some petunias taken with a 50mm lens alone. The image on the film is about 1/10 (.10x) the actual size of the flowers. (The pictures here are enlarged slightly above the film size.) Next is a view taken with a basic set of extension tubes: a life-sized image (1x) of part of a single blossom is produced. Greater or lesser magnification could be obtained by changing the number of rings used in the tube set. The next picture was taken with the same basic extension-tube set but with the 50mm lens reversed: The front end of the lens instead of the back was attached (with an adapter ring) to the extension tube. Because of the optical design of the lens (page 102), this gives a somewhat greater magnification (here 1.5x) without any further extension of the lens from the camera. The bottom picture was taken with the 50mm lens, in its regular position, attached to a fully extended bellows. This shows the center of a single flower, magnified to 5x life size.

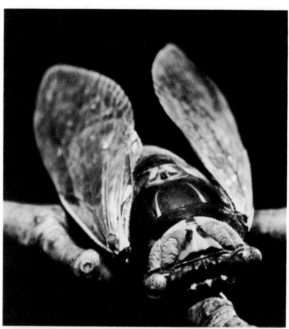

The focal length of a lens determines how far it must be extended for a certain degree of magnification. The focal length also determines the "working distance" between lens and subject. Thus a 50mm lens requires a 75mm bellows extension (above) for a 1.5x life-sized image of a cicada (right). Lens-to-subject distance is about three and a half inches. The shorter the focal length, the smaller this distance.

With a 135mm lens, the bellows must be extended to its farthest limit (about 190mm) for the same magnification. But the working distance increases to about nine inches. Also, the longer lens improves the perspective, with less foreshortening of the cicada, particularly of its swept-back wings. Thus long lenses (90mm to 135mm) are preferable with tubes or bellows, if they will provide enough magnification.

How to Use Macro Lenses

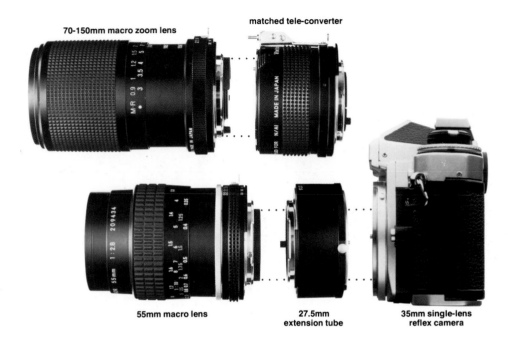

70-150mm macro zoom lens

matched tele-converter

55mm macro lens

27.5mm extension tube

35mm single-lens reflex camera

55mm macro at medium distance

55mm macro at closest distance, 10 inches

55mm macro with extension tube, 8 inches

The most valuable piece of equipment a close-up photographer can own is a macro lens. Most macro lenses will focus at distances from infinity to a few inches without the aid of accessories and will produce ½ life-sized (.5x) images on film. Their close-ups are sharp even when a large aperture is used.

Macro lenses are available in several fixed focal lengths from 55mm to 200mm, and some are zoom lenses. The most versatile macro zooms can be used at their closest focusing distance through their full range of focal lengths, as shown in the pictures on the opposite page.

The magnification of a macro lens can be increased two or more times by inserting an extension tube or a tele-converter between the lens and the camera body. Tele-converters are especially useful with long-focal-length lenses. A long lens requires an unwieldy length of bellows or extension tubes to achieve large close-up images. A 200mm lens, for example, requires an additional 200mm of bellows or tubes to produce a life-sized image on film; a 2x tele-converter cuts that requirement in half.

Advantages: Macro lenses give close-up images with edge-to-edge sharpness superior to that of such images produced by regular or supplementary lenses, and they perform equally well when used for normal, nonclose-up photography. Most macro lenses couple directly to the camera body, retaining all automatic features and meter connections.

Disadvantages: There are few macro lenses that are available with apertures greater than f/2.8 or f/3.5, limiting their usefulness in dim light. This problem is aggravated when extension tubes and tele-converters are added, further reducing the amount of light reaching the film.

The magnifications produced by moving closer to a subject with a 55mm macro lens are demonstrated above. The top picture was taken from five feet away; the resulting image (here slightly enlarged) was about 1/25 life size. For the middle picture the lens was set to its closest focus setting and the camera moved to 10 inches from a flower, producing an image ½ life size. For the bottom picture, shot eight inches from the flower with the same focus setting, an extension tube was added. A life-sized image resulted.

Instead of moving the camera, the photographer can obtain a wide range of magnifications with a stationary camera by adjusting the focal length of a macro zoom lens. For this picture of a caladium plant, a camera with a 70-150mm macro zoom (above) was first placed at the closest focusing distance of the lens and the zoom was set at 70mm. The resulting image (here enlarged) was ¼ life size. For the second picture (center) the camera remained in place and the zoom was adjusted to 150mm, producing an image ½ life size. For the last shot (bottom), a 2x tele-converter was fitted behind the lens, making focal length 300mm and giving a life-sized image (bottom).

macro zoom at 3 feet with shortest focal length, 70mm

macro zoom at 3 feet with longest focal length, 150mm

macro zoom with 2x tele-converter at 3 feet for focal length of 300mm

Formulas for Computing Magnification

In close-up photography it is sometimes necessary to know the exact relationship between the size of the image on the film and the actual size of the subject. This relationship usually ranges from film images of 1/10 life size (.10x) to images that are magnified to 10 times life size (10x). If a particular magnification is desired, the photographer needs to know how to set the camera before taking the picture.

In the example on this page the problem is to find the lens extension that will best provide the desired close-up. This is done by measuring the dimension intended to fill the frame *(top, near right)* and dividing the result into the film size.

One frame of 35mm film measures 24mm on the narrow side and 36mm on the long side. In the example shown here, the film size (24mm) divided by subject size (60mm) gives a magnification of 4/10 life size (.4x).

This figure can now be used to determine how far a particular lens must be extended to achieve this degree of magnification. The formula is: $Ext = (Mag + 1) \times Focal\ L. - Focal\ L.$ In this example, with a 105mm lens, the figures are as follows: The magnification (.4) plus 1 is 1.4. This figure, multiplied by the focal length of the lens (105), gives 147, from which the focal length (105), is subtracted. The result is 42 — which means that the bellows (or the tubes if they are being used) have to be extended 42mm to achieve the desired amount of magnification. This formula can also be used to maintain the same image magnification when using lenses of different focal lengths.

To determine the lens extension required for a flower to fill a frame of film, hold a measuring tape against the portion of the subject to be photographed. Then divide the subject measurement (here 60mm) into the film width or length (here 24mm) to calculate the exact degree of magnification that should be achieved.

After the desired magnification figure is computed it is used with the formula in the text at left to find how far the lens must be extended to produce that degree of magnification. The bellows should then be adjusted to this setting. If the bellows does not have a built-in scale (as shown above), a ruler can be used.

With the bellows set at the desired extension, and the lens focusing ring set at infinity, the entire camera rig is positioned (above) so that the subject is sharp. The predetermined magnification is now achieved automatically, producing the picture at right.

To find out how much a subject is being magnified, hold a measuring tape in front of it (above) and look at the tape through the viewfinder (above right). Read the distance (75mm in this case) from one edge of the viewfinder to the other. Use this figure with the formula in the text on page 98 to compute the magnification,

dividing 75 into 36 (the long side of the film frame). The answer here is .48 times actual size, or approximately .5x. Turn to the chart on page 100; in the third column, under the heading "image magnification," find the entry for a magnification of .5x. Follow the instructions given with the chart to determine the correct exposure.

Extending a camera's lens for close-up photography reduces the amount of light that reaches the film. The through-the-lens meters on most SLR cameras will compensate automatically for this loss of light, but if the illumination is so poor that a hand-held meter is required—or if a camera without a through-the-lens meter is used—it will be necessary to adjust the exposure settings determined by the hand meter to correct for the effects of the extension of the lens. How to do this is described on this page and on the following three.

First the photographer must determine the amount of change that will occur, either in the image size or in the physical distance the lens is moved in relation to the film or the subject. This can be done by making any one of the three measurements demonstrated on this page. The result is then used with the chart on page 100 to find the corrected camera setting.

The two pictures at the top show how to measure the degree of image magnification. This figure can be used directly with the chart because it accounts for the effect of both the lens extension and the power of the lens that was used.

The bottom two pictures indicate how to measure the lens-to-film distance (left) and the lens-to-subject distance (near left). Before applying either of these measurements to the chart, however, they must be divided by the focal length of the lens that is being used. To minimize the possibility of errors in the computation, use the longer of the two measurements in any given situation.

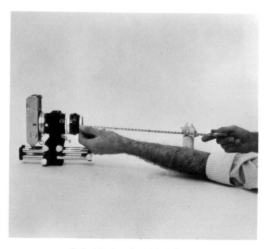

To find the lens-to-film distance, measure from back of the camera to the front of the lens. (It is not the precise optical distance, but close enough for practical purposes.) Divide this distance (300mm) by the lens's focal length (50mm); find the answer (6.0) in column one of the chart (page 100).

To find the lens-to-subject distance, measure from the front of the lens to the nearest edge of the subject. Divide this distance (300mm) by the focal length (50mm); find the result (6.0) in column two of the chart (page 100). Use this measurement when it is greater than the lens-to-film distance.

Handy Devices for Changing Exposures

Exposure Correction for Lens Extension

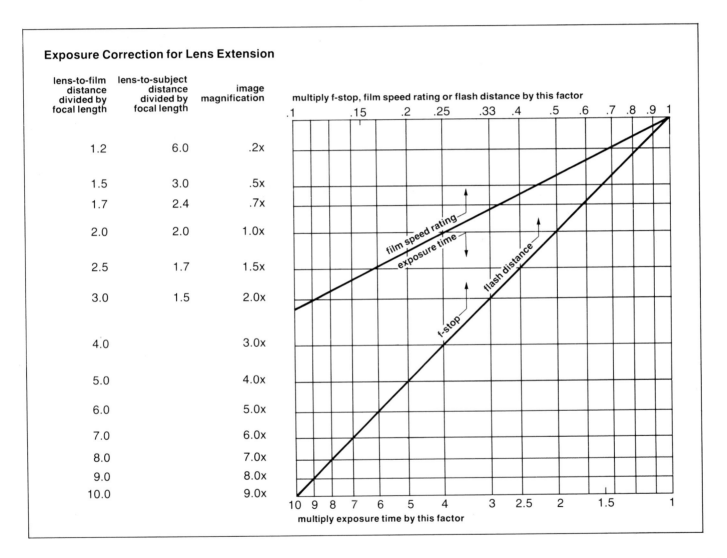

lens-to-film distance divided by focal length	lens-to-subject distance divided by focal length	image magnification
1.2	6.0	.2x
1.5	3.0	.5x
1.7	2.4	.7x
2.0	2.0	1.0x
2.5	1.7	1.5x
3.0	1.5	2.0x
4.0		3.0x
5.0		4.0x
6.0		5.0x
7.0		6.0x
8.0		7.0x
9.0		8.0x
10.0		9.0x

multiply f-stop, film speed rating or flash distance by this factor

multiply exposure time by this factor

To use this chart, choose the most convenient measurement of the three in the columns at left. Make the measurement as shown on page 99, and find the figure in the appropriate column. Now decide which kind of exposure correction to make. The chart gives four choices: increase the exposure time; or use a larger f-stop; or decrease the film speed rating on the meter; or decrease the distance between subject and flash. As the labels on the chart show, two of the corrective factors are found by following the upper diagonal line, the others by following the lower diagonal line.

Having decided which factor to use, draw an imaginary line from your starting figure straight across into the chart until it hits the diagonal line that you want. From here follow the arrow that is next to the kind of correction you have chosen: Go straight to the top of the chart and use the figure there if the arrow points up; go straight to the bottom if the arrow points down. These figures are factors, not the final answer. Multiply the film speed rating or exposure setting (from a light meter), or the flash distance by these factors for the new setting.

Example: A light-meter reading indicates an aperture setting of f/16. The subject is to be photographed life size (1x). To find the corrected f-stop, start at the figure 1.0x (third column). Read across to the diagonal line labeled f-stop. Follow the arrow upward. The factor is .5. Now multiply f/16 by .5; the new setting is: f/8.

For making close-up photographs with a symmetrically designed lens — the elements on both sides of the diaphragm are optically similar — the chart at left and the measuring ruler below provide two methods for correcting the exposure settings that have been previously determined by a hand-held light meter. Light readings made with a through-the-lens metering system can also be verified by these methods — such a system may not always give accurate exposure settings in close-up situations. The chart, like a road map, offers several starting points and several different routes for getting from one place to another — in this case from a normal exposure setting to one properly adjusted for making a close-up. A variety of starting points and routes can be chosen, but as the instructions below the chart explain, only one combination need be used for each picture situation.

The measuring ruler is a short-cut device that combines the several steps required with the chart into a single step.

It is not quite as detailed or as versatile as the chart, but it can be useful for quick computations, especially when working in the field. Exposures determined with both ruler and chart must be adjusted for asymmetrical lenses *(page 102).*

The chart provides not camera settings but factors — the numbers that are used to determine the corrected exposure setting by simple multiplication. Because these factors can be applied in any situation, the photographer can work out his own list of specific corrections for every combination of lenses, magnifications, film speeds, f-stops, exposure times and other variables for the film and camera equipment he uses most often. Such a list of exposure corrections is essential for close-up work.

Alternatively, the same kind of data can be set down on a ruler similar to the one shown below. The figures then will actually be the corrected camera settings rather than factors for finding the settings, as in the chart.

To use the close-up correction scale shown below, transfer the lines and numbers to a piece of cardboard. After a picture is in focus, hold this scale parallel to the film plane and directly on the subject. Adjust the scale so the left-hand edge is lined up with the left side of the viewfinder. Read the numbers nearest to the right side of the viewfinder. To correct exposure by changing shutter speed, multiply the exposure time from the light meter by the upper number on the scale. (Here the nearest upper number is 2.25. If the present shutter speed is 1/100 second, then 2.25 x 1/100 gives a new speed of about 1/50.) To change the f-stop, open up the aperture the number of stops shown by the lower numbers. (Here the nearest lower number is 1¼. If the present f-stop is f/16, open up the aperture one and one quarter stops, just beyond f/11.)

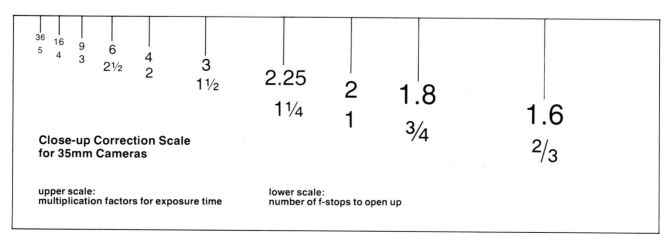

| 36 | 16 | 9 | 6 | 4 | 3 | 2.25 | 2 | 1.8 | 1.6 |
| 5 | 4 | 3 | 2½ | 2 | 1½ | 1¼ | 1 | ¾ | ⅔ |

**Close-up Correction Scale
for 35mm Cameras**

upper scale:
multiplication factors for exposure time

lower scale:
number of f-stops to open up

Lens Designs That Alter Performance

The design of a lens may have unexpected effects on exposure in extreme close-ups when through-the-lens metering is not used. The problems arise if the lens is asymmetrical: The elements in front of the diaphragm opening are optically different from those behind — a design used for telephoto lenses and retrofocus wide-angle lenses.

These lenses use concave lens elements to alter the relationship between the lens-to-film distance and the focal length. The focal length of a telephoto, for instance, is greater than its lens-to-film distance — not equal to that distance, as with a symmetrical lens. This trick gives a long focal length in a conveniently smaller size, but it complicates exposure when the telephoto is extended for close-ups.

The magnification obtained by extension depends on focal length, not on lens-to-film distance, so the asymmetrical telephoto must be extended relatively farther than a symmetrical lens for the same magnification. At this relatively greater distance from the film, the light from the lens spreads over a greater area — and the image is dimmer. For this reason, the exposure-correction factors used with a symmetrical lens *(page 100)* are not accurate for a markedly asymmetrical lens. The correction must be adjusted as shown at right above.

Even the slightly asymmetrical lens may fail to give uniform sharpness in close-ups. Stopping down to a small aperture is usually necessary. And for magnifications life size or larger, it is best to reverse the lens, using a special adapter ring. Rear lens elements that work best at short range will normally be close to the film. With the lens extended, they still work best at short range — i.e., close to the subject, or reversed.

On an asymmetrical lens like the 105mm at left, the front and rear aperture sizes seem different. For correct close-up exposures, determine the ratio of the apparent apertures. Set the diaphragm wide open and hold the lens at arm's length. Using one eye, measure with a ruler (a metric ruler is shown here) the diameters of both front and rear apparent apertures. The front (far left) is 31mm and the rear (near left) 19mm. Divide the rear measurement by the front for the "pupillary magnification factor," or PM–.6. Now divide the image magnification (page 99) by this figure, add 1 and square the result. Multiply this answer by the shutter-speed setting given by a light-meter reading for a corrected shutter-speed setting. The adjustment matters only if the PM factor is below .8 or over 1.2.

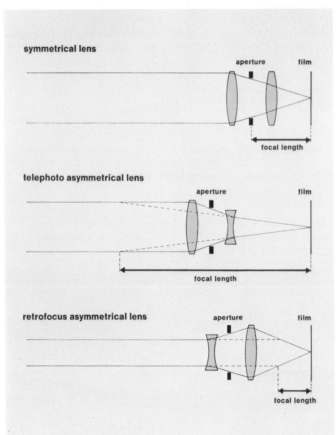

symmetrical lens

aperture film

focal length

telephoto asymmetrical lens

aperture film

focal length

retrofocus asymmetrical lens

aperture film

focal length

The basic designs of symmetrical and asymmetrical lenses are shown in these three diagrams. A symmetrical lens (top) has similar convex elements on both sides of the diaphragm aperture. This arrangement produces a focal length that is substantially the same as the distance from the lens to the film. Asymmetrical lenses have convex elements on one side of the aperture and concave elements on the other. A telephoto lens (center) has its concave elements behind the aperture, making its focal length longer than the lens-to-film distance. A retrofocus lens (bottom) is a wide-angle lens with concave elements in front of the aperture, making its focal length shorter than the lens-to-film distance. When extended for close-up use, the telephoto dims the image more than a symmetrical lens would, while the retrofocus dims it less.

An underexposed picture (above) results when light readings call for a very slow shutter speed and there is no compensation for the effects of reciprocity failure. The exposure setting indicated by the meter was 16 seconds at f/16.

In this picture, reciprocity failure was corrected by using the chart below. Lens aperture was opened two f-stops—for an exposure of 16 seconds at f/8—and developing time was reduced 20 per cent to correct contrast.

Extended lenses and small apertures frequently require exposure times that can result in underexposures. This phenomenon is known as reciprocity failure—the film emulsion reacts more slowly than normal when the light forming the image is very weak. A through-the-lens meter will not correct the problem, and camera settings determined by any meter must be adjusted to compensate.

When compensating for reciprocity failure (table at left) be sure to make the corrections only after correcting for exposure settings obtained with a hand-held meter (pages 99-100). And whenever possible, increase the exposure by opening the aperture.

With black-and-white film, a side effect of reciprocity failure is an increase in contrast, but this can be corrected as the table shows by reducing the film development time. With color film, reciprocity failure also produces a shift in color. Proper color balance can be restored, however, by using color-compensating, or CC, filters. They come in six colors: red, green, blue, cyan, magenta and yellow, and their color strength is indicated by a number, usually between 5 and 50. The exposure corrections given in the table allow for the slight decrease in light caused by the filters.

Compensating for the Effect of Long Exposures

film	exposure time (seconds)							
	1	2	4	8	16	30	60	120
Kodacolor II	½ stop 15C	½ stop 15C	1 stop 20C	1 ½ stops 30C	1 ½ stops 30C	1 ½ stops 30C	1 ½ stops 30C	1 ½ stops 30C
Kodacolor 400	½ stop —	½ stop —	1 stop 05M	1 ½ stops 10M	1 ¾ stops 10M	2 stops 10M	2 stops 10M	2 ¼ stops 10M
Ektachrome 50	— —	— —	¼ stop 05B	½ stop 10B	1 ¾ stops 15B	2 stops 20B	2 stops 20B	2 stops 20B
Ektachrome 160	½ stop 10R	½ stop 10R	¾ stop 10R	1 stop 15R	1 ¼ stops 15R	1 ½ stops 15R	2 stops 20R	2 ½ stops 20R
Ektachrome 200	½ stop 10R	½ stop 10R	¾ stop 10R	1 stop 15R	1 ½ stops 20R	1 ½ stops 20R	2 stops 20R	2 ½ stops 20R
Ektachrome 400	½ stop —	½ stop —	1 stop 05C	1 ½ stops 10C	1 ¾ stops 10C	2 stops 10C	2 ½ stops 10C	2 ½ stops 10C
Kodachrome 25	½ stop —	1 stop —	1 ½ stops 05B	2 stops 10B	2 ¼ stops 15B	2 ¼ stops 20B	2 ½ stops 20B	3 stops 20B
Kodachrome 40	½ stop —	¾ stop —	1 stop —	1 ¼ stops —	1 ½ stops —	2 stops —	2 stops —	2 ¼ stops —
Kodachrome 64	— —	— —	½ stop 05R	1 stop 10R	1 ½ stops 10R	2 stops 15R	2 ½ stops 15R	2 ½ stops 15R
Black-and-white films	1 stop 10%	1 ½ stops 10%	1 ½ stops 10%	2 stops 20%	2 stops 20%	2 ½ stops 20%	2 ½ stops 30%	3 stops 30%

This chart lists the most commonly used color films, each of which requires its own exposure and color corrections for long exposures. Below them, black-and-white films are grouped under a single heading because the same corrections apply to all commonly used types. Exposure times are given across the top, and compensations for reciprocity failure are listed in the columns. The upper entry in each case is the increase in f-stop required. For color films the lower entry, if any, specifies the filter needed by the numbers and letter that identify each gelatin filter. For black-and-white films, the lower entry shows the percentage decrease from normal development required to correct contrast.

Calculating Exposures with Manual Flash

When a close-up picture is taken with a flash unit the exposure must be corrected for any extension of the lens just as if natural light were being used. A correction can be made in two ways: by changing the aperture setting or by changing the distance from the flash to the subject. The latter method, demonstrated at right, is usually the one preferred because it permits small apertures that give great depth of field.

Despite the convenience of automatic flash, which regulates its own light output *(opposite)*, many photographers prefer manual flash; it gives maximum control over illumination, particularly when more than one flash is used *(pages 108-109)*. The use of manual flash necessitates calculations with "guide numbers," which are furnished by the flash unit manufacturer. Guide numbers are factors indicating the light output of the unit when used with films of various speeds. They should be checked for accuracy by shooting a test roll of film with carefully recorded bracketed exposures.

To determine flash-to-subject distance with a guide-number table, first find the guide number for the film you are using and divide this number by the f-stop you have selected. This gives the distance in feet and inches at which the flash must be placed from the subject for a normal picture. Now match the desired image magnification with the flash-distance factor as shown on the chart on page 100.

If the aperture is to be changed, rather than the flash-to-subject distance, follow the same procedure as that used for taking a normal picture. Then, by making any one of the measurements that are described on page 99, use it in connection with the chart on page 100 in order to find the corrected f-stop.

Ready to take a close-up picture of a flower, a 35mm camera is set up with a bellows attachment to extend a reversed 55mm macro lens to get a 1.5x magnification. The aperture setting is at f/22. The desired composition is made, and the camera is focused; it will not have to be moved again.

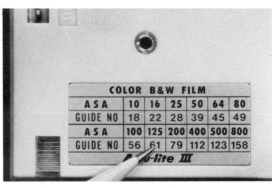

Flash-guide numbers for film speeds (ASA, DIN or the newer ISO ratings) are on the flash (above) or in its instruction book. The film here is ASA 125, so the number is 61. This number divided by the f-stop (f/22) gives flash-to-subject distance (three feet)—but without allowing for lens extension.

Because the lens has been extended to obtain a 1.5x magnification, the amount of light reaching the film is decreased. To get more light without changing the f-stop, the flash must be moved nearer to the subject. To find the proper flash-to-subject distance, refer to the chart on page 100 and use the diagonal line labeled flash distance. For a magnification of 1.5x, the flash-distance factor is .4. The original distance, calculated with the guide number above right but not allowing for lens extension, was three feet. This "normal" distance is now multiplied by .4 to give the new flash-to-subject distance: 1.2 feet, about 15 inches. The result: a perfect exposure of fuchsia stamens.

Correcting Exposures with Automatic Flash

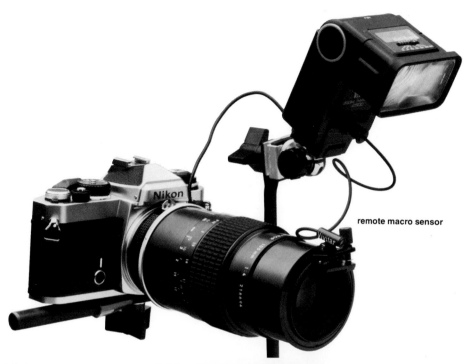

remote macro sensor

With an automatic flash unit rigged like the one above, it is possible to freeze such close-up action as the hovering bee pictured at right. The flash unit is attached to the camera with a bracket and a ball-and-socket joint so that it can be aimed at the area to be photographed. A remote sensor connected to the flash is clipped to the end of the 105mm macro lens for accurate measurement of the light entering the lens.

For the close-up photographer stalking an elusive insect in the field, an automatic flash unit can be a great convenience. It eliminates the need for guide-number calculations described opposite by shutting itself off when the amount of light needed for proper exposure has been reflected from the subject. A sensor in the unit gauges the reflected light and stops the flash at the right instant.

To obtain maximum versatility, the photographer should choose an automatic unit specially adapted for close-up work. Ordinary automatic flashes will not respond accurately at distances of less than two or three feet, and they operate automatically at only a few comparatively large apertures. Specially adapted units, however, can be used with subjects just an inch or two from the lens, and the apertures at which they function automatically are much smaller than those offered by ordinary sensors— as small as f/32 with fast film. They are designed for use with small remote macro sensors that clip to the end of the lens to read just the light that enters the lens; they permit the flash itself to be mounted anywhere, on or off the camera, for the proper lighting angle.

As convenient as they are, automatic flashes may not eliminate the need for all calculations. With most cameras, the photographer must still compensate for lens extension in close-up work by opening the aperture in accordance with the chart on page 100. Several advanced SLRs, however, are equipped with ingenious through-the-lens metering systems that gauge the amount of light passing through the lens and control the flash duration during exposure. When these are combined with companion automatic flash units, no exposure calculations are required for close-up work.

To capture the foraging bee at right, the photographer set the flash unit above for automatic operation at f/32 and adjusted the macro lens to its closest focusing position for maximum magnification, .5x. To compensate for the lens extension, he opened the aperture one stop to f/22 (chart, page 100). Then, waiting near a nectar-laden flower, he followed a bee with his camera until it flew into focus and snapped the picture, relying on the flash automation for correct exposure.

Lighting from Different Angles for Different Effects

The direction from which light falls on a close-up subject is as important as the amount that hits it. For some subjects there may be only one suitable lighting angle. But with others, like the leaf in the pictures at right, the direction of the light may be varied to achieve a special effect or to emphasize certain details of shape, texture or structure.

A photograph is also affected by whether the light comes from a broad source, which throws wide, evenly diffused beams, or from a point source, which throws straight, narrow beams. A broad source is essential for even illumination in extreme close-ups. A point source will produce shadows and sharp edges. The narrow beam of an electronic flash becomes a broad source if placed very near the subject, while the sun, normally considered the broadest source of all, is actually a point source because it is so distant.

The examples of lighting arrangements shown here were made with a small electronic flash and a floodlight. The principles involved apply to natural lighting as well, because sunlight hits outdoor objects from different angles depending on the time of day and the position of the camera.

With an electronic flash unit mounted on the camera, the subject, a basswood leaf, is illuminated with straight-on, frontal lighting (below). All parts of the leaf receive substantially the same amount of light, so there are almost no highlights or shadows and no particular emphasis on form or texture (photograph above).

With the light aimed at the leaf from the right side (below), a sharp contrast is produced between shadow areas and highlights (above). This lighting gives a clear modeling of the main structural parts and gives the picture of the leaf a three-dimensional quality. Some of the leaf's texture is lost, however, in the shadow areas.

When the light is aimed from the right side and a white reflector card is held on the opposite side and near the subject (below), some of the light is bounced back into the shadow areas. This lessens the extreme contrast between the light and dark parts of the picture (above). Although modeling is not so vivid, the texture of the leaf is more visible.

A floodlight in a large reflector, aimed from one side (below), gives a broad and even illumination with good modeling of the structure but without strong contrasts between light and dark areas (above). This kind of lighting is especially effective when used with color film, which has a comparatively narrow range of contrast.

With the flash unit behind the subject (below), the light comes through the translucent leaf and reveals its intricate vein structure (above). If the subject were opaque, a light placed in this position would produce a silhouette. Technically all five of these pictures are well lighted; the choice depends on the photographer's taste.

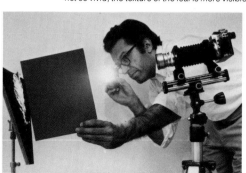 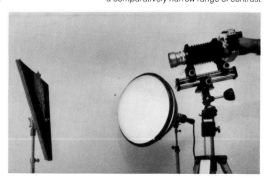

Controlling Reflections at Close Range

Lighting difficulties, which are enough of a problem under normal circumstances, are aggravated in close-up photography. The problems are particularly acute with flash equipment. Yet most of them can be avoided by knowing ahead of time the effects of different lighting techniques when the camera is close to the subject.

Ringlights, for example, produce an even frontal lighting of the subject by fitting right over the lens. So they permit the camera to come very close to the subject. But as the example at right shows, a ringlight aimed at a shiny subject may leave errant images of itself in the picture. The best solution is not to use them at all with subjects that have highly reflective surfaces.

The best light sources are those that can be moved about so as to avoid undesirable reflections. Some flash units have diffusing lenses that can be used instead of the regular one; or a piece of diffusing material can be taped over the unit (thin white cloth will do). An excellent alternative to this method is to place a light-diffusing "tent" over the subject itself, as shown at far right.

Two (or more) flashes provide more even illumination than one, and their light looks most natural when they are placed at different distances from the subject, as in the pictures on the opposite page. Exposure for multiple flashes is the same as for the flash giving the most light. If two flashes are giving the same amount of light, then reduce normal flash exposure by one f-stop *(page 104)*. Alternatively, multiple flash illumination can be gauged by firing the flashes before exposure and metering with a special flash meter or a hand-held meter equipped with a flash meter attachment *(pages 90-91)*.

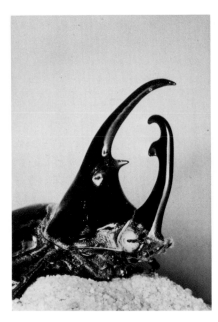

A beetle, with its mirror-like surfaces, is a poor subject for ringlight illumination. The picture below shows the beetle being photographed with the ringlight, which is fitted around the lens and draws its power from an electronic flash unit. The beetle's surfaces reflect the direct flash of the ringlight as hot spots (above), canceling out the device's ability to produce evenly distributed light, and failing to provide definition of the beetle's curves and facets.

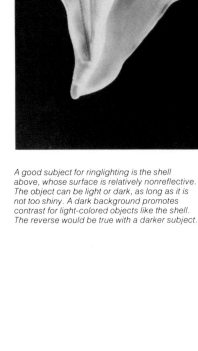

A good subject for ringlighting is the shell above, whose surface is relatively nonreflective. The object can be light or dark, as long as it is not too shiny. A dark background promotes contrast for light-colored objects like the shell. The reverse would be true with a darker subject.

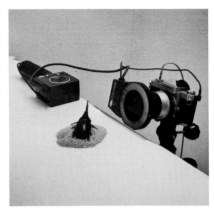

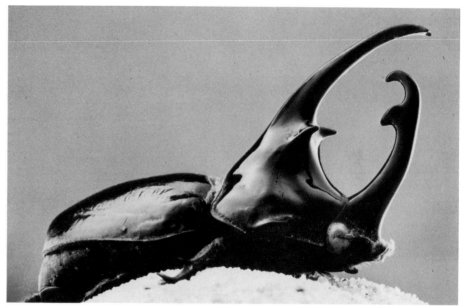

Regular electronic flash units (below) produce
uneven illumination and distracting bright spots
when their direct beams are aimed at a shiny subject
like the beetle (above). The two units are correctly
positioned for best rendition of shape and detail. But
the different angles and distances of the units
distribute the light unevenly, and the beetle is both
badly lit and marred by reflections.

The setup below is the same as the one at
left except that a curved piece of plastic has
been placed over the beetle to diffuse the light
coming from the two flash units. The unit angled
from the left of and above the subject gives
broad overall illumination while the other
provides strong, even sidelighting to define the
edges. Thus the picture shows the beetle's
shiny surface without distracting reflections.

Adapting Rangefinder Cameras

Any 35mm rangefinder camera can be used for close-ups by adding supplementary lenses. The rangefinder mechanism will not focus at very close distances, however, nor will the viewfinder show the exact area being photographed. Therefore, some external device must be used to position the camera at the correct distance from the subject, and to make sure that the picture is properly composed.

A simple way to position the camera is to cut a piece of cardboard *(right)* to the proportions of lens-to-subject distance and the area that will be covered. The measurements are in the chart at right, below. They vary according to the focal length of the regular lens and the diopter power *(page 92)* of the supplementary lens. The center line on the card is the distance from lens to subject (ab on the chart); the diagonal lines show the width (cd) of the area.

A wire frame *(second right)* is more accurate and convenient. To make one, determine the length of wire by referring to the diagrams and chart. For example, with a 50mm lens and a +2 supplementary lens, the measurements are: ab, 19½ inches; bc, 9½ inches; cd, 14 inches; bc again (opposite side of frame), 9½ inches; and ab, 19½ inches. The total is 72 inches. Add three inches to each end for attaching the frame to a piece of board. Bend the wire into the shape shown, drill two holes in the board and insert the ends of the frame. Drill another hole in the bottom of the board and use a tripod mounting screw to attach board and frame to the camera, making sure the lens-to-subject distance equals ab on the chart. These measurements assume that the camera lens is set at infinity.

To take a close-up, a rangefinder camera with a supplementary lens is held against a cardboard cut to the proper lens-to-subject distance and width of the subject area. The card is removed from the field of view before the picture is made.

A wire frame, which is easier to use than the marked card at left and is simple to construct (details in text), conveniently outlines the subject area. Since the wire frame surrounds the area seen by the lens, it will not appear in the picture.

Dimensions (inches) of Close-up Focusing Frames for 35mm Rangefinder Cameras

close-up lenses	ab	50mm		camera lens 44-46mm		38-40mm	
		bc	cd	bc	cd	bc	cd
+2	19½	9½	14	10	15	11½	17
+3	13	6	9	6¾	10	7¼	10¾
+4	9½	4½	7	5	7½	5½	7¾
+5	8	3¾	5	4	6	4¼	6¼
+6	6½	3¼	4¾	3½	5	3½	5

Close-up pictures are difficult to take with twin-lens cameras because the framing of the scene shown by the viewing lens is corrected only for normal distances; at close-up distances it overshoots the field of view seen by the taking lens. There are two ways of dealing with this problem, both methods retaining the use of the camera's regular viewing and focusing system so that no external measuring devices are needed.

One method consists of placing a supplementary lens over the viewing lens and composing and focusing on the subject. Then the camera is raised until the taking lens is at the level where the viewing lens was focused. The supplementary lens is then moved from the viewing to the taking lens, so that the already-focused picture can be made through the close-up lens. The two pictures at left, above, demonstrate how this is done. The drawback, of course, is that the camera must be lowered and raised each time it is focused on a different subject.

A more convenient method is to use a special pair of supplementary lenses that automatically correct the framing for viewing and taking close-ups, as shown at left, below. The supplementary lenses come in various diopters.

For a close-up with a twin-lens camera, a supplementary lens is placed on the viewing lens (above). The picture is composed and focused. The camera's position on the tripod is marked with tape, and the distance between the centers of the viewing and taking lenses is measured.

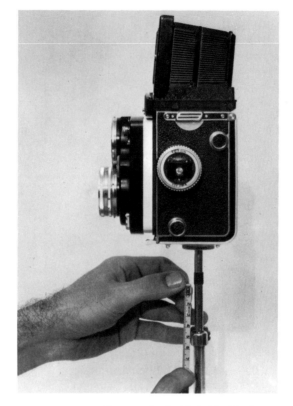

The camera is raised the height of the distance between the centers of the viewing and taking lenses (above) so the taking lens has the same view of the subject the viewing lens had. The supplementary lens is moved from the viewing lens to the taking lens, and the picture made.

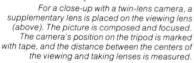

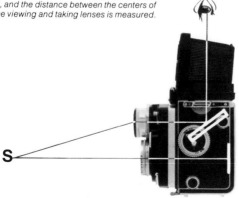

S

A different method from the one above utilizes twin supplementary lenses that fit over the two regular lenses of the camera (left). The lower, or taking, supplementary lens magnifies the image of the subject in the usual way. The upper, or viewing, supplementary lens also magnifies the image. And it does something more: It changes the framing of the camera's viewing system so that the area covered by the two lenses is the same. This trick is accomplished by a prism in the upper supplementary lens that aims the viewing lens slightly downward, as shown in the diagram.

Bringing Out the Inner Beauty

Flowers are among the most popular, plentiful and readily accessible of all nature subjects. Yet too many pictures of them turn out trite and disappointing. The fault is not that of the flower, nor entirely that of the photographer. It comes from inherent differences between the way an object appears to the viewer and the way the camera records its image. The photographer sees a flower with stereoscopic, or three-dimensional, vision that separates it from its surroundings, while the mind's eye compensates for such things as motion and subtle changes in color and lighting. The camera, by contrast, has monocular, or two-dimensional, vision and tends to place equal emphasis on everything in its one-eyed field of view. Thus a rose that stands out clearly when a photographer looks at it will be lost amidst the other flowers and nearby objects if he takes a picture of it from a normal viewing distance.

The solution to this problem is to regard flowers, almost without exception, as subjects for close-up photography. With close-up techniques a single blossom or a cluster of blossoms can be emphasized so that the background either does not show or is reduced to an undistracting blur. The contrast of colors further separates the flower from the background or in extreme close-ups enhances the view of its structure. This technique provides an automatic dividend: Details are enlarged so that they can be seen more clearly, as in the picture at right.

Along with the merits of close-up photography come the limitations that are discussed earlier in this chapter. But the resourceful photographer can overcome these and even make virtues of some of them. The shallow depth of field when working up close, for example, is the very characteristic that permits a sharp separation of a flower from its surroundings. And in extreme close-ups, such as that on page 115, it can be used to concentrate attention on a single part of a flower.

When lenses are extended in close-up photography, less light falls on the film. Longer exposures are required. Fast lenses, high-speed film, reflectors and fill-in flash can help with the exposure problem. But the photographer should realize that lighting is an esthetic as well as a technical consideration. Broad sunlight is not always necessary or desirable, for natural-looking pictures can be taken in shadows and hazy weather *(pages 118-119)*. A shadow can also focus attention onto a plant in the field, obscuring surroundings so that the plant stands out dramatically *(page 116)*.

Perhaps the toughest challenge that flowers present is the least expected one: that of motion. Flowers are not the docile subjects they seem, but sway and twitch and flutter incessantly, often for no perceptible reason. The slightest movement, moreover, is exaggerated by the magnifying effect of close-up equipment. The best motion stopper is a fast shutter speed. If a low light level does not permit the use of a fast shutter, the photographer must find a way to keep the flower from moving. He can erect a windbreak (any handy material will do as long as it does not reflect its own color on the flower). Or he can tie long-stemmed flowers to a stake, carefully placed so as not to show in the picture. If all else fails, he can move a garden flower bodily to a sheltered place, in which case it is wise to dig it up, and replant it after the picture has been taken.

WALTER IOOSS JR: *Geranium*, 1971

Sprinkled with tiny raindrops that might have been barely visible to the naked eye, a geranium blossom was photographed with an SLR fitted with a macro lens, producing a life-sized image on the 35mm film. During the printing process it was enlarged to about 6 times life size.

Coping with Depth of Field

Technically speaking, a lens will focus sharply only across a given plane; yet the eye will accept objects just in front of and just behind this plane as being in focus. This zone in which everything seems to be in focus is called the depth of field. At a moderate or extreme distance from the camera the depth of field is great. But the closer the subject is to the lens, the shallower the depth of field becomes. In close-up photography the depth of field may be only a few millimeters.

This limitation on the extent of sharp focus can be converted into an asset, as it was in the picture opposite. If the lens is very close to the flower only a small portion of it is in focus; that portion becomes the principal subject, the rest dissolving into a muted blur.

For most flower pictures, however, a small spot of sharp focus is not enough. There are only two ways to obtain greater depth of field. One method is to settle for a smaller film image, either by using less powerful close-up equipment or by moving the camera farther away from the object and refocusing the lens. The other way is to stop the aperture down as far as possible. This method, however, reduces the amount of light reaching the film: so the picture must be taken either with a slower shutter speed or with additional light; the latter can be provided by a reflector or a flash unit.

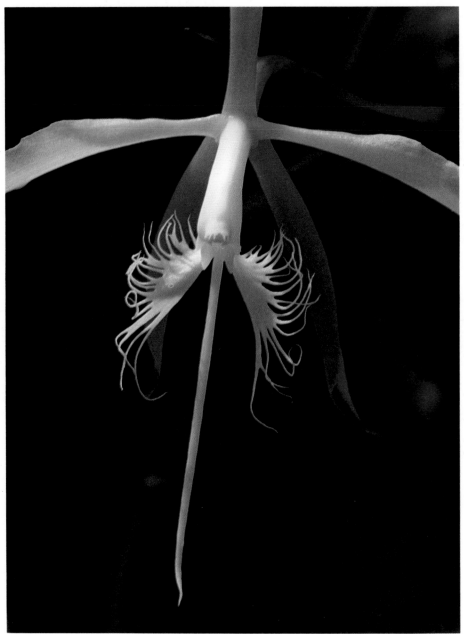

JAMES H. CARMICHAEL JR.: *Epidendrum Orchid,* 1979

Photographed with a 100mm macro lens on a tripod-mounted 35mm SLR, all parts of a delicate tropical orchid are in sharp focus because the photographer was far enough away from the flower — 10 inches — to keep its leaves within the lens's depth of field. He also closed the lens down to its smallest aperture (f/22 in this case), which gives maximum depth of field. On the original slide the orchid was 1/3 life size; it is reproduced close to life size.

A hand-held 35mm SLR was used to record this life-sized image (here enlarged to about 6 times life size) of the underside of an orchid. It was possible to get only a small section of the picture in sharp focus because the orchid extends beyond the shallow depth of field that is available at this close range. Even with the 50mm lens stopped down to an aperture of f/16, the depth of field is only two millimeters. This was enough, though, to give a clear view of a glistening drop of sap clinging to the stem of the orchid just below the petals.

NICHOLAS FOSTER: Orchid, 1970

Dramatic Effects with Directional Light

Backlighted by a late-afternoon sun, the heads of ▶ Arctic cotton grass glow like tufts of luminous silk. Shooting directly into the sun, the photographer positioned his camera to get the sun into a corner of the frame to minimize lens reflections that would appear as distracting rings.

Every detail of these three pasqueflowers—relatives of the buttercup—stand out as if spotlighted in this close-up. To create this unusual effect, the photographer's companions held their coats to cast a deep shadow over the background, letting sunlight get through only where it would strike the flowers.

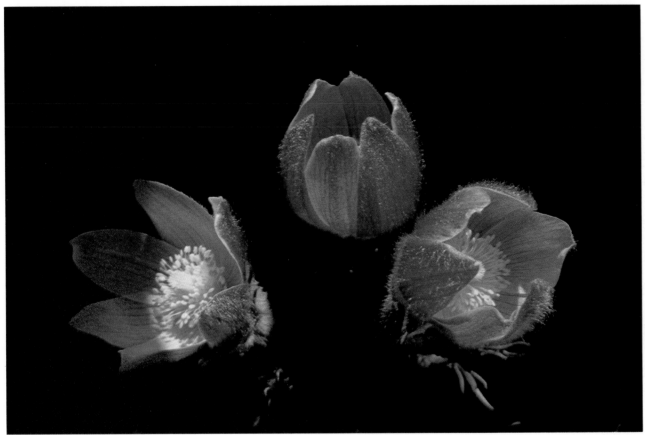

BILL RATCLIFFE: *Pasqueflowers, Wyoming,* 1980

Out of doors, available light shines indiscriminately on both the subject and its surroundings, so that it may be tricky to separate the plant from its background. A common solution to this common problem, exploited in the shot of pasqueflowers above, uses a shadow deliberately cast over the background to make the plant stand out. Some photographers create shadows where needed by setting up umbrellas on stands to block the light; most, however, simply hold up a piece of cardboard or a coat.

Sunlight illuminating a subject from an unusual angle can also enhance close-ups. Some plants show up best when the sun's rays are shining from one side to create strong crosslighting. Others, like the silky Arctic cotton grass at far right, are most attractive when the sun comes from behind.

To obtain such effects the photographer must patiently search for the spot where his camera can catch the proper angle of the sun's rays. And the strong contrasts in brightness call for extra care in calculating exposures.

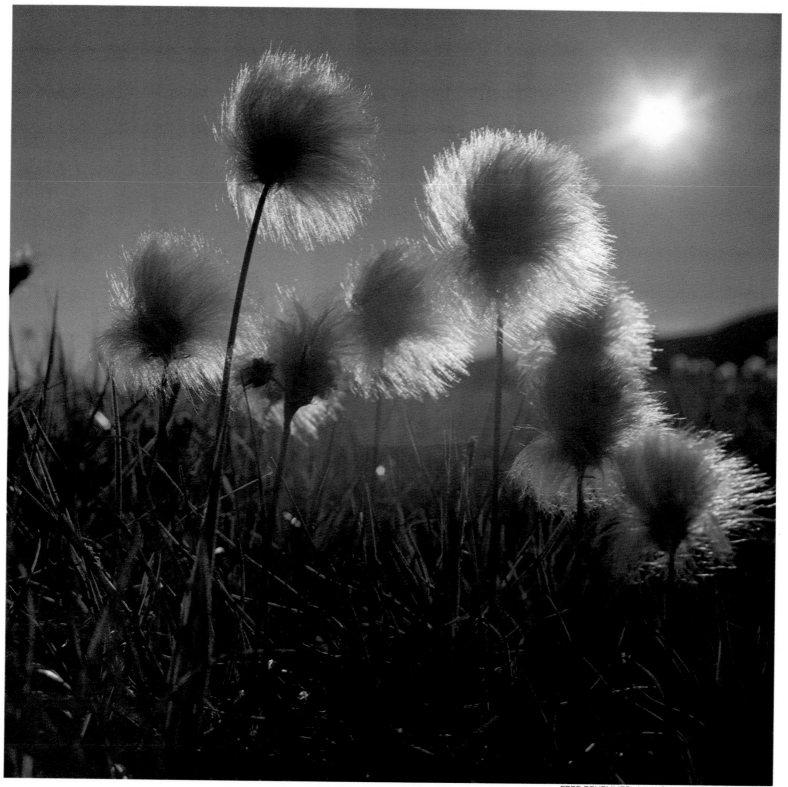

FRED BRUEMMER: *Arctic Cotton Grass, Labrador,* 1973

The Changing Hues of a Tiger Lily

Which of the two pictures on these pages has the more accurate color? Both show the same tiger-lily plant and were taken in sunlight with the same kind of film and camera only a short time apart. Yet the petals and leaves are of different shades in the two views.

The colors in both pictures are perfectly accurate. What makes them look different is the atmosphere. At the time the picture at right was taken, haze left by a light rain filtered the sunlight, diffusing and softening the illumination (raindrops are still visible on some of the petals). The haze had lifted by the time the second picture was taken, and the unfiltered sun struck the flower directly. Neither picture is preferable to the other; the photographer's choice is purely that of esthetic consideration.

Light falling on a flower changes color not only with atmospheric conditions but with the time of day and year. When the sun is at a low angle, the colors are warmer. When it is high, the colors are "truer," that is, closer to what we regard as the exact hues. Light is also affected by the surroundings: Sand, rocks or snow may reflect the blue of the sky; sunlight filtering through foliage will have a greenish cast.

We are accustomed to seeing flowers under changeable light conditions, and a certain amount of variation adds to the naturalness of a picture. But color film often shows flowers with colors that are not exactly what we remember seeing. The photographer may then wish to take a hand in obtaining the colors he wants in the picture. He can use haze filters to reduce blue, and reflectors or daylight strobes to correct the light. Or he can simply wait until the sun has reached a better angle.

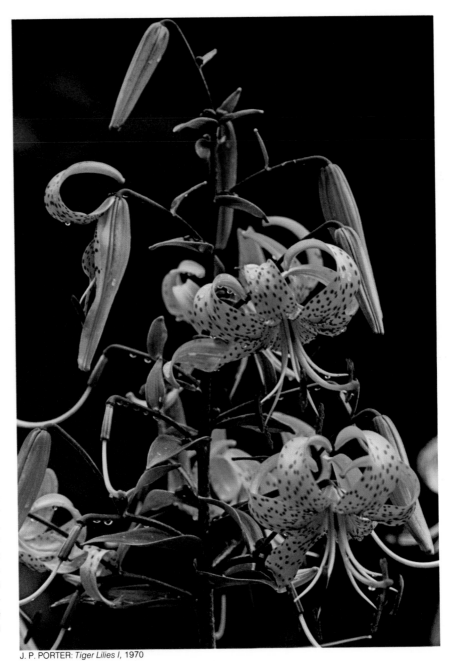

J. P. PORTER: *Tiger Lilies I*, 1970

◀ *Enveloped in a soft haze, the tiger lilies at left were photographed a few moments after an early morning rain in the Adirondack Mountains in New York. The picture was taken with a 35mm SLR and a 135mm lens from eight feet away. The intervening distance permitted the hazy quality of the atmosphere to influence the colors that were registered on the film.*

Two hours after the picture at left was taken, the sun had burned the haze away and illuminated the tiger lily with the strong rays of midmorning. To compose a picture that showed all the life stages of the lily—unopened buds, a full blossom and the dark bulblets on the stem—the photographer moved to within 30 inches of the flower and added a close-up bellows to the camera. A polarizing filter cut down reflections from leaves and petals.

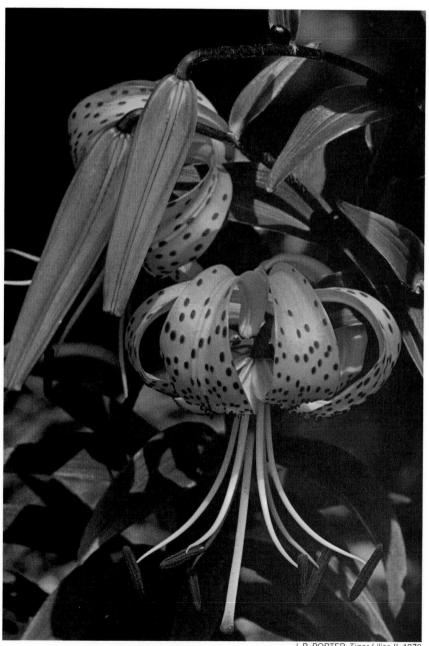

J. P. PORTER: *Tiger Lilies II,* 1970

Putting the Background to Work

Although backgrounds are often ignored or nonexistent in close-up photography, they can sometimes be incorporated to heighten the dramatic effect. Some photographers spread sand, gravel or wood chips around a plant to create a pleasing backdrop; others rearrange existing elements for a special impact *(right)*. But the most dramatic backgrounds are frequently the ones that nature itself has provided: pastel fuschias against their own green leaves, or fiery heather on a bed of snow.

Natural backgrounds can also provide information about a plant and its environment. The picture of a giant sedum opposite not only incorporates a sycamore leaf that reveals the plant's location near a grove of trees but it also includes evidence of the plant's mode of survival in a drought-plagued region of southern California. During a dry spell, the outer leaves of the thick succulent shrivel, releasing stored liquids to nourish the vital core—a feat that has earned the plant the popular name, live-forever.

To combine the traditional elements of a Japanese garden—water, rocks, plants—into one composition for a book illustration, the photographer artfully rearranged nature. He placed a lone azalea blossom on a stream bed of rocks glistening beneath dappled sunlight, then used a relatively slow shutter speed (1/4 second) so that highlights on the swiftly running water would blur slightly and create a feeling of motion.

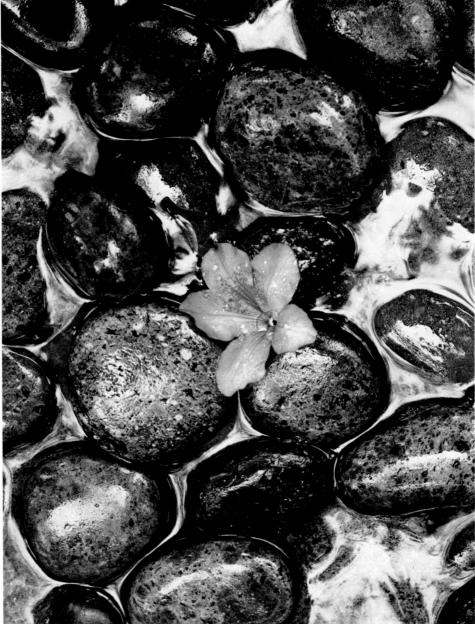

JOHN NEUBAUER: *Azalea Blossom,* 1979

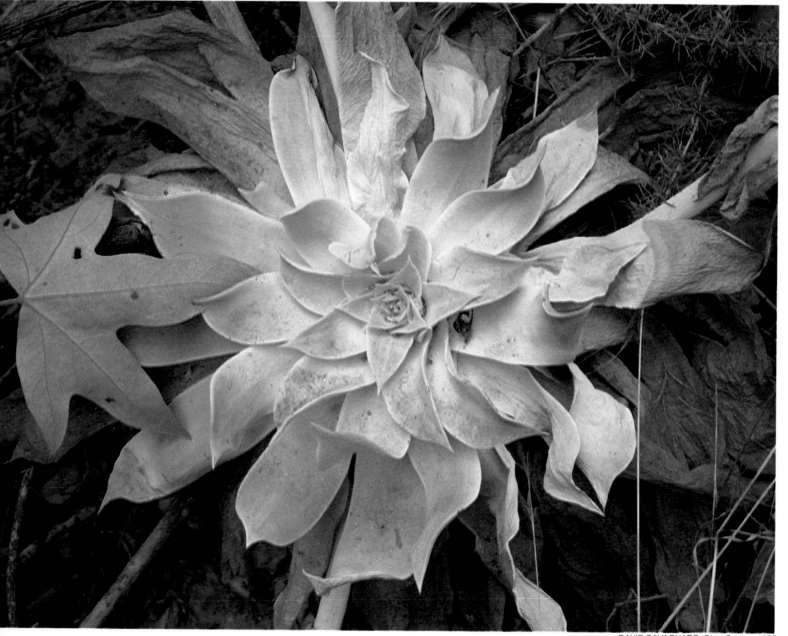

DAVID CAVAGNARO: *Giant Sedum*, 1977

Bringing Nature Indoors

Nature photographers collect plants and shoot them indoors for the same reason that photographers shoot other subjects in the studio: control. Away from the vagaries of nature—clouds that suddenly block the sun or breezes that unexpectedly cause a flower to flutter—the photographer has complete direction of the lighting, background and subject position. With a table-top setup that is no more elaborate than the ones shown on pages 104 and 108-109, he can dramatically isolate a plant, rendering every detail with the vivid clarity seen in the picture of milkweed at right.

Uncommon angles and tricky lighting effects are also more easily produced indoors. The back-lighted tulip on the opposite page, for example, required a meticulous arrangement of reflectors and strobe that would have been difficult, if not impossible, to accomplish outdoors.

GARY R. ZAHM: *Common Milkweed*, 1975

A spectacularly sharp view of tufted milkweed seeds seeming to erupt from their pods was taken on a basement workbench with a simple setup. A 35mm SLR camera with a 50mm macro lens was mounted on a table-top tripod and a piece of poster board, spray-painted dull black to prevent reflections, served as a background. An electronic flash, hand-held at an angle to the plant, provided the light.

To produce this dramatically back-lighted close-up of a tulip — ½ life size on the original slide and reproduced here almost 3 times life size — a petal was removed from the camera side of the flower to open a clear view of the pistils and stamen in the center. A powerful strobe was placed behind the flower and reflectors were set above and below it. The back petals of the tulip acted as miniature diffusers, softening the strobe's intense illumination. Added light was bounced into the heart of the flower by the reflectors.

CLAUDE NURIDSANY and MARIE PÉRENNOU: *Tulip*, 1973

The Problems of Picturing Bugs

The neophyte in the field of nature photography might be excused for assuming that one of the most difficult camera subjects in the world is the bug. Its size ranges from small to infinitesimal. It is elusive; although not usually fast-moving, it is often a master of camouflage. At life size, it can be so tiny as to be indiscernible; magnified, it can be hideous. Besides, it may bite or sting.

Yet for the observant, understanding and, most of all, patient photographer, the bug can be a delight. There are bugs in almost unlimited supply. The arthropods, including insects, scorpions and spiders, are the most numerous of all living creatures; there are 300,000 kinds of beetles alone. The bug also provides a heady range of colors, behavior, habitat, facial expressions, eccentricities and sexual customs that have to be photographed to be believed.

For all their bizarre attraction, bugs do present some formidable technical problems for the photographer. Not the least of these problems is size; special equipment of all sorts is required to look the horsefly in the eye, or to observe the acrobatic egg-laying of damsel flies (right). And many an insect subject cannot be induced to hold still. So the photographer, who has already sacrificed some of the necessary light by using his magnification equipment, frequently has to employ electronic flash—out of doors as well as in the studio.

Electronic flash can give bright enough light at close distances to allow the camera aperture to be closed down, often to f/16 or f/22. This combination of added light and smaller aperture has two advantages: It increases depth of field and, if the shooting is done during the day or in a lighted room, the small aperture excludes most of the light except that from the flash, preventing a double image.

Electronic flash has other advantages: Its burst of light is so brief—as fast as 1/50,000 second—that stop-action photographs of insects in motion can be achieved, often without special equipment; its color closely matches that of sunlight at noon, so natural-looking pictures can usually be obtained without special films or filters; and it produces no evident heat to annoy or harm an insect.

If the flash is the type that has automatic exposure control and is fitted with a remote sensor (pages 104-105), all the photographer needs to do is set up his equipment and shoot. If an automatic unit is not used, however, correct exposure must be calculated separately for each combination of lens attachments, lighting and subject distance; such calculations are much simplified if a list of exposure corrections is prepared in advance, as described on pages 98-101.

For all these reasons, bugs can be difficult. But—for the reasons illustrated on these pages—the resulting pictures can be exotic and exciting.

In this striking close-up, reproduced 3½ times life size, two pairs of damsel flies complete a mating ritual on the leaf of a water plant. As two golden-toned females arch their bodies to deposit their eggs, two tall males anchor themselves to the females' necks while supporting each other in a precarious upright hug. To take this picture, the photographer used an electronic flash unit, an SLR equipped with a macro lens and an extension ring— and a pair of waterproof hip boots to wade into the shallows where the scene took place.

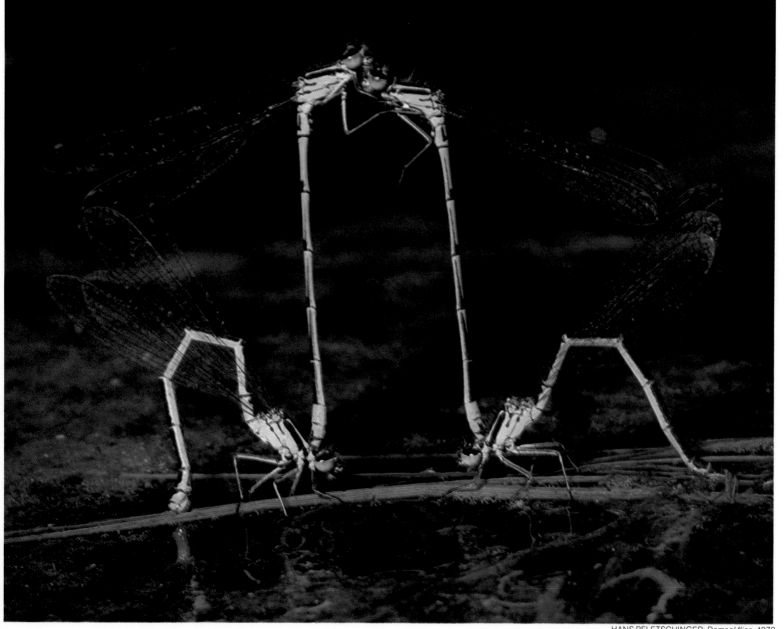

HANS PFLETSCHINGER: *Damsel flies,* 1972

Documenting Life Cycles

Insect metamorphosis is remarkably well suited to the camera; each change can be frozen on film, and a photographic sequence can reveal the entire transformation at a glance. To create such a series a photographer must first study the insects' life cycle to be able to predict when each phase of the cycle will occur. And he must provide a hospitable indoor environment for weeks or months to nurture his metamorphosing subjects.

Depending on the species, this studio-laboratory may be a precise re-creation of the insect's natural surroundings, or merely a spare household corner where bugs can be temporarily parked.

For a series recording the development of pothole mosquitoes *(top right)*, Bob Sisson, natural science photographer for *National Geographic* magazine, spent eight weeks observing his subjects in the Utah desert; then, inside the trailer he had brought for a studio, he painstakingly simulated their habitat — the small catch basins known as potholes that hold rainwater for a few days or weeks. He filled a tank in the trailer studio with water of the same salinity and acidity as water found in the potholes, he kept the temperature in the same range and he put in some of the same vegetation. "Look, study, research," said Sisson. "The last thing you do is push the button."

Less elaborate preparations were required for the sequence of a caterpillar becoming a butterfly at bottom right. Terence Shaw, who was 16 years old when he took the photographs, used the family living room as his studio. There he brought the monarch larvae to feed on potted milkweed plants. Using a 4 x 5 portable view camera and two electronic flash lamps, Shaw recorded all the stages of the gradual metamorphosis.

larval stage

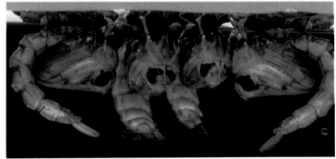

pupal stage

A sequence of four pictures reveals the development of pothole mosquitoes. Above, two delicate larvae swim free after having cracked the caps off their eggs. Approximately four days later (above right), a group of larvae have changed into hard-shelled pupae that float as a clump just under the water's surface, breathing through tiny tubes. After another day and a half (near right), a soft, damp adult emerges into the air. Finally (far right), an adult female is poised on the water's surface, completely free, waiting for its wings to dry and harden. The series was taken with a bellows-mounted 55mm macro lens; light came from three strobe lights.

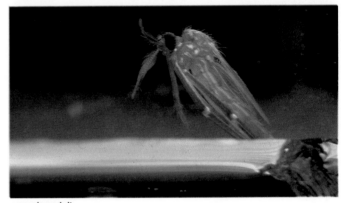

emerging adult

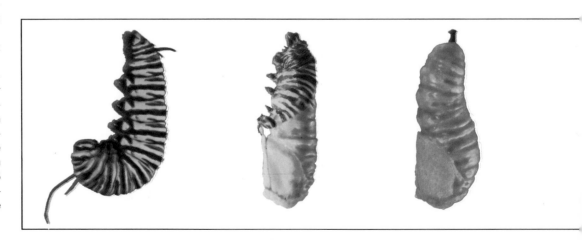

free adult

ROBERT F. SISSON: *Life Cycle of a Pothole Mosquito*, 1974

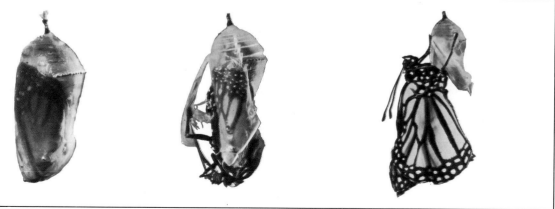

TERENCE SHAW: *Monarch Metamorphosis*, 1957

Stages in the development of a monarch butterfly are shown in this series. From left are the full-grown caterpillar, molting caterpillar, pupa, completed metamorphosis, emerging butterfly and fully developed butterfly on the shell of the pupa. Careful observation was needed because some pictures had to be taken only hours apart, others days apart. The process took two weeks.

Keeping the Subject in Focus

HANS PFLETSCHINGER: *Great Puss-Moth Caterpillar,* 1974

The shape as well as the size of an insect can influence the way its picture should be taken. Because depth of field is extremely shallow with close-up equipment, elongated subjects like the caterpillar shown above should be photographed from the side, or nearly so, if the entire insect is to be kept in focus. If the caterpillar had been photographed from the front, only its head would be in focus and the remainder would be a blur. This shallow depth of field can, of course, be turned into a virtue. When the photographer wants to give prominence to only part of a subject, the shallow depth of field will cause the rest of the picture to become indistinct.

This effect is inevitable with subjects magnified to considerably larger than life size, as shown opposite. At this degree of magnification there is no appreciable depth of field, so the photographer must compose his picture to concentrate on objects that lie in a virtually flat plane. Thus, Dr. Alexander Klots emphasized one eye of a horsefly; by so doing he got a more striking photograph than if the whole insect had been in sharp focus.

A broadside view of a great puss-moth caterpillar, head turned coyly cameraward, keeps all of the insect in sharp focus, including a drop of liquid on its red frontal ring—an acidic secretion it shoots at predatory birds to blind them temporarily. Sharp detail in this insect portrait is possible in part because the caterpillar is extended in a relatively flat plane in front of the camera and the picture was not taken as an extreme close-up. The caterpillar is reproduced at 4½ times life size.

ALEXANDER KLOTS: *Eye of Female Horsefly,* 1962

A head-on view of a female horsefly concentrates on the iridescent structure of a single eye, while purposely letting the rest of the picture fade gently out of focus. This shallow depth of field was obtained by photographing close to the subject, with a 35mm SLR, extension tubes and a 50mm lens stopped down to f/22. The subject was photographed at 1½ times life size on the film (here enlarged to about 12 times life size), which permitted a zone of sharpness barely 1/12 inch deep.

A Natural Setting in the Studio

JOHN COOKE: *Walking Stick,* 1967

Some of the close-up photographer's subjects are so skittish or need such careful lighting that they have to be captured and taken into the studio to be photographed. Even indoors the pictures can be made to look as real as they would outside so long as some of the insect's habitat is also collected and taken along to be photographed with it. This is normally not a major problem because a clump of foliage or a shovelful of sand is generally all that is re-

quired to fill the frame in a close-up view.

But sometimes the setting for the picture must be transported as carefully as the bug itself. This is particularly important when taking pictures like that of the walking stick above. The purpose was to show how the insect blends into its setting. Thus the subject and its environment were of equal pictorial interest. And it was an easier matter to bring the insect indoors by bringing its habitat along with it.

Looking like another twig, a walking stick stretches away from a branch. It was brought, branch and all, from a bush in Jamaica into a portable studio. There the photographer was able to adjust two electronic-flash units so that highlights along the length of the insect would make it more visible in the picture.

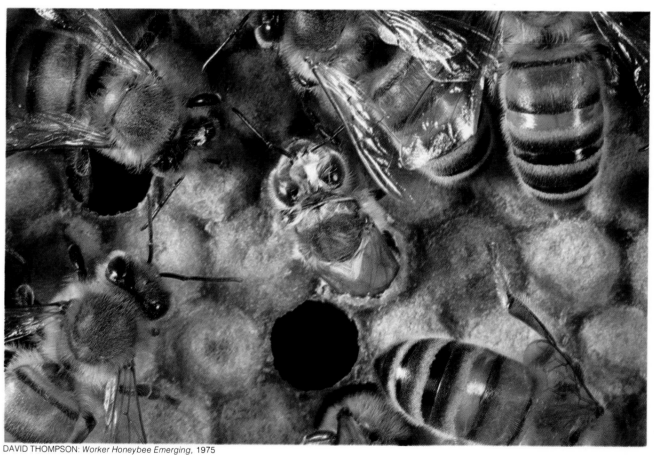

DAVID THOMPSON: *Worker Honeybee Emerging,* 1975

A beehive moved into the studio provided the controlled environment that the photographer needed to take this close-up of a worker honeybee emerging from its cell in the center. To have maximum freedom in shooting—and to avoid optical distortion—the photographer chose not to enclose the hive in glass; he risked an occasional sting to shoot at very close range, using an electronic flash and a hand-held SLR fitted with a 55mm macro lens.

Catching Action in the Field

JOHN COOKE: *Crab Spiders,* 1969

Capturing the activities of agile insects in the wild is a supreme test of photographic skill. A knowledge of insects' favorite haunts, foods and daily and seasonal habits greatly increases the chances of success. For example, if a photographer knows a particular flower is favored by a species of nectar gatherers, he can set up his camera in advance and focus on a blossom that his subject is likely to visit. Many photographers make such a flower even more attractive to insects by adding a drop of a dilute honey-water mixture. Another promising site is a spider web like the one in the picture above.

A macro lens with a moderately long focal length—135mm focal length for a 35mm camera—helps the photographer keep his distance. And flash is indispensable. It not only eliminates harsh daylight shadows and freezes restless subjects but also permits the use of small apertures that give enough depth of field to keep the subject sharp.

In an instinctive gamble with death, a male crab spider climbs along the underside of the larger female and attempts to identify himself to her. If he does not do so quickly enough, the cannibalistic female may eat him before mating can take place. This picture was taken outdoors in daylight, but since the photographer stopped the aperture down to f/22 to gain depth of field, he had to use two flash units to provide additional light.

A voracious African driver ant attacks a ▶
grasshopper in a close-up made by a photographer who wore a rubber skin-diving outfit—in 98° heat—to protect himself against the insects' vicious bites; the ants got to him anyway.

CARLO BAVAGNOLI: *African Driver Ant Killing a Grasshopper*, 1967

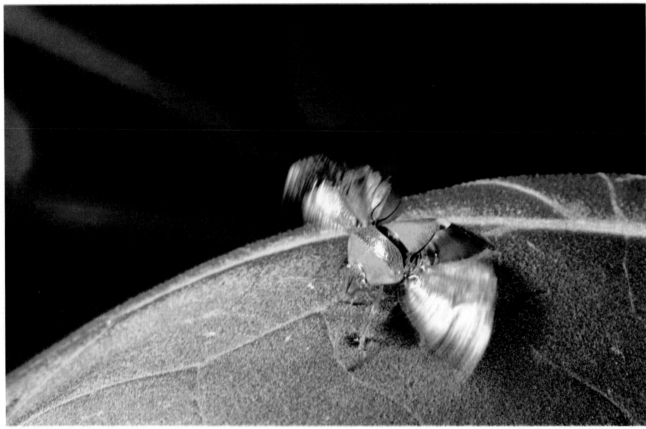

JOHN COOKE: *Stink Bug,* 1970

After pausing on a leaf in the cool night air of Arizona, a stink bug exercises to warm up before flying away. The photographer, an entomologist, glimpsed the bug with the aid of a flashlight and was familiar enough with its habits to know it would continue its calisthenics for the few seconds needed to adjust his camera rig and take a picture. Even the high speed of an electronic flash was not enough to stop the motion of the wings, but the blurring adds to the naturalism of an exceptional photograph.

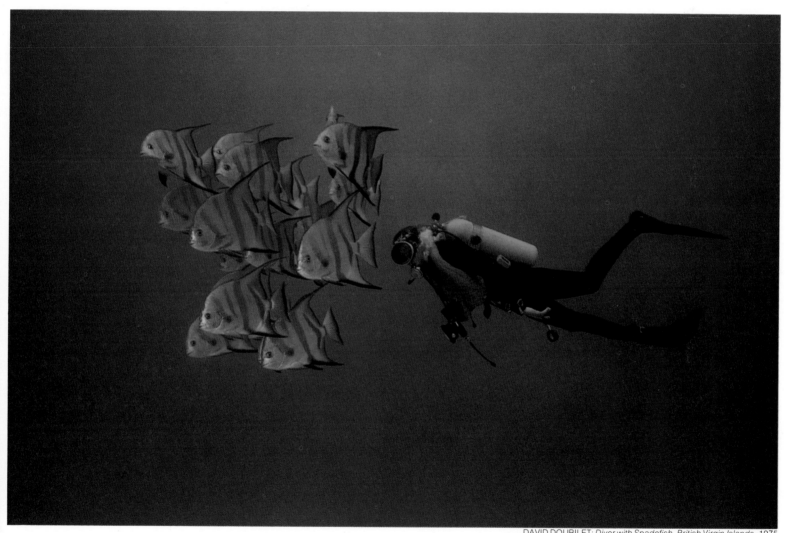

DAVID DOUBILET: *Diver with Spadefish, British Virgin Islands,* 1975

The Deceptive Deeps

Man and the undersea world are not really meant for each other. Human eyesight is weak and blurry underwater; ears cannot pick out the direction of sound; human skin wrinkles like a prune after lengthy immersion. The pressure of water, increasing by 14.7 pounds per square inch for every 33 feet of depth, poses a threat to the air spaces in the lungs, ears and sinuses. Water's drag makes swimming slow and fatiguing. And its thermal property, draining off precious calories many times faster than they are lost in air, is inimical to a warm-blooded intruder.

Despite all these obstacles, the romance between man and the underwater realm flourishes as never before. With a face mask to restore sight, scuba gear to provide air and to counter water pressure, swim fins to improve locomotion, and a rubber wet suit to preserve body heat, a new amphibious creature has come into being. Properly trained, this man-fish can dive safely to 130 feet—and breathing a special mixture of gases and taking precautions to avoid the bends, he can go deeper than 1,000 feet.

Nowadays a diver's equipment will often include one item not related to survival—the camera. Carried into the sea, it has recorded visual wonders that can equal anything found on the surface of the planet. It has revealed labyrinthine landscapes of coral, fish as sleek as swords or bright as chips of sunshine, creatures that sail the currents like diaphanous yachts, stodgy animals that spend a lifetime in a single spot, worms as beautiful as flowers, odd denizens of the deep that move on armored legs or by jet propulsion, and countless other fascinating sights. No one who has seen the results of underwater photography ever asks, "Why bother?"

Yet underwater photography was in fact too much of a bother for three decades after the camera was invented. The reason was simple: Ordinary cameras were no better suited for taking pictures underwater than human beings are for living there. Water will corrode the metal parts of a camera and damage photographic emulsions. And even if the camera is waterproof, it must also be structurally strong enough to resist great pressures (at a depth of only 60 feet, an eight-inch cube is subjected to a crushing force of more than five tons). In addition to these liabilities, light—the basic necessity for photography—weakens rapidly as it passes through water. In the clearest seas, seven eighths of daylight is lost after traveling 35 feet down.

William Thompson, the first man to dunk a camera intentionally, was not aware of the finer points of these difficulties when the inspiration for underwater photography seized him in 1856. But he probably would not have been deterred, because the applications that he envisioned were far from artistic. An engineer by training and a photographer by avocation, he was watching the swollen Wey River in England rush through the arches of a bridge one rainy day when it occurred to him that a camera might be useful for inspect-

Louis Boutan, posing here for an underwater self-portrait, recognized the limitations of trying to study marine life from above the surface. His pioneering experimentation with underwater photographic and lighting techniques led in 1900 to one of the earliest books on the subject.

ing the threatened, submerged part of the structure. Translating idea into actuality, he constructed a watertight box large enough to hold a camera, with a sheet of plate glass at one end. Outside the glass he placed a heavy wooden drop-shutter, attaching a string to it so that it could be lowered and raised. Then he and a friend rowed out into Weymouth Bay and eased the unwieldy apparatus 18 feet down to the riverbed. The shutter was opened for 10 minutes. When the two men pulled the camera aboard again, it was full of water. However, Thompson succeeded in developing a dim image that showed sand and boulders covered with weeds. He sent a print to the Society of Arts, along with a note saying: "This application of photography may prove of incalculable benefit to science. Should a pier or bridge require to be examined, you have but to suit your camera, and you will obtain a sketch of the pier, with any dilapidations, and the engineer will thus obtain far better information than he could from any report made by a diver."

Thompson's interest waned, and several decades passed before the idea was picked up again. But Louis Boutan, the next man to build an underwater camera, made tremendous advances and deserves to be credited as the true founder of underwater photography. A robust and adventurous zoologist, Boutan had roamed the world before accepting a position on the Paris Faculty of Science. During the summers, he lectured and did research at the Arago Marine Laboratory in the South of France and there, in 1892, he conceived the idea of taking underwater photographs to aid his studies.

Originality marked his efforts from the very beginning. One of his early underwater cameras was housed in a large copper box connected by a tube to a rubber balloon full of air; when the apparatus was submerged the water squeezed the balloon, forcing air into the housing, where it helped to offset the exterior pressure. Another even bolder design was a "drowned camera" whose innards were permitted to fill up with water. This eliminated any concern about pressure and waterproofing, as well as certain optical problems. Boutan procured some specially varnished photographic plates that were almost impervious to salt water, then proceeded to test the system. The results were not auspicious. Apparently the shutter stirred the water in such a way that the image was blurred. Boutan's most successful design utilized a strong housing that required no balloon for pressure equalization. The inventor himself put on a diver's suit and went down to operate the camera.

Although the waters of the Mediterranean were clear, available light was too weak to register images of moving fish on the gelatin dry-plates that Boutan employed. Depending on the depth, he had to make exposures lasting anywhere from 10 to 30 minutes. (Since waterproof watches did not exist in those days, the exposure time was gauged by assistants in the boat above, who signaled to Boutan by tugging on his safety line.) Undiscouraged by this

problem, Boutan set out to solve it by creating the world's first submersible lights. With the help of an electrical engineer, he came up with a gadget whose description sounds strangely familiar. It consisted, Boutan wrote, "of a spiral wire of magnesium in a glass balloon containing oxygen, and a fine platinum wire, connected to the two poles of a battery. When the current was turned on, the platinum wire reddened and ignited the magnesium, which oxidized with a brilliant light." It was, in short, the progenitor of the modern flash bulb. Unfortunately the bulbs often overheated and burst.

The indefatigable Boutan went on to new schemes for underwater light. In 1899 he built two submersible arc lamps and attached them to a camera housing. Lowering the rig 165 feet into the sea, he operated the electromagnetic shutter by remote control and snapped a picture of a sign that had been attached in front of the lens. It was not an exciting sign; it merely stated that this was an underwater picture, and gave the depth. When Boutan pulled the apparatus up, one of the lamps was out of action, but the picture came out sharp and clear. Boutan never took another underwater photograph; he devoted the rest of his career to other research. Some 40 years were to pass before anyone dared to descend deeper into the water for a picture than he had done.

The public got its first taste of undersea cinematography through the efforts of a shrewd moviemaker named Jack Williamson. Strictly speaking, his technique was not in-water photography. Both the camera and its operator were enclosed in an observation ball dangling from the bottom of a barge. Through the glass porthole of this "photosphere," as he called it, Williamson filmed such gripping subject matter as a treasure hunt, divers fighting sharks with knives, and one lissome swimmer starring in a movie entitled *Girl of the Sea.* In 1915, he shot his greatest hit, the first film version of Jules Verne's epic *Twenty Thousand Leagues under the Sea.* Its cast included a giant octopus — U.S. Patent No. 1,378,641 — made of rubber and coiled springs, with a diver manning the controls inside the monster. The public, ready to believe anything about the alien undersea world, generally regarded the octopus as real.

The first underwater pictures in color were taken in the 1920s by a more serious experimenter, the American ichthyologist W. H. Longley. Working with a professional photographer from *National Geographic* magazine, Longley used the Autochrome process, a pioneering form of color photography that produced a positive transparency on a glass plate. Autochromes were very slow, requiring 1,600 times the exposure of modern high-speed color film. To create enough light to freeze moving subjects, Longley placed tremendous one-pound charges of powdered magnesium on an open-bottomed raft. The blast, equal to 2,400 flash bulbs, produced the greatest illumination ever used for undersea pictures. It was really "more than human nerves could stand,"

Early underwater cameraman Louis Boutan devised an ingenious way of making his heavy photographic equipment easy to manage. The watertight and pressure-resistant housing was so massive that even though it was buoyed by submergence a block and tackle had to be used to raise and lower it in the water, and Boutan wore himself out maneuvering it on the sea floor. Boutan's solution to this problem was to hang the equipment from a floating barrel that counterbalanced most of the weight. The pulley system between barrel and housing could be adjusted to set the apparatus at the desired depth.

When W. H. Longley, an American scientist from Goucher College in Maryland, and Charles Martin, a photographer for National Geographic magazine, took the first underwater photographs in color, this homely hogfish swimming off Dry Tortugas, Florida, was one of their subjects. The original is a transparency made by the Autochrome process—a color system popular in the early 20th Century.

Longley said, and one charge blew the raft to smithereens. But this rather cataclysmic lighting system worked most of the time, however, and the pioneering pictures that it yielded were printed in the National Geographic magazine in 1927 (left). Nearly three more decades passed before another underwater color picture was published.

Undersea photography, moving by fits and starts for almost a century, finally came into its own in the 1950s. The main reason was the development of the Aqualung, a contrivance of cylinders with compressed air that permitted divers to breathe for longer periods underwater. This was a true quantum leap in undersea freedom, and photographic equipment manufacturers were not quite ready for it. Divers who wanted to document what they found down there had to improvise their own photographic gear at first. Waterproof housings of every description were used—homemade wood and plastic boxes, Mason jars, and even rubber hot-water bottles with glass portholes. Today divers can readily buy factory-made housings, light meters, lenses—even a camera with automatic exposure control—designed for undersea photography. This does not mean that taking pictures under water is now a simple matter. Although almost anyone can get a reasonable picture a few feet below the surface of the Caribbean with a snapshot camera in a plastic case, the subjects of the deep cannot be recorded so easily. Underwater photography still has definite hazards and restrictions.

What should an entrant into this field know? First of all, he ought to be familiar with what happens to light in water—and he does not need a camera to see that a great deal happens. Looking through the glass of a face mask, a diver will note that the underwater world is dimmer than the surface world, that he cannot see very far and that there is a general lack of contrast and a loss of color as he goes deeper. He will find that everything appears a bit larger and closer than it really is. If he stays below for a few minutes, his brain will become partially adjusted to these conditions, and he will be less aware of them. But a camera does not possess this amazing power of adjustment—which explains why so many underwater pictures surprise the inexperienced photographer by turning out to be dull, monochromatic, badly exposed or improperly focused.

The purest water is very "hazy" compared to air. Even in such crystalline spots as the eastern Mediterranean or the Sargasso Sea off Bermuda, where clear surface water is continuously sinking downward, visibility is limited to a few hundred feet. Elsewhere, the visibility only a dozen feet below the surface may be so poor that a diver will hardly be able to see his hands directly in front of his face mask. There is always less light below water than above, one reason being that some of the sun's rays bounce off the surface of the sea—the amount depending on the angle of the sun and the roughness of the

surface. The main difficulties of vision, however, stem from two phenomena known as scattering and absorption.

Scattering occurs when photons—the energy packets of light—are briefly trapped and then reemitted in a new direction by suspended particles in the water or by the water molecules themselves. Absorption occurs when photons strike water molecules or suspended particles and are converted from light energy into heat. Both of these processes happen in air to a certain extent, but much more so in water. Not only is water about 800 times denser than air, but it has a great deal more particulate matter—which may consist of bits of sand, mud, coral, decayed organic matter, minerals, bubbles and plankton or other minute organisms.

Scattering lowers contrast by creating nondirectional, diffuse light, thus eliminating the shadows that help to define an object. Contrast is further reduced by the diffuse glow of scattered light from the surrounding water. Scattering and absorption together diminish the light reflected from an object, reducing its brightness and making details more difficult to distinguish.

Both scattering and absorption also affect color, by acting on different wavelengths to different degrees. Short blue wavelengths are scattered more than long red ones in water. Absorption, however, is the main determinant of colors in the undersea world. Water absorbs more of the longer wavelengths—the "warm" hues of red, orange and yellow—than of the shorter green and blue wavelengths. This selective absorption, together with scattering, is responsible for the so-called blue-green window of the sea—a metaphor that simply means that blue and green wavelengths pass efficiently through the water while warmer colors are blocked. Actually, peak transmission of light energy is not always located in the blue-green part of the spectrum. Decayed marine plants produce a yellowish pigment that absorbs strongly in the blue spectral region, shifting the "window" of maximum transmission to the green-yellow area. This fact explains why water looks greenish wherever vegetative life is abundant in the seas—near coasts and the closer one approaches the poles. Nevertheless, the absorption of warm colors occurs everywhere, from the plankton-rich waters of Labrador to the clear waters of the Bahamas.

The depletion of red, orange and yellow wavelengths begins to be noticeable only a short distance below the surface. If a brilliant red object is photographed 15 feet down in clear tropical waters, it will appear rather dull, even close up. At 30 feet the object will hardly look red at all, because the red wavelengths are almost entirely attenuated at that depth. Yet a blue or green object will retain much of its color as deep as sunlight can reach, since these wavelengths are only slightly absorbed. (To the eye, a full range of colors may appear to be present at 30 feet beneath the surface, but film will

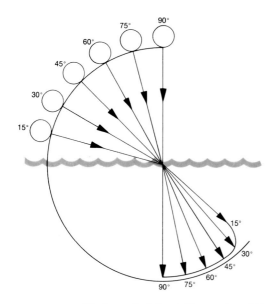

This diagram illustrates what happens to sunlight when it goes underwater. The spaces shown between the light rays are smaller beneath the surface because the rays are bent, or refracted, when they pass from air to water. At any given depth the brightness of the underwater rays is proportionate to their length on the diagram. A ray entering the water at an angle of 90°—when the sun is directly overhead—will travel straight down, the shortest possible distance, to reach an underwater point. A ray entering at a lesser angle— in morning or afternoon—must travel obliquely through a greater distance of water to reach the same point, and its brightness will be lessened along the way by diffusion and absorption.

record the real proportions of various wavelengths with greater honesty.)

What can the underwater photographer do about these various effects of scattering and absorption? For one thing, he must forswear long shots. They simply will not work. In general, high-quality images cannot be made at a distance of more than one fifth of the range of visibility. That is, if a diver can see 50 feet, he should not try to take a picture of anything more than 10 feet away, because the camera, contradicting the testimony of the eye, will yield images degraded by loss of contrast. To obtain maximum contrast, it is almost always desirable to be as close to the subject as possible. For this reason, underwater photographers use wide-angle lenses much of the time. A wide-angle, that is, short focal-length, lens can be focused at closer range than a long lens while still encompassing a generous field of view. Also, a wide-angle lens has more depth of field than a long lens. This is a major asset underwater, where exact focusing is often difficult, due to the movement of the subject or of the weightless diver himself, who cannot steady himself by planting his feet on firm ground.

In black-and-white photography the loss of image contrast can be partially countered by choosing a medium-speed film. Slow films have the greatest contrast, but are not very practical in such dim conditions; fast films permit smaller apertures for more depth of field, but have the least contrast. Medium-speed film is a wise compromise, except in the gloomy deeps, where sensitivity is the foremost concern. A yellow filter will heighten contrast somewhat by holding back the scattered blue wavelengths, but then the background will come out almost black if the camera is aimed toward open water. Still another means of increasing contrast is to underexpose the film deliberately and to extend the developing time by 10 to 20 per cent. High-contrast printing paper also helps.

Color film, of course, raises the ante, holding out the promise of exciting images—and at the same time introducing a clutch of new problems.

Few picture-taking experiences are more frustrating than photographing a reef that seems to be exploding with yellows, oranges and violets—and getting back from the film processor what looks like a black-and-white picture that has been tinted blue-green. If disappointing underwater pictures are taken with color negative film, color balance can be improved during printing. But most photographers prefer slides, taken with color reversal film, which cannot be corrected so easily. With either film type, it is possible to adjust color by using filters, but down below the filters do not work as well as on land. Color-correcting filters that restrain the blues and greens while passing the longer wavelengths will help to keep natural-looking color if the light does not pass through more than about 30 feet of water. However, at greater distances the filter is not very useful; the long wavelengths are virtually gone, and nothing

can restore them except artificial light. Filters also call for increased exposure, which can be a drawback in situations where light intensity is low to begin with.

Artificial light provided by electronic flash units or flash bulbs is the answer to many of these difficulties of underwater photography. With its fresh infusion of a full range of wavelengths, artificial light revives colors that have been dulled or extinguished by the passage of light through the water. It also allows pictures to be taken at any depth at any time of day, and it permits the use of slow-speed color films, which usually provide the greatest sharpness, color richness and contrast.

Most photographers today use battery-powered electronic flashes—either specially designed underwater units or regular units in watertight housings. Large units that give the powerful flash needed for underwater photography are relatively expensive, but over the long run they cost less per shot than flash bulbs. Electronic flash units are also easier to use: There is no need to make fumbling changes of bulbs with numb fingers.

However, an electronic flash may cause a problem in relatively bright water near the surface, producing a disturbing half-sharp, half-blurred picture. The reason is the slow shutter speed—generally 1/60 second—used to synchronize the flash on most 35mm cameras. Those portions of the image illuminated by the available light will blur during the long exposure required by the flash; the sharp parts will be those close enough to the flash to be illuminated—frozen—by its brief burst. This effect will not occur with cameras having leaf shutters, as do twin-lens reflexes and most SLRs using larger film sizes; leaf shutters synchronize with electronic flash at any shutter speed.

There is also no synchronization problem with flash bulbs because their flash lasts long enough—about 1/20 second—to fully illuminate the film at the shutter speeds most frequently used when shooting underwater. This is why some photographers still prefer bulbs. Clear bulbs offer another advantage; they produce an excess of red wavelengths that offsets the loss of red color from absorption at distances greater than five feet. At closer distances, however, blue bulbs, which produce a wavelength mixture approximating daylight colors, are best. Bulbs, however, can be a nuisance; some popular areas have become littered with worn-out bulbs left by careless photographers.

To calculate exposure settings for flash bulbs or an electronic flash unit that does not provide automatic exposure control, a rough rule in clear water is to divide the above-water flash factor by four. This allows for the water's attenuation of light as well as the absence of reflecting surfaces. (Special allowances must be made for very murky water or, at the opposite extreme, an underwater cave where the walls reflect much of the light. In this case divide by two and a half.) For the most part, the use of flash underwater is as much an art as a science. Several artistic tricks—such as shooting into the sun in shallow water

How Focal Length and Angle of View Change Underwater

	focal length of lens		angle of view	
	above water	underwater	above water	underwater
35mm cameras	21mm	28mm	92°	75°
	28mm	37mm	75°	60°
	35mm	47mm	63°	50°
	50mm	67mm	47°	36°
medium-format cameras	38mm	51mm	93°	77°
	50mm	67mm	78°	62°
	60mm	80mm	68°	53°
	80mm	106mm	53°	41°

Because light is refracted as it passes from water into the air in the camera housing, both the focal length and angle of view of lenses are affected, as shown in this chart. Thus the focal length of a 50mm lens, normal for a 35mm camera above water, is increased by one third to 67mm underwater, and the angle of view is narrowed from 47° to 36°. Note that the slightly wide-angle 35mm lens performs underwater much as the normal 50mm performs out of the water.

or panning to purposely blur backgrounds—are shown in the picture essay that begins on page 148.

Underwater light obviously places a brand-new set of demands on photographers. Not only do scattering and absorption have profound consequences, but even the optical behavior of lenses may change. When light passes from water to air, its speed increases from 135,000 miles per second to 186,000 miles per second. As a result, the path of the rays bends slightly. This bending, called refraction, produces a 33 per cent magnification, making everything look larger or closer than it is. A lens, in effect, becomes longer: Because of refraction, its effective focal length increases by one third, causing it to have a narrower angle of view and less depth of field than it would in air *(chart)*. Since the photographer's eye and the lens of a 35mm SLR camera see the same thing, the lens should be focused at the apparent distance of the subject, rather than the actual measured distance. A flash unit, however, should be aimed to point where the subject actually is, not where it appears to be. Flash factors must also be calculated for the actual distance. Focusing errors can sometimes occur, especially with rangefinder cameras, because the mind second-guesses this optical change. If the photographer employs the viewfinder of a reflex camera he will avoid trouble, since he will be seeing exactly what the lens sees.

Another optical complication is produced by the glass or plastic window, or port, through which the camera lens looks. In most housings the port is flat. Rays of light striking the flat surface at a sharp angle are refracted more than those that strike nearer to the perpendicular—and this causes distortion and the prismatic effect on colors called chromatic aberration. In practice the trouble arises only with wide-angle lenses. An extreme wide-angle lens, shooting through a flat port, will yield pictures that are blurred and "stretched out" at the edges; also, the colors near the edges will display rainbow-like fringes. A moderate wide-angle lens will produce better images. With a normal or telephoto lens—useful for photographing shy fish—the distortion and chromatic aberration are nearly imperceptible, because such lenses have a narrower angle of view; hence the light rays they admit are close to being perpendicular to the port.

Clearly, the photographer faces a conflict of interest here. Does he have to accept distortion and blurring of colors in order to gain the benefits of a wide-angle lens that enables him to get close to the subject? He does not; several ways out of the dilemma have been devised. Dome-shaped ports can correct much of the distortion. Due to the curvature of a dome port, most of the light rays pass through it fairly close to the perpendicular, eliminating the sharp angles that cause trouble. When extreme wide-angle lenses are used, a dome port is absolutely necessary; otherwise the distortion would

be intolerable. Another optical remedy for the problem makes use of a plano-concave port (flat on the outside and curved on the inside) and introduces a corrective lens between the port and the camera. Both these systems pay an extra dividend: They restore the above-water focal length of lenses, making them perform in their normal fashion. But there are drawbacks, too: These optical systems add considerably to the expense of the equipment and they give good results only if the additional lens is very carefully positioned inside the housing between the port and the camera.

The camera housing itself can mean the difference between success and exasperation. There are dozens of different kinds of housings on the market, at a vast range of prices: They are manufactured to fit all kinds of cameras, from pocket models to large-format view cameras. Most of them are made either of rigid plastic or of cast aluminum with a port made of glass or optically clear plastic. The primary criteria are that a housing be watertight and able to withstand the water pressure down to normal diving limits of about 130 feet. For a satisfying degree of photographic flexibility, the housing should be equipped with outside controls that will manipulate focus, shutter and aperture settings, film transport, and shutter release on the enclosed camera. A housing that lacks any of these controls (or is so constructed that they are difficult to operate) will soon frustrate its owner.

The housing should be as small as possible so that extra air space between housing and camera is kept to a minimum: Too much space will cause the unit to float, necessitating extra ballast. To solve this problem, manufacturers of molded plastic housings construct units that hug the contours of a camera. In both metal and plastic cases, the camera lens sometimes fogs over because the cool underwater temperature causes condensation of moisture in the air within the housing. This can be controlled by placing packets of moisture-absorbing silica gel inside the housing.

The most versatile housings give the photographer full access to the viewer of a reflex camera for easy composition and focusing. With many housings, only a small part of the viewer is visible because the photographer cannot get his eye close to it. This can be an inconvenience, forcing the photographer to focus by estimate and to compose the picture with some inherently inaccurate device like a wire-frame sport-finder.

One solution is to get rid of the housing altogether. Exactly that has been done with the Nikonos camera, a versatile viewfinder camera that looks much like an ordinary 35mm camera but is watertight and pressure resistant. The Nikonos can accommodate 15mm and 28mm lenses that are specially designed for underwater use only, as well as watertight 35mm and 80mm lenses that can be employed either above water (in a driving rainstorm, for example) or below. Some models offer automatic exposure control and will accept an

electronic flash that regulates its light output automatically for proper exposure. All models accept extension tubes for close-up work to magnify small animals and plants in the water; with them, magnifications up to life size are possible underwater.

Yet even with the finest equipment, underwater photography is full of uncertainties. The number of suspended particles and the amount of yellow pigment in water change so much from place to place that there can be no such thing as perfectly accurate and universal exposure tables, flash-guide numbers, or rules for the use of color-correction filters. A light meter, either in the camera or in a separate housing, is a must. And water affects light in so unpredictable a fashion that the photographer should take out some insurance by bracketing his shots.

The underwater realm must be approached with proper caution and humility. Besides all the photographic liabilities, there are physical dangers to the photographer himself — the bristling spines of sea urchins; fire coral whose touch can produce a painful burning sensation; sharks and stinging jellyfish; and such exotic killers as the stonefish, whose 13 dorsal spines are hypodermic needles filled with deadly poison. But after learning what to avoid, a diver can easily spend a lifetime learning what to look for — the intricate life styles of the creatures of a coral reef, the fauna that have perfected the art of camouflage, the tiny color displays of coral polyps and nudibranches and other fragile forms of life. Once seen, this world offers the photographer irresistible temptations, repaying him a thousandfold for whatever obstacles he has to overcome. □

How the Aquatic Experts Work

Undersea photography with flash is like alchemy come true. While the medieval experimenters failed to find the magic key that would transmute lead into gold, an underwater photographer has but to fire a flash bulb, flash cube or electronic flash unit and the touch of light will briefly turn a blue-green world into an extravaganza of color. There is nothing faked about the transformation. The pigments for such hues as those of the vibrant queen angelfish at right are there to begin with; they lack only a full spectrum of light to reveal their presence.

How beautifully that spectrum can be supplied by flash is indicated in the eight pages that follow. All the photographs were taken with flash but the techniques sharply diverged, resulting in dramatically different images. The shot at right was made by panning a flash-equipped camera—a motion-picture method that must have seemed natural to the photographer, Leni Riefenstahl, who is best known for her movie work in Nazi-era Germany.

Many underwater photographers use relatively simple equipment that lets them shoot the same way nearly every time. They concentrate on close-ups, getting good composition and rich colors. For the pictures on pages 151-153 and 155, Douglas Faulkner focused on a subject nearby, between 12 and 20 inches away, using a supplementary close-up lens and a Number 5 flash bulb. Anne Doubilet used a special close-up electronic flash unit held at arm's length for her picture of soft coral on page 150. She shot with an underwater 35mm camera having an extension tube connected to a wire frame guide like the one on page 110, which allowed her to frame accurately and to control camera-to-subject distance.

A greater, more varied range of pictures is made underwater by photojournalists who go down with what amounts to a subsea studio, taking along several types of cameras, lenses and accessories. David Doubilet, a regular contributor to the *National Geographic* magazine, has dived with as many as two special underwater cameras, two or three conventional SLRs with wide-angle and normal lenses in special housings, and three electronic flash units.

With such equipment it is possible to obtain candids underwater, such as the picture of Doubilet's wife, Anne, with a school of spadefish that unexpectedly swam into the scene *(page 137)*. And there is little limitation on the breadth of a scene. To produce the unique underwater panorama shown on page 154, Flip Nicklin used a 16mm wide-angle lens with a 170° angle of view and a special underwater strobe unit.

The brilliance of this 17-inch queen angelfish, swimming 50 feet below the surface, could be revealed only with flash—at that depth water has absorbed most of the yellow color in sunlight. The fish swims so fast that the photographer had to follow it with her camera, blurring the background. The picture appeared in a 1978 book about coral gardens by Riefenstahl, who took up underwater photography when she was 71 years old.

LENI RIEFENSTAHL: *Queen Angelfish, Turks Island, British West Indies,* 1976

Using Flash for Maximum Effect

Flash possesses an amazing ability to liberate the secret beauties of the blue-green underwater world, but one caveat should be borne in mind. If a flash unit is mounted on or held close to the camera, part of its burst of light will be reflected back to the lens from the nearest suspended particles that always seem to be present in sea water. As a result of this backscatter of light, the picture will appear as though it had been taken during a snowstorm. One remedy is to photograph as close as possible, thus keeping the number of particles to a minimum. Another solution is to prevent the light rays from passing immediately in front of the lens by positioning the flash unit off to one side of the camera.

However, the position of the flash unit ought not to be dictated by purely defensive considerations. Just as a studio photographer deploys his floods and spots to create highlights, to soften shadows or to generate other shadows for dramatic effect, the undersea photographer can wield his flash unit to make the most of his subject. Even though both of the pictures shown here were shot from within a foot or two of the subject, the photographers used light from different angles to accentuate features characteristic of each coral type, revealing overall pattern in one case and deep surface convolutions in the other.

The plantlike appearance of a soft coral's translucent trunk and branching structure was emphasized in this close-up by light from a hand-held flash unit and a straight-on camera angle. The combination produced a shadowless flattening, minimized depth and clearly delineated details of the coral structure. Shot in late evening with flash as the only light source, the picture was taken with an extension tube and a wire framing guide similar to the one shown on page 110.

ANNE L. DOUBILET: *Soft Coral Extending to Feed, Red Sea, Israel,* 1974

DOUGLAS FAULKNER: *Maze Coral, Palau, Caroline Islands, 1967*

Toplighting and a 45° camera angle were used for this portrait of maze coral. The shadows cast across the coral clearly display the cleft surface structure of this Pacific species and impart a strong three-dimensional quality to the picture.

DOUGLAS FAULKNER: *Formosa Jellyfish*, 1966

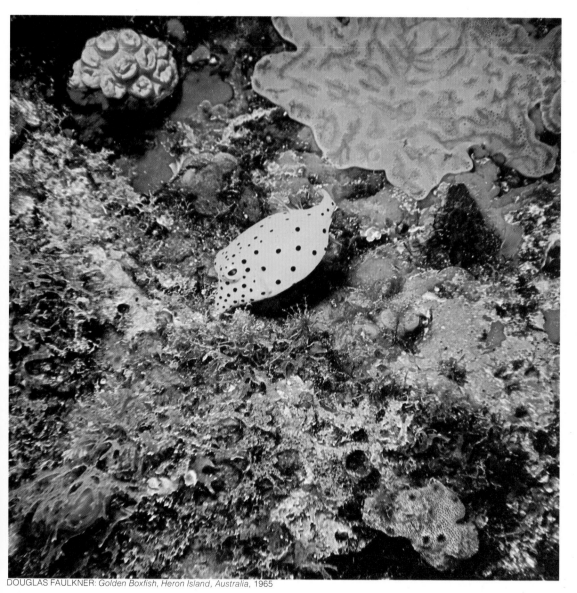

DOUGLAS FAULKNER: *Golden Boxfish, Heron Island, Australia,* 1965

Underwater, as on land, the background can spell the difference between a merely satisfactory photograph and a stunning one. A creature as photogenic as the boxfish at left, an impressive subject in any surroundings, can make an even better picture when it is captured swimming past some spectacular underwater scenery that provides a bonus of color. On the other hand, an animal that is as intricate and as subtly hued as the jellyfish shown opposite is generally best photographed isolated against a backdrop of total darkness.

The choice of background often depends on where the photographer finds his fish and what sort of flash equipment he is using. If the fish is swimming near the bottom then a single flash will illuminate both fish and background. Away from the bottom, where there are no surfaces nearby to reflect light, a single flash will illuminate the subject but the background will be black.

With its chunky shape, bulbous eyes and bright polka-dotted skin, a golden boxfish is one of nature's more outrageous creations. But when photographed swimming along a colorful sea bottom of coral, algae and tunicates, it becomes the central character in an unexpected fairyland. The picture was taken at a depth of 40 feet in clear water off Australia and one flash illuminated both the subject and its nearby background.

153

*To encompass the broad panorama of this lush
kelp forest, an extra-wide-angle lens—16mm—was
needed. But no undersea flash unit produces a
light beam that wide. To get enough light,
the photographer stayed near the surface and
shot directly into the sun, using rays of sunlight
as his primary light source and the flash as a
secondary, or fill, light.*

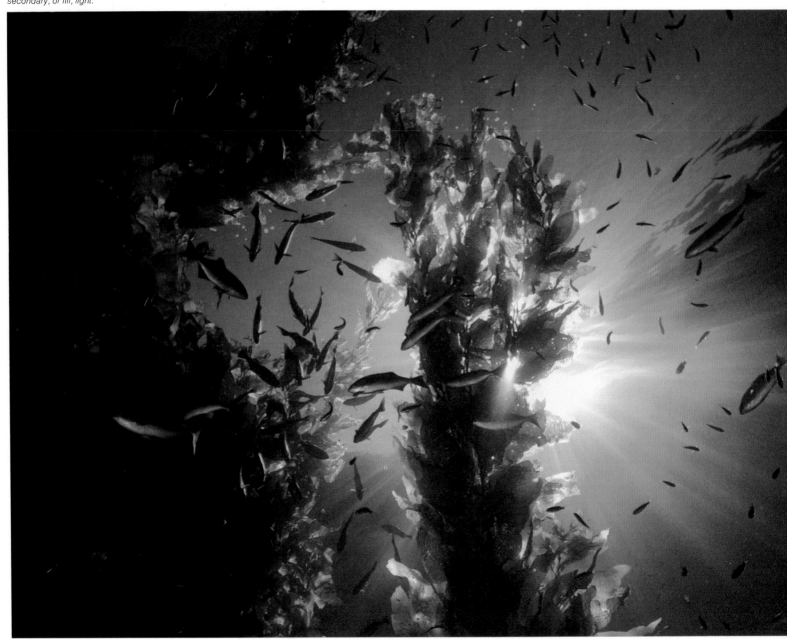

FLIP NICKLIN: *Kelp Forest with Fish, San Clemente Island, California, 1978*

Combining Natural and Artificial Light

DOUGLAS FAULKNER: *Jellyfish in Sunlight, Palau, Caroline Islands, 1969*

The strong direct rays of sunlight passing through this jellyfish floating five feet beneath the surface of the Pacific made it look almost as transparent as glass. Although flash was used as a fill light to record the shape and solidity of the creature, the preponderance of sunlight required a full stop less exposure than shown on the meter.

By itself, indirect sunlight can give sufficient light for picture taking as far as 35 feet below the surface, but even there flash is often needed to illuminate detail in shadow areas. Special exposure compensations are called for.

To balance flash and indirect sunlight, give the flash-lighted areas the equivalent of one stop less light than the sunlighted ones. To do this, set the camera for the aperture its meter indicates as correct for exposure by sunlight alone. If the sun itself is in the scene, as it is here, its brightness will distort meter measurements — angle the camera or meter to keep the sun's rays from shining directly into the light sensors.

With the camera properly set, consult the flash guide number table (corrected for underwater as explained on page 144); from the table, select the aperture one stop wider than the camera's and divide it into its corrected guide number. The result of this calculation will indicate how far from the subject to hold your flash so that shadows receive enough extra illumination to bring out their colors but not so much as to create an imbalance with the natural light.

Guarding Against the Dangers of the Deep

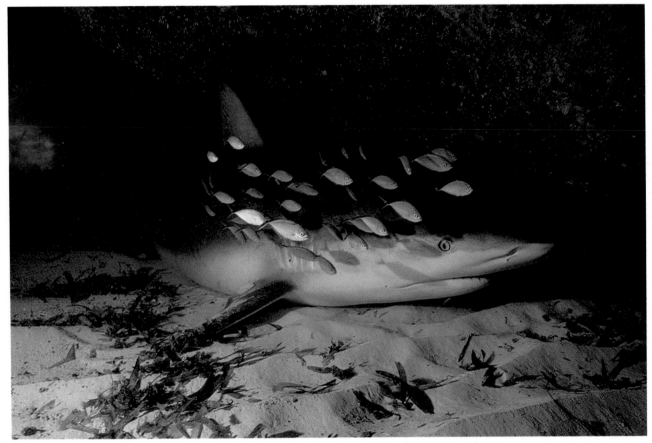

DAVID DOUBILET: *Springer Shark with Barjacks, Yucatan, Mexico,* 1974

Although the nature photographer can stalk large dangerous animals on land with minimal risk to life and limb *(pages 159-179),* he cannot do the same underwater. Not only is he encumbered with equipment and slowed down by an alien element, but he must get close to his quarry — the sea is too murky for telephoto lenses to penetrate. Many professionals work only within a cage, leaving its protective confines only under favorable circumstances for such an exceptional opportunity as recording a shark resting in a completely motionless state.

Before entering unfamiliar waters, amateurs should check with local fishermen and owners of diving-equipment stores, who will usually know if there have been recent sightings of sharks or other large predators. A local underwater guide can point out more common hazards such as tricky currents and stinging corals.

Sharks normally have to stay continuously in motion to keep fresh supplies of oxygen-bearing water rushing over their gills. For this rare shot of one, seemingly comatose, on the bottom of an underwater cave, the photographer made 80 dives over a two-year period. While moving cautiously to avoid arousing the nine-foot predator, he waited until a school of barjacks passed by in formation before making his exposure.

Wild Animals, Free and Captive 5

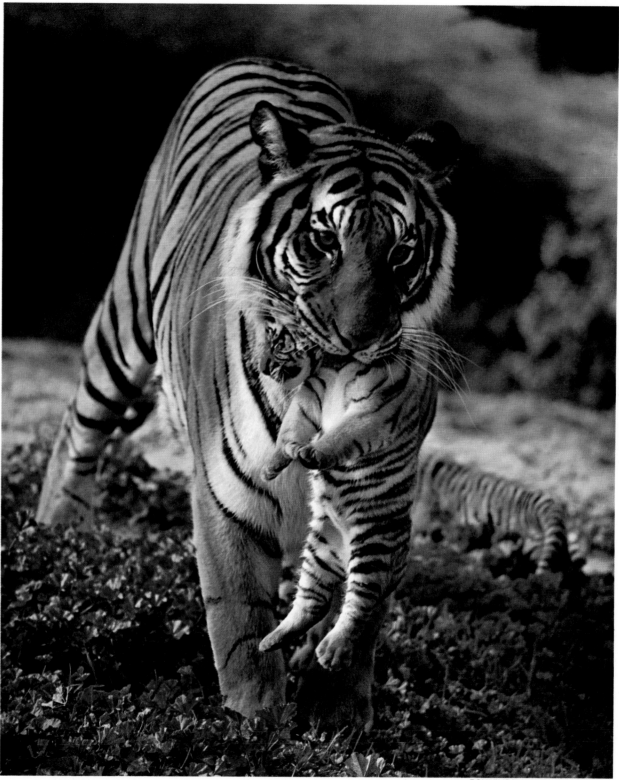

RON KIMBALL: *Mother and Cub*, 1978

Trophies from a Photographic Safari

Although I am writing here specifically about animal photography in Africa, much of what I say is applicable to other places. If you are not about to go to Africa, you may still get ideas that will be useful next summer in Yellowstone Park or the Everglades, or even on a lakefront near your home.

The company you keep

If you plan to take pictures of animals on a trip into the wild, try to travel only with photographers. If it is an arranged trip such as a safari, it is worth some effort to find out in advance as much as you can about any group you may join. Sign up with an outfit that not only bills itself as a photographic one, but also makes an honest effort to accommodate photographers by keeping its numbers small and limited to people who really want to take pictures. Otherwise you will be under constant pressure from nonphotographers in the party to move on, which means you will be rushed in your picture taking, and the results will show it.

Cameras

For me the 35mm single-lens reflex is the only camera that makes any sense on a field trip. Its lightness, ease of handling and lens-interchangeability make it the choice over any other type. If you already own a larger camera, if you do not mind its bulk, and can work well with it in fast-moving situations, then by all means take it—but only if long lenses can be fitted to it. If they cannot, leave it at home, because the majority of your pictures will be taken with such lenses.

On any long journey away from civilization take two camera bodies. If one breaks down, you will have a spare. And with two, you can keep one loaded with black-and-white film, the other with color. Or, even more convenient, you can keep a short lens on one and a long lens on the other. Be sure your second body is the same make as your first and has the same controls in the same places; then you will never have to fumble for them when shifting from one camera to the other. Most major companies offer different camera bodies that will accept the same lenses and accessories. For your second, buy the cheapest compatible body that the manufacturer supplies. There is no sense in spending money to duplicate all the features of your first; however a camera body that controls exposure automatically is a valuable convenience when animals are moving quickly between sun and shade, or in rapidly changing light, as at dawn or dusk.

Focusing devices are often a problem when using long lenses. They admit less light than lenses of normal focal length, so the image on the viewing screen may be dim. And, because of their shallow depth of field and their high magnification, a slight error in focusing may be disastrous. Finding the

This article, with the accompanying portfolio and its notes, is the work of an amateur photographer, Maitland A. Edey. It is presented here to show what a nature-minded photographer who is willing to think about his pictures and work at them can accomplish in this field—in this case, in that mecca for nature photographers, East Africa.

To be sure, Edey is not exactly a casual tourist. He is a naturalist's naturalist, editor of the LIFE Nature Library and author of The Cats of Africa. But at the time he took these pictures, his photographic career had been relatively brief. The first photograph he ever took was on an African safari in 1962; he had never handled a camera before. Predictably, many of his early efforts were failures, but the opportunities were so good that he came home with some fine shots in spite of himself. Now he carries a camera on all vacations and trips, where his safari experience is invaluable, but he is still convinced that for sheer eye-popping excitement and opportunity, there is nothing in the world of nature photography to match a few weeks in East Africa's game parks.

Campers in Tanzania's celebrated Ngorongoro Crater relax under an enormous fig tree as herds of zebra and wildebeest graze in the background. A normal lens included enough of the tree to give an idea of its size without forcing the photographer to move too far from the campers. Exposure was a compromise between sun and shade readings.

sharp point with such a lens, particularly late in the afternoon when the light is low—and most particularly after a long day's shooting when the eyes are tired—is sometimes very hard. If you have had difficulty of this kind, discuss it with your camera dealer to see if a special low-light viewing screen can be fitted to one of your camera bodies. If you are shopping for a new camera, I would recommend your putting viewer-brightness high on your priority list. It is important in nature photography.

Lenses

This may sound like madness, but if I could take only one lens on a wilderness field trip, it would be a 300mm. It is the one I find myself using most of the time. To prove its exceptional usefulness in many different kinds of wildlife situations, the picture essay that follows has been made up almost entirely of photographs taken with that single lens.

Wild-animal photography, whether of lions or raccoons, absolutely requires a long lens. The problem is cost, which goes up rapidly with focal length. Many photographers already have 135mm lenses. If you have one, take it along, together with any others you have, for lenses take up little room. But for close-ups, something bigger is needed. The 300mm is the ideal; 200mm often cannot bring you quite close enough, and 400mm begins to get unacceptably heavy and very expensive. If you must have such great magnification, consider the more compact, less costly mirror lenses, available in focal lengths of 250 to 1,000mm.

Two other alternatives to the conventional long lens are zooms and converters. Well-made tele-zooms of approximately 70 to 200mm size almost equal the optical quality of comparable fixed-focal-length lenses. One can take the place of a whole set of conventional lenses, and it allows you to compose, crop and follow action without removing your eye from the viewfinder. Matched teleconverters can be fitted to such a zoom, doubling or tripling its effective focal length—but also reducing its speed by the same factor.

Although a good tele-zoom, with or without a converter, is such a handy and versatile tool that it would probably see a lot of use on a wildlife safari, it still cannot match the sharpness of a fixed-focal-length lens. For my own long lens I would still choose a good conventional 300mm. I emphasize "good." A poor lens, no matter how cheap, is worthless. Buy the very best you can afford, and if you must compromise, always give up something in speed in exchange for high-class optics.

If I were limited to two lenses, I would add to the 300mm the 50mm normal lens that usually comes with the camera. My third lens would be a wide-angle one, either 28mm or 35mm (although there are quite good zooms that cover the 28 to 85mm range). My fourth would be a 105mm or a 135mm—all of

them, if possible, from the same manufacturer. You will get an argument that a wide-angle lens is almost never used in the field. On the basis of my safari experience, I disagree. Shots in and around camp, especially those into which dramatically large foreground objects can be worked, scenic shots made in gorges and other narrow or close positions — these and many others are possible only with a wide-angle lens, and they lend variety to your take.

Other equipment

Light meters. You probably have meters built into your camera bodies, but take a spare in case of breakdown. Use it periodically to check the other meters.

Motor drives. These accessories automatically wind film and cock the shutter to enable you to shoot two to five frames per second — handy for catching predators squabbling over a carcass or birds in flight. However, their noise can frighten animals within earshot.

Lens hoods. You will be shooting into the sun a lot and will need them. If you have bought all your lenses from one manufacturer, then most of them will accommodate the same lens hoods and filters — a great convenience.

Skylight filters. Take one for each lens. It protects the lens from dust, and it can be wiped clean without the worry of scratching. If its surface gets marred, it can be replaced for a couple of dollars — not so with a lens.

Extension rings. If your lens is not the macro type that focuses very close, extension rings — which fit between the camera body and the lens to permit focusing for extreme close-ups — are worthwhile additions that cost little and take up almost no space. I use a single adjustable ring that enables me to get life-sized views of insects, flowers and the like with my 300mm lens.

Extra batteries. Do not count on being able to find them wherever you go.

X-ray proof bags. These lead-lined bags will protect your film from airport security detectors. Many airports around the world will not check your film by hand, insisting that everything go through the X-ray machine.

A watchmaker's small screwdriver. The constant vibration of an automobile engine, to say nothing of travel over rough ground, may loosen camera or lens screws. This has happened in the film advance of one of my cameras. Without a screwdriver, the camera would have been inoperative.

Two cable releases. You may lose one.

A roll of black masking tape. It provides an easy fix for light leaks in broken or bent bodies.

Lens-cleaning paper and fluid.

Film

For black and white, choose a fast film, ISO 400/27°. It will have an acceptable grain structure and will be fast enough to be used in near darkness. For desert,

seashore or tropics take along a neutral-density filter in case the midday sun is too bright for the aperture and shutter speed you want.

For color slides and prints, take the film you know and like best, and stick with it. I use fine-grain film, ISO 25/15°, because I am familiar with it and am willing to put up with its slow speed in order to get the richness of detail and good color balance that it provides. Also, it is not all that slow. The pictures on pages 176 and 177 were made at f/4 just after sunset, and yet the film was able to stop the movement of a frisky young hippopotamus pretty well.

There are, however, color slide and print films that offer much more speed with only a moderate increase in graininess; if you value the flexibility that faster speed will give you, then use faster film—many professional photographers do. But do not switch around; it is best to stick with the film whose characteristics you understand.

Never leave any kind of film in the sun, and never take it out of the cardboard box until you are ready to use it. Try to find a shady corner for a film change; never do it in direct sunlight. Always put the exposed roll in the can that the new roll just came out of. Do it immediately. That way, you are never in any doubt as to what a particular can contains—if it is in a box it is new film; if not, it is used. Canning the rolls also helps keep your exposed film moisture- and dust-free. Back in camp, put your exposed film in the bottom of your suitcase and leave it there. That is the coolest and safest place for it. If you are traveling overseas, do not try to have film processed there, even though you may be away from home for some time.

Spend film! Considering the cost of your equipment and the time, money and distance often involved in getting you to wherever you are, it is downright stupid to be chintzy with film, particularly color film. Color tolerances are narrower than black and white, and it pays to bracket exposures. Do not waste film by popping at random as you go, but when you find a subject with potential, milk it.

When I have a couple of lions in a good setting, I often shoot half a roll or even a full roll on them, using different poses, different angles, different combinations of aperture and shutter speed, even different lenses. What you want is one good picture and if you are as uncertain as I am about exact exposure factors, you will be thankful when you get back home for the bracketing you have done. Furthermore, that one subject may end up producing three or four superior pictures that stand on their own.

Keep an eye on your film counter. If it shows only three or four frames left on a roll, and you suspect that something interesting is coming up, forget about those last few frames; change the roll. Otherwise you may catch yourself with the back of your camera open just as the action breaks—a priceless opportunity missed in an attempt to save a few cents.

Upkeep

Check out all your equipment before you leave home. If it has not had a professional going-over in some time, it is worthwhile taking it to a camera service shop for tests of meter and shutter-speed accuracy and lens condition.

In the field, dust, heat and vibration will be your principal problems. I deal with the former by conscientiously following a rule that so far has saved me from any malfunction due to dust. I keep a lens cap and rear cover on every lens all the time, except when the lens is on a camera. For a lens change, it takes only a moment to remove these and put them on the lens being replaced. Anything I am not actually using I put back in the camera bag, and I throw a sweater or jacket over the bag rather than bothering to zip it up. Zippers may jam, and if you cannot get into the bag as the herd approaches. . . ! Dust also gets through zippers more easily than through thick cloth.

In a car I try to keep the camera bag on the floor and in the shade. I never put it up on the shelf behind the back seat, where it will almost certainly be exposed to sun. If you are traveling in some sort of field vehicle like a Jeep, Scout or Land Rover, the rough cross-country trips may jounce the bag to the floor, so put it there in the first place. Cut a piece of inch-thick foam plastic to place in the bottom of the bag. This will soften the shock of all but the worst bumps you hit — and you will hit a lot of bumps.

Make a habit of devoting some of your down time, during siesta or after supper, to sorting out your equipment — which may have become rather jumbled during the excitement of the day — and to cleaning the dust from lenses and viewfinders. I find that blowing briskly, followed by rubbing gently with lens paper, will do the trick. A bit of lens paper wound around the end of a toothpick will get dust out of the corners of a viewfinder.

Lighting conditions

In the morning, the first hour after sunrise is the best time for making pictures. The animals are at their most active. The light is warm and low, with interesting long shadows. There is a freshness and dewiness that disappears as the sun goes higher. Exposures will change very fast early in the morning (particularly in the tropics, where the sun comes almost straight up). Keep checking camera settings as you shoot — aperture, shutter speed and depth of field may not be what you thought they were.

Midday photography in mixed sun and shade is very difficult. The contrasts are extreme and the shadows hard. But beautiful pictures can be made in shade, just because of the great amount of light that is bouncing around.

If the weather is right, late afternoon is the best time of all for pictures. Although I have been able to find no scientific reason for it, the afternoon light seems to be warmer than it is in the morning, producing magnificent tones of

deep gold on plains and escarpments. I noticed this golden effect particularly in the Masai Mara Game Reserve in southwestern Kenya, where the topography produces local thundershowers that clear the air and often provide dramatic dark backgrounds for all that rich sun. In such light animals stand out realer than real. But remember, the light is skidding away fast, and you must keep an eye on exposure settings.

Holding steady

Most of your work will be done with your longest lens, which produces such a magnified image that the slightest camera shake blurs the picture. I have found that, even at 1/500 second, I get perceptibly sharper pictures by resting my 300mm on something, rather than hand-holding it. At 1/250 I refuse even to try to hand-hold, although I know photographers who claim they can get acceptable hand-held pictures at such speeds. My advice is: Always use a rest unless you are panning on a moving animal or bird. Since you will probably be shooting from the window or roof hatch of a vehicle, there is no reason not to support your camera. The best support of all, quicker than a tripod and just as resistant to camera motion, is a simple beanbag or sandbag. Put the bag on the car's roof or window sill, and settle the camera firmly on the bag, holding it down and guiding it with one hand while you operate the shutter and film advance with the other. A little practice will enable you to frame and focus, and also hold the camera rock-steady — all with the left hand. If you cannot locate a beanbag, then use a folded coat or sweater; either will do nearly as well.

Whether you take along a tripod depends on the kind of trip you are making. If you remain in the car, you may not need one, for you can always rely on the vehicle itself for support. (Conventional tours in Africa stick to game parks whose rules forbid visitors to get out of vehicles.) But if you are going camping, you will probably be doing a lot of walking in interesting wild country — sometimes in flat places without a handy tree or rock pile anywhere nearby. So for campers and hikers I do recommend a tripod, and with it a small universal-joint attachment to go between tripod and camera.

Technical notes

The pictures that follow were all made on Kodachrome II film, with Pentax cameras and (except for two shots) a 300mm f/4 Takumar lens. ☐

First Principles, Including Patience

The shot that you will find yourself making over and over again on any nature trip is a portrait of an animal just standing there. At first, the thrill of being able to get right on top of your subject is reason enough to begin clicking away. But if worthwhile pictures are to result, you will have to begin thinking about how to elevate that moose or antelope shot into something more than just a statement that the animal was there and was photographed.

There are two basic ways of attacking this problem. The first is to settle for a portrait, but try to make it interesting. For example, the body surface of a lion, notably the heavily maned head of a male, is utterly unlike the leathery covering of an elephant or a rhino. A picture of any animal should be lit to bring such features out—and low-angle light is most useful. It is not merely a matter of color, but of texture, which can be properly revealed only by tonal contrasts induced by the numerous and extremely valuable small highlights and shadows that soft, low light produces. Take a look at the elephant shown on pages 178-179 and note how low-light shadowing has brought up the mud caked on its head and the veins in its ears. (Elephants are very hard to photograph; their hides are dull gray and soak up light monotonously unless it is coming from a usefully low angle.)

The potential in low light jumped out at me the first time I began photographing a lion under these conditions. Its mane responded magnificently to sidelighting or to backlighting—particularly against a dark background, as in the picture at right.

Obviously a good pose will help any portrait. With herbivores, this is a matter of luck, persistence and quick reflexes, waiting for that pair of giraffes to line themselves up artistically and for both to look your way at the same time. Lions are more cooperative. They are phlegmatic beasts that almost automatically fall into noble and benign attitudes, oblivious to the photographer. I have found it worth considerable effort to maneuver around a lion to get the pose and light I want. But it takes alertness: Just when everything is set, the subject may flop over on its side with a thud and go to sleep. When this happens, I get set anyway, then give the side of the Land Rover a swat; the lion may just sit up again to see what the noise was all about.

The second way of building interest is to try and catch the animal doing something—eating, yawning, scratching, fighting, mating, running. Position yourself, and hope. With lions I have learned to invest some time around a pride, but only if its members seem to be waking up. I train my lens on one animal or a pair of cubs, and keep shooting as they move. I have slowly learned to synchronize my own movements with theirs, and am getting better at capturing moments of action. I am also learning to build interesting sequences, not only of lions but of seemingly unpromising animals such as hippos *(pages 176-177)*. The key to success is patience, and more patience.

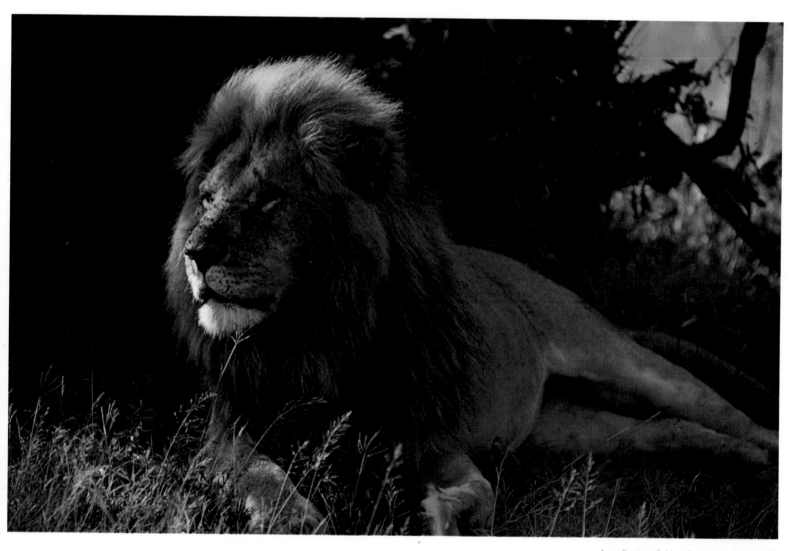

Low direct sunlight on the mane and beard of a lion — against a dark background — gives this picture its snap. Luckily the lion was a magnificent specimen that obligingly held a regal pose while I got the angle I wanted — enough to suggest the far side of the face but not enough to lose the contour of the nose. Low light also brings out the flies on the nose. I hoped to find a highlight in the eye, but the lion was too sleepy; his brow sagged too low.

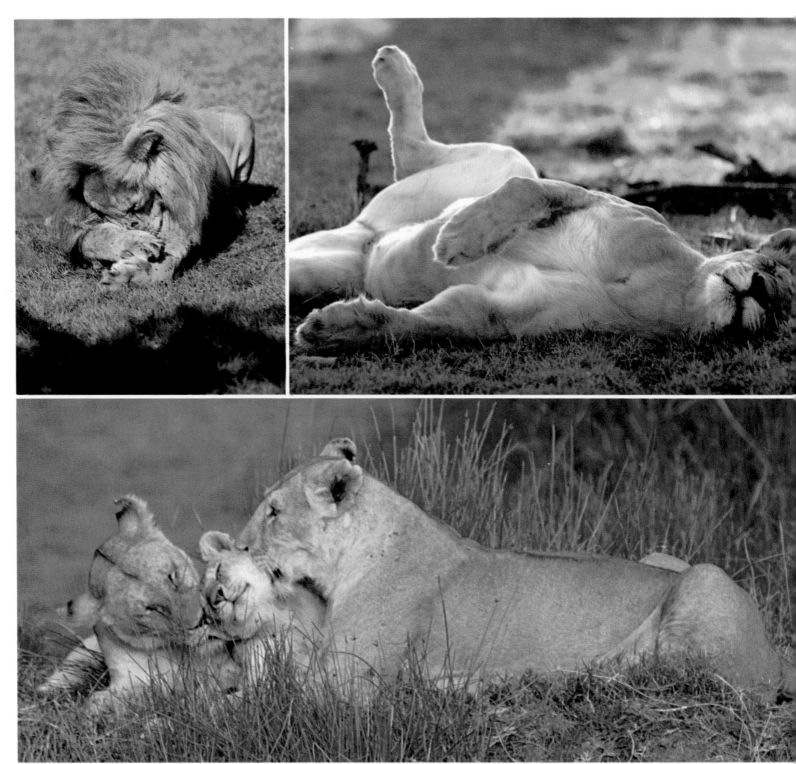

Some of the activities that can be recorded by hanging around lions: rubbing a sore nose, rolling, licking an ecstatic cub, an elderly clubman taking a snooze in the club lounge.

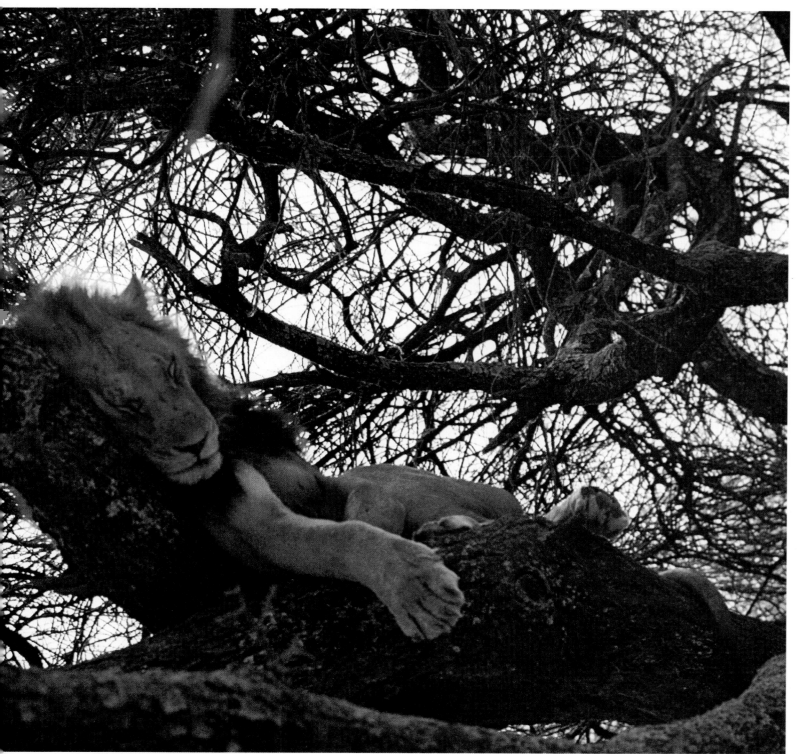

All these pictures were taken with different lighting, the best being that in the shot of the rolling lioness —low sun that backlighted edges to convey the furriness of legs and undersides.

Overcoming Difficulties Posed by Birds

Birds are exceptionally hard to photograph; they are usually too fast-moving, too small, too far away. But sometimes their appearance in certain places can be predicted and then prepared for. The picture at right of a crowd of vultures descending on a wildebeest carcass in East Africa is a case in point. The kill was there. It was certain that vultures would come to it, and they did. They were so intent on the food, scuffling about in a very confined area, that I was able to get quite close and had time to focus carefully—a must for an action picture like this.

Other birds' activities are also predictable. The garbage dumps behind safari lodges often lure marabou storks, such as the one caught scavenging in the picture opposite. Kingfishers and bee eaters return to certain perches over water, fish eagles to favored trees, sunbirds to their nestlings. Water birds such as egrets, flamingos and pelicans come in flocks. It is sometimes possible to approach them where they congregate at water's edge, and get a picture just as they take off or while they are circling.

But in bird photography you need not shoot strictly for the birds. It is possible to work around them, to photograph odd-shaped nests and even do scenic shots in which birds merely provide enriching elements. (An entire picture essay on bird photography begins on page 56.)

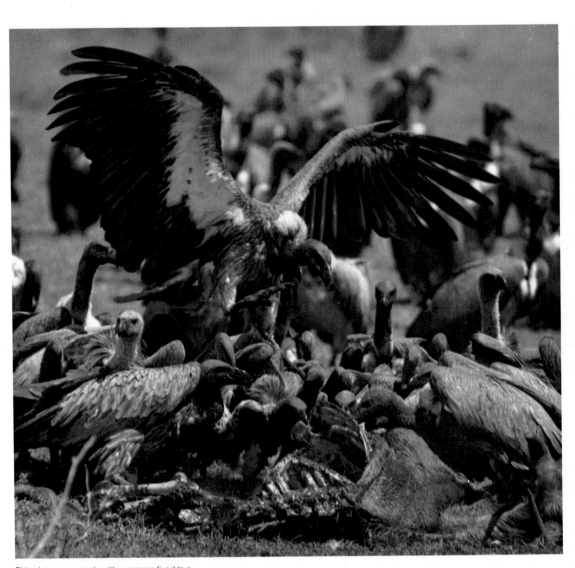

This picture was made with a camera fixed to a mount in a Land Rover. Thus it was possible to frame and focus with great care, then take my eye from the viewfinder so that I could see the entire scene, and trip the shutter at a moment of peak action. I was lucky to catch a bird about to land, freezing it with a 1/500-second shutter speed.

In photographing the nest of a spectacled weaver above, I used a 300mm lens to take advantage of the long lens's limited depth of field and to be able to isolate the nest. The palm fronds nearby turn into graceful blurs, as does the background, which is actually the muddy surface of the Mara River.

◀ The marabou stork at left was a moocher at Serengeti's Seronera Lodge and did not mind a close approach. In photographing long-billed birds close up, try to get them with their heads turned. Otherwise, when you focus on the eye—as you should—the end of the bill may blur slightly.

How to Photograph Herds

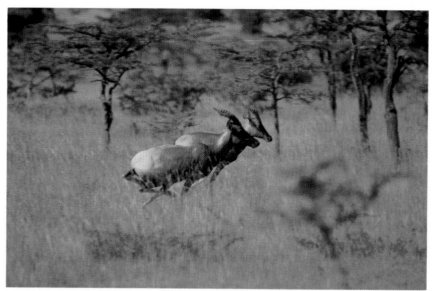

◀ *A slow shutter speed—demanded by the very poor light—managed to stop this herd of moving animals. The high viewing angle has spread them through the picture, which would have been less successful if shot from ground level.*

Antelope, as soon as they sense danger, run. They zip past constantly, and your efforts to capture their motion can be directed either toward panning—with its attendant problems of sharpness—or else toward focusing in advance on a spot you think the animals will run through, and tripping your shutter when they enter the viewfinder. This picture was made the latter way.

One of the features of open country is the immense herds of grazing animals that may inhabit it. If you are lucky enough to catch a sizable herd in migration, you may get some fantastic pictures, but only if you can photograph from an elevation. Down low, even a group numbering hundreds becomes simply a line of animals. Fortunately much of the world's open land is rolling. And if no hill is at hand, you can always stand on the roof of your car.

The Serengeti Plains in Tanzania, where large herds of wildebeest flow back and forth, is studded with kopjes, or hillocks. A scramble up a kopje —first making sure there were no lions or leopards denned up in the rocks —usually spread out the herd nicely before me. The picture at left was made from a low ridge in Ishasha, Uganda, over which a huge herd of topi was pouring. Luckily, the flow was to the left away from the sun, which was right on the horizon. It lit up their rumps as they trotted by, and—although a shutter speed of 1/15 second is usually too slow to stop such action—it just held them here because they were far enough away not to blur.

Finding Something Fresh to Say

The picture at left could be dismissed as a nicely composed portrait of a mother hippo with her baby. But it is really more than that; it says something about the animals that will be new to most viewers. Because the hippos have their heads close together, and both face the camera, it is possible to compare the two and to note the enormous widening of a hippo's jaw that takes place as it matures. If you are showing your slides to an audience, a picture like this can lead into an absorbing discussion of an animal's way of life, and of the reasons it needs its special physical equipment — in this case, a big mouth and teeth to handle the load of green stuff it eats.

African animals provide many such opportunities. Antelope have horns of every conceivable size and shape. The patterns on zebras are worth investigating close up, as are the rasplike tongues of yawning lions and the sweeping eyelashes of ostriches. Ostrich eyelashes? Yes, I managed to photograph them in a center for ailing animals in the Nairobi National Park. Do not turn up your nose at photographing captive or tame animals *(pages 180-196);* they often provide better opportunities than wild ones.

The picture above is the only one in this essay (apart from the photograph made in camp) that was not made with a 300mm lens. It was taken from only a few feet away, with a wide-angle 35mm Takumar stopped down to f/11 to get good depth of field at a short distance. The picture is a little underexposed, but it brings out details of the hairlike feathers that grow on the heads of ostriches, giving them what seem to be sweeping eyelashes — something other birds lack.

These normally aquatic hippos were gently nudged ashore by a motorboat for an unusually close shot. And the female hippo obligingly turned its head so that I caught a view emphasizing the difference in physiognomy between adult and young.

Building Sequences to Tell a Story

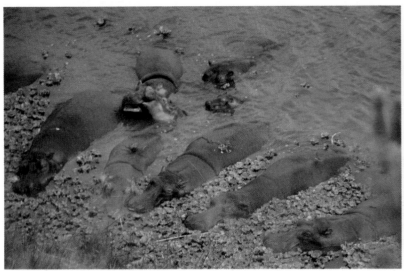

Ready for play, a young hippo nibbles gently at the lips of a friend, while the adults continue their snooze. Hippos can usually be found snoozing in water or mudholes during the day, and come ashore to do their feeding only at night.

Deciding to do a little dog-paddling, the youngster rears up and waves its front legs energetically. The rolls of loose flesh and fat built up around its neck are clearly visible in this photograph.

I have made sequences of lion cubs scuffling over their mother's nipples, prides waking up and going off to hunt, but never anything quite as unusual as this short story of a young hippo skylarking in the water. Any one of these pictures, by capturing something that is not often observed, would have made a shot worth keeping. By staying with the action to get a variety of nip-ups by one of the little hippos, I was able to build to the climax of its act: a backward somersault in the water *(far right)*.

Equally important in underlining the friskiness of the youngster is the comic immobility of the grownups, which lie there like sunken barges, paying no at-

tention whatsoever to all of the antics around them.

One picture could not possibly have revealed this monumental inaction; a sequence does it well. Obviously, those adults have been here for quite a while, nosed into the bank, a stray festoon of Nile cabbage on the back of one, a spatter of bird dropping on another. In the third picture a sandpiper lights briefly; still the animals pay no attention.

This strip also proves the value of being prepared at all times to take pictures. You never know, when photographing animals, exactly what will happen next — or when or where. I *always* carry a camera, right up to night-

fall — a tripod too if I am walking. And I make a habit of checking shutter speed and f-stop periodically against the meter reading as I move about, so that in case something suddenly starts up in front of me, I can bang away without having to worry about exposure.

Thus, when I was camped on the bank of a lake channel and taking a stroll one evening, I was ready — when I looked down and saw the opportunity below me. It was nearly dark, but thanks to the tripod and that wonderful 300mm lens, I was able, at a shutter speed of 1/8 second, to get pictures. The long exposure did wash out the color somewhat, but that was a small price to pay.

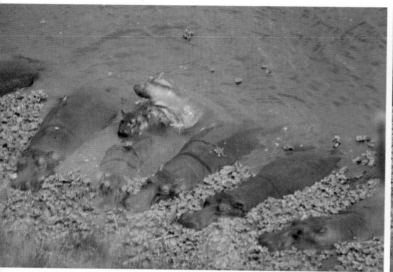

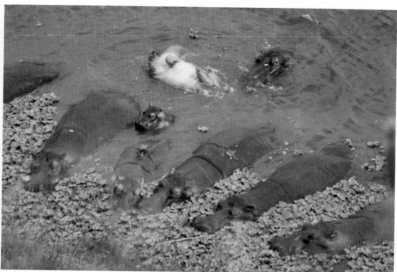

A sandpiper pauses on one adult, undisturbed by the decision of the youngster to leapfrog over its friend. This action, a bit too fast for the ⅛-second shutter speed, blurs somewhat.

With all four feet waving, the baby hippo flips over on its back. These shots were the best of nearly an entire roll. I bracketed at 1/15 and 1/30 second, but those pictures turned out too dark.

Shooting through Foliage

One of the great virtues of a long lens is its extremely limited depth of field. This not only blurs backgrounds but throws intervening twigs and leaves so far out of focus that they tend to disappear. If an animal seems hidden in foliage, don't give up. Focus on it anyway; you may be surprised by the clarity of the portrait that emerges when you preview depth of field in your viewfinder. Blurred foliage also heightens the sense of reality, suggesting that the animal has been caught unaware in its own environment. □

This oribi was so well screened that I despaired of photographing it until I focused on it. The blurred surroundings actually help the picture by concentrating attention on the animal and by suggesting what a shy little creature it is.

A low angle was deliberately chosen here to ▶ enhance the huge bulk of an elephant. This put grass in the way, but again, it improved the picture. The grass let one ear, one eye and one tusk come through, but made a menacing blur of the rest of the elephant's head.

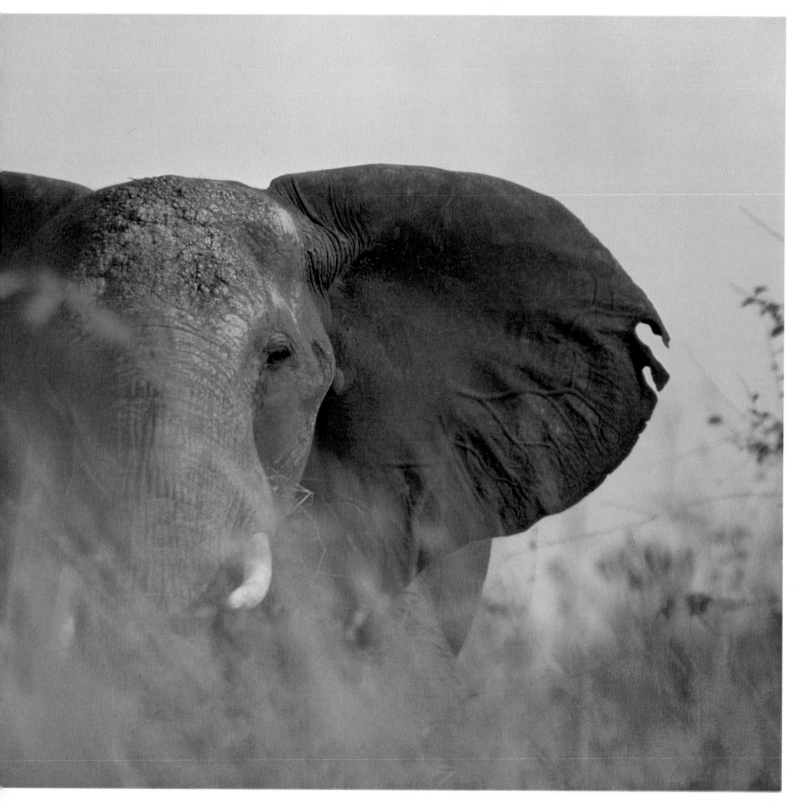

Photography at the Zoo

If you are among the vast majority of photographers who cannot go on safaris to Africa, you need not give up. There is still the zoo. Years ago, someone estimated that for the investment of an hour in time and a nickel in fare a New Yorker could see at the Bronx Zoo animals that would require 10 years and a quarter of a million dollars to see in the wild. Today subway rides cost more and safaris cost less, but a zoo is still a bargain.

Within a small area you can see everything from arctic bears to tropical snakes. The animals are easier to locate than they are in the wilderness; they cannot stalk you; they are good specimens of their kinds; and they are more or less accustomed to the oddities of human behavior. If you plan later to photograph nature in the wild, the zoo offers ideal training. Even if you do not, photographing at the zoo can be exciting and worthwhile in its own right.

It will be a more satisfying experience if you consider ahead of time the problems of zoo photography. In traditional zoos, for example, animals are kept behind bars. But by careful planning of angles and lighting and the proper use of your equipment, you can minimize or obliterate the telltale signs of imprisonment. Or you can find views like those on pages 182-183 that put the man-made environment to good use. In the newer zoos you can walk or ride among the birds and the animals. But with this new accessibility come new problems—keeping a protective moat out of the picture, or detecting the animal despite its camouflage.

The more you know about an animal, the better your pictures will be. Zoo animals live under artificial conditions, and their behavior often differs from that of creatures in the wild. The differences can provide a picture that is more interesting than what you would get in the forest. A raccoon, for example, washes its food when in captivity. In the wild it fishes for food, and the rinsing is an adaptation of the fishing instinct. Thus in a zoo you can get a picture of a raccoon you could not get in the wild.

Watch the animals' daily routine, and learn what to expect at different hours. Some animals grow restless as feeding time approaches; their movement—and the feeding itself—can provide good action photographs. Most animals are placid after meals and obligingly, or unwittingly, sit for their portraits.

Nearly any type of camera will work under such controlled conditions, but most photographers prefer the 35mm single-lens reflex because of its versatility. Besides a normal lens, you will require a wide-angle lens (28 or 35mm will do) and a long one (perhaps 200-300mm) or a medium-to-telephoto zoom such as an 80-200mm. Close-focusing macro lenses are particularly useful for small animals, which can be photographed at remarkably close range.

Animals in outdoor enclosures generally can be taken in natural light, but indoors you are likely to need flash. Some zoos prohibit the use of flash bulbs because of the danger of popping; others place no restrictions on either flash or strobe, so long as you take care not to frighten the animals.

Last but not least, you will need patience and concern for the animals. Nina Leen, who took several of the pictures shown here, talks to her subjects constantly while she is photographing them on the theory that "every animal is trying to communicate with humans, if the humans are willing to get to know him."

Nowhere but at the zoo can you get a portrait like this; such an exotic snake can be found only in remote areas, and even there it would be elusive and hard to see. Nina Leen got this one, an Indian tree snake, shown here life size, at the Bronx Zoo. She lit the scene with a small strobe unit and shot with a 35mm camera fitted with a macro lens, a device favored by many photographers for its versatility. It can take everything from a close-up to a long shot with just a twist of the focusing ring, and is therefore useful in photographing creatures that move rapidly about.

NINA LEEN: *Indian Long-nosed Tree Snake*, 1962

Putting the Environment into the Picture

FRANCIE SCHROEDER: *Bengal Tiger*, 1974

Sometimes it is all but impossible to keep unnatural elements such as the animals' enclosures out of pictures taken at the zoo. Ordinarily these surroundings may interfere with picture taking and introduce unwelcome notes of artificiality. But the man-made environment of the zoo can also lend interest or humor to images of wild creatures no longer in the wild.

In making the portrait of a Bengal tiger lounging in its outdoor cage *(above),* Francie Schroeder had to contend with the unavoidable shadows cast by the heavy bars. She solved the problem by making these reminders of the zoo part of her composition. Russ Kinne, who photographed the proud penguins opposite, chose to include in his picture as much as possible of the civilized surroundings through which the flock strutted.

The bars virtually surrounding this tiger in an enclosure at the National Zoo in Washington, D.C., created shadows that imitate the animal's stripes. To show the pattern without showing the bars themselves, the photographer stood close enough to shoot between the bars and used a wide angle to encompass the shadows.

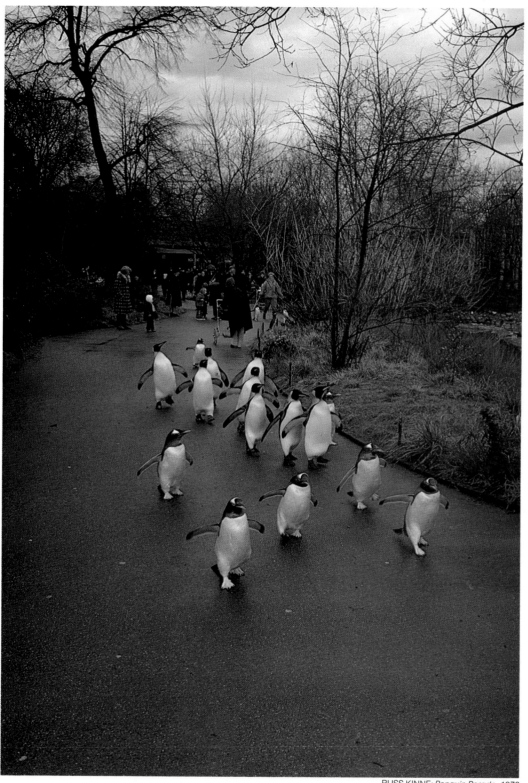

As if on a people-viewing jaunt, penguins stroll the paths of a zoo in Basel, Switzerland, free of confinement. Many other zoos occasionally allow unaggressive species that are unlikely to escape—such as peacocks, guinea fowl and wild turkeys—to roam the grounds.

RUSS KINNE: *Penguin Parade*, 1978

The Beast as a Manageable Subject

The biggest single advantage to photographing an animal at the zoo, particularly one kept in a cage, is that even the most elusive or ferocious beast is, in effect, a sitting duck. The snow leopard at right belongs to a species so rare and aloof that a photographer with unlimited time and funds could scarcely hope to catch a glimpse of it in its native Asian mountains, much less compose a finely framed close-up. But at New York City's Bronx Zoo, the animal becomes easy pictorial prey for any visitor.

The plains zebra opposite is not nearly so difficult to photograph in the wild as the leopard, but in this case the animal's confinement presented an opportunity to produce an original view of its familiar markings: The remarkable graphic effect created by the zebra's stripes against a background of new-fallen snow could have been achieved only in a captive environment—no snow falls in the animal's native African plains.

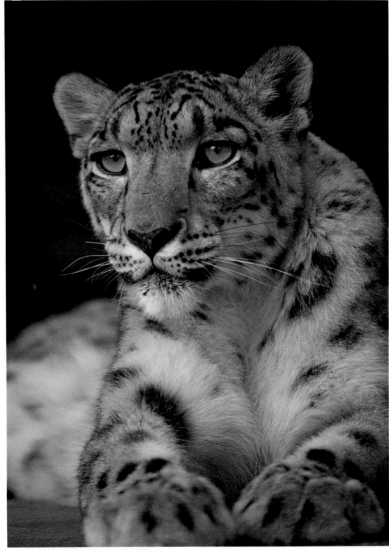

For this meditative portrait of a snow leopard at New York City's Bronx Zoo the photographer shot through the wire mesh of the animal's cage. He used a long lens and a wide aperture to minimize depth of field, thereby obliterating the wire mesh and blurring distracting background detail.

WILLIAM MENG: *Snow Leopard,* 1979

To take his unusual picture of a zebra in the snow at Washington, D.C.'s National Zoo, the photographer managed to shoot as the animal descended an embankment. Thus isolated against the featureless background, the boldly figured zebra is emphasized in a way it could never be if photographed in the wild.

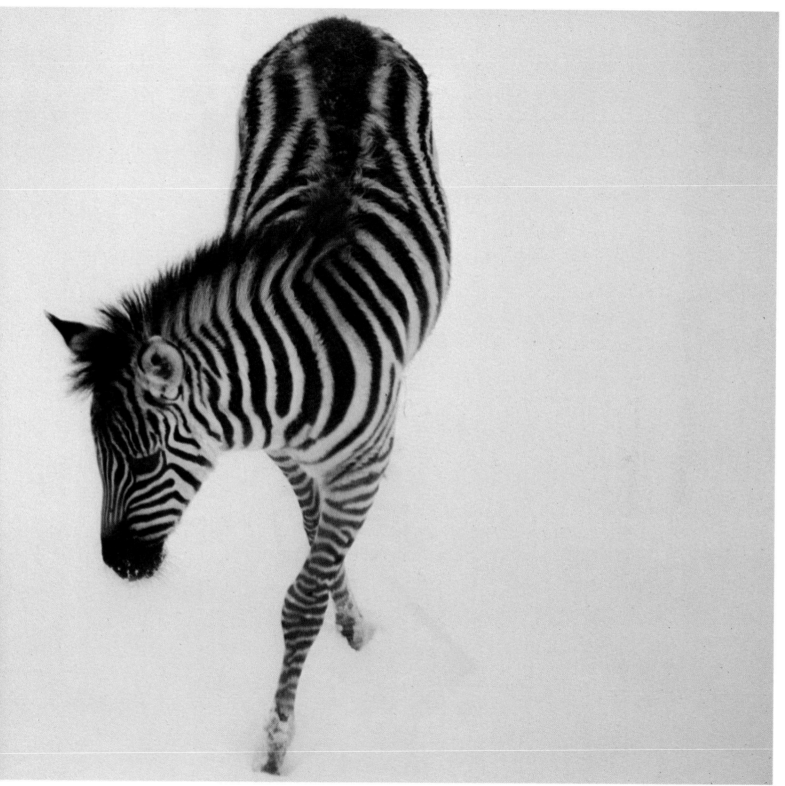

STAN BAROUH: *Plains Zebra*, 1979

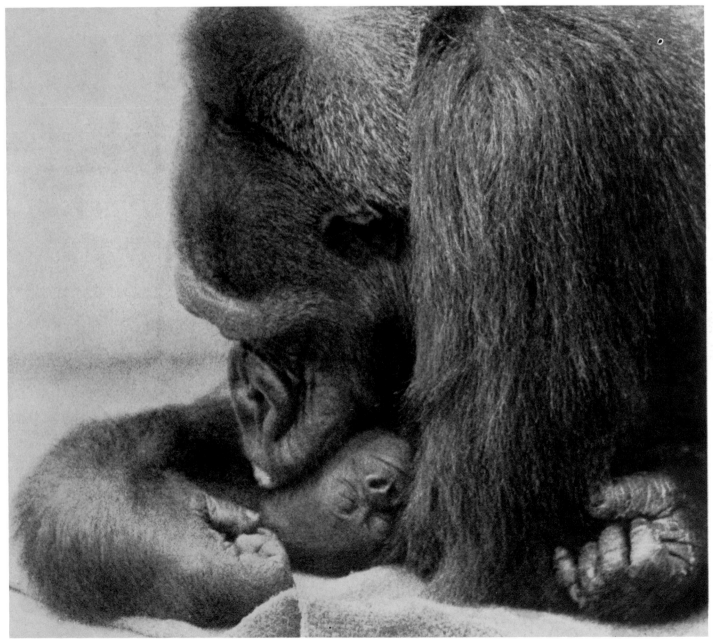

JÖRG HESS-HAESER: *Mother and Infant,* 1968

Watching a Baby Gorilla Grow

If a baby animal is your quarry, watch the newspapers for birth announcements at your local zoo. Lions, tigers, kangaroos and swans are among the most prolific of the creatures in captivity, but more and more animals are breeding as zoos learn how to make them feel at home.

Beyond offering obvious advantages over trying to photograph a skittish animal mother and her young in the wild, the zoo provides the added convenience of permitting a series of pictures documenting a baby's growth and development. One such study took place at the zoo in Basel, Switzerland, the residence of a gorilla named Achilla.

Achilla had already borne three young in captivity when, in the spring of 1968, her keepers found she was pregnant again. She was known to be a model mother—which is not always the case with gorillas that have been taken from the wild at too young an age to have learned from their elders. So when she showed signs of a fourth pregnancy, animal behaviorist Jörg Hess-Haeser began to watch her daily. One May morning he arrived shortly before 6 a.m. to find Achilla cradling a new baby, an almost hairless mite of less than six pounds. The zoo keepers christened the baby Quarta, and Hess-Haeser documented her development, as well as the tender care and instruction that Achilla gave her. The picture record took Hess-Haeser a year, and the photographs shown here are just two of the 10,000 that he made.

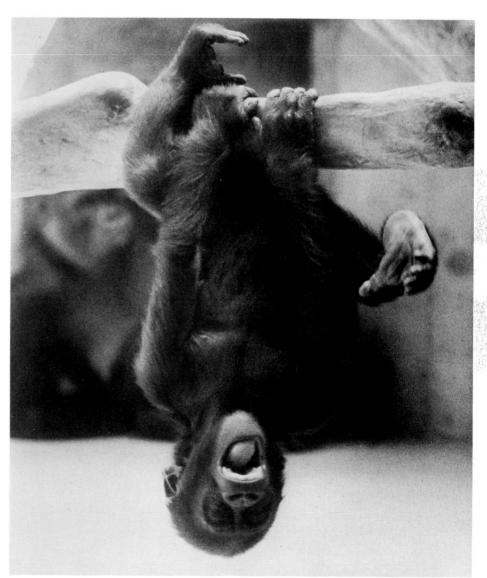

JÖRG HESS-HAESER: *Baby Swinging*, 1969

◀ *For this close-up of a 43-day-old gorilla asleep in its mother's arms, Dr. Hess-Haeser poked his 35mm camera between the bars of their cage. The cloth sacking was provided by the zoo keeper to cushion the baby from the cold floor.*

Just before the baby's first birthday, the photographer got this picture of the young gorilla swinging from a bar. He had to shoot through the glass of the gorilla's new house and he held his 85mm lens close to the glass.

187

A Lens for Every Place and Personality

HELEN GREENWAY: *Polar Bear,* 1971

What kind of picture do you want to get? In many modern zoos you can photograph an animal in its native habitat as well as in a characteristic display of personality. Once you have decided what you want, the lens you use is all important. It can widen the field around the animal to present him in his background *(above),* or it can crop out the scenery in order to emphasize his characteristics and his temperament *(right).*

The picture above was taken at the Bronx Zoo in New York, where the animals live in environments carefully designed to give them the comforts of home and to create verisimilitude in the setting. Though the snow and some of the rocks are synthetic and the pool is colored blue on the bottom to make it look deeper than it is, the setting provides the bear with an icelike turf to patrol as he was born to do. The scene

was captured on film with a 35mm wide-angle lens.

Quite a different character is the Alaskan Kodiak bear, which may look ferocious but is actually a playful fellow. To convey that disposition the two Kodiaks were snapped, also at the Bronx Zoo, as they engaged in a mock water battle *(right).* The photographer used a long lens that filled the frame with their faces and their cuffing paws.

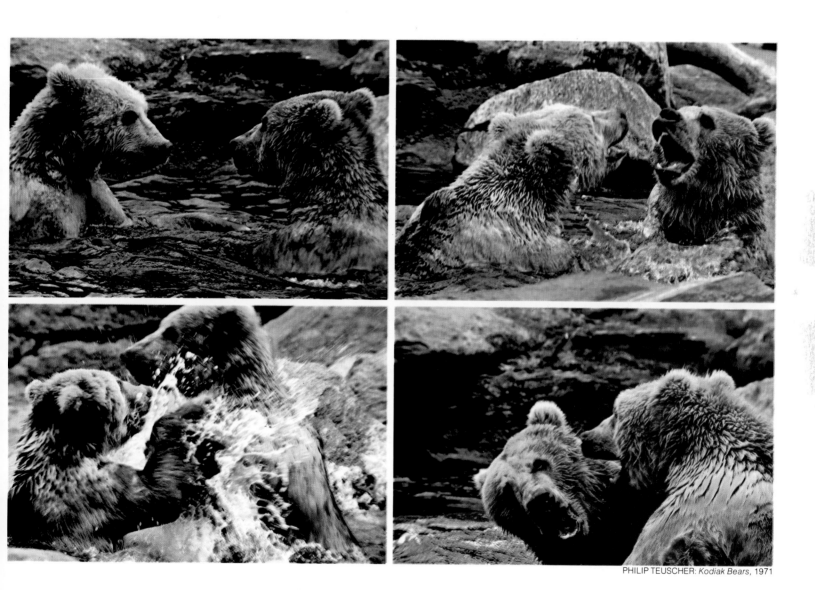

PHILIP TEUSCHER: *Kodiak Bears*, 1971

A polar bear (left) strikes a regal pose in the Bronx Zoo, just as he would in the Arctic, where he is king of his icy domain. A wide-angle lens enabled the photographer to take in the landscape on either side of the bear; and by careful framing she eliminated the concrete walls that separate him from the other animals.

Patience and a 400mm long lens made this sequence of Alaskan Kodiak bears at play in the Bronx Zoo. The photographer mounted his 35mm camera on a tripod and waited until the bears tangled with each other. Then he shot fast and got this lively progression, from face-off (upper left) to playful reconciliation (lower right).

Handling a Bird in the Bush

AL FRENI: *White-crested Touraco, 1971*

For a front view of an East African touraco confined within the Bronx Zoo's aviary, the photographer imitated the bird's call until it flew close. A 300mm lens and an aperture of f/4.5 put the bird's crested head and body feathers in focus, blurring almost everything else.

At the Los Angeles County Arboretum, birds are not ▶ *truly captive—they can run and fly freely, but do not try to escape because they are fed and protected there. Capitalizing on their tameness, the photographer was able to approach the birds and use a normal lens for this group portrait.*

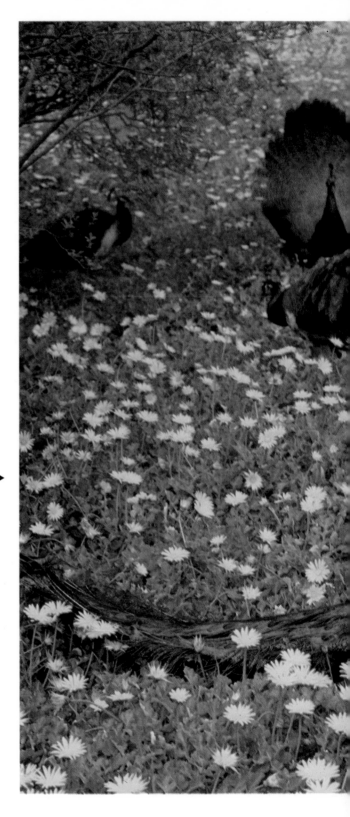

For photographers, a modern aviary provides an attractive combination of birds in an accessible location, which often is a replica of their natural environment—in effect, a bird in the hand as well as in the bush. The Bronx, San Diego, Copenhagen and Frankfurt zoos, among others, have aviaries with trees and shrubbery appropriate to the birds on display. No fences, bars or wires separate them from the viewer; the birds stay in the trees of their own accord. Visitors move along darkened passageways, some of which rise to treetop level. And the photographer can get a splendid vantage point.

Likewise, in arboretums like the one in which the picture on the right was taken, birds are free to act as they would in the wild and a photographer need not cope with artificial obstructions.

But by their very authenticity, such aviaries can present many of the problems the photographer would face in the wild. Shrubbery acts as camouflage, trees get in the way, leaves flick in front of the camera. Worst of all, the birds are darting all over the place. Even under the controlled conditions of the aviary, the bird photographer needs a quick eye, a quick hand and a fast-operating camera.

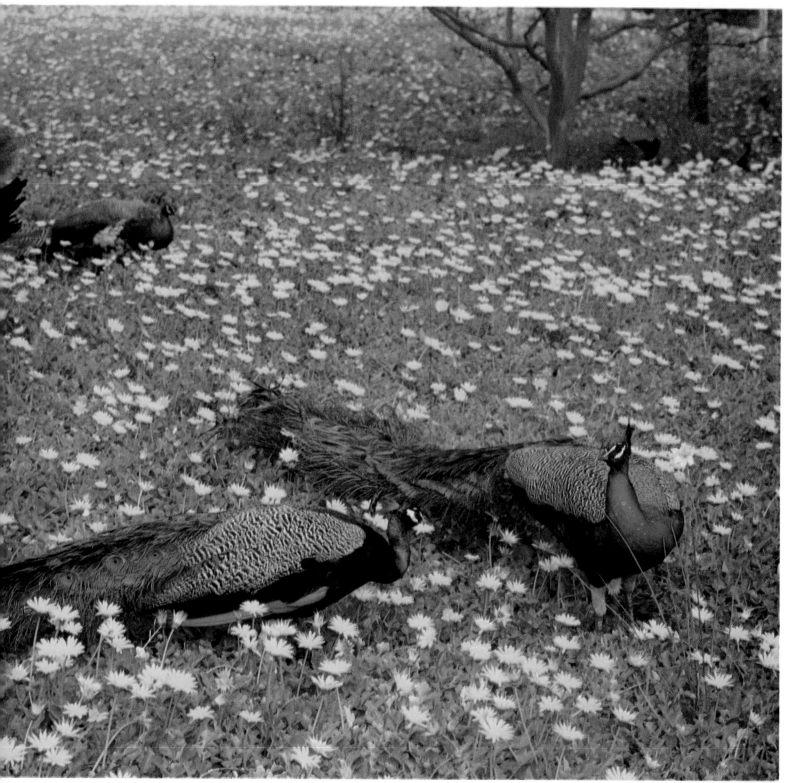

FRANCIE SCHROEDER: *Peacocks,* 1980

Where Rare Beasts Roam Free

The wrinkles and runny nose of a male rhinoceros were recorded as the animal rested its head on the back of a truck at the San Diego Wild Animal Park. The rhino came so close to the photographer that a 24mm wide-angle lens was needed to get the animal's face on the film.

ROBERT BURROUGHS: *Indian Rhinoceros,* 1980

Today, large wildlife preserves set up as breeding grounds for endangered species bring exotic beasts in natural settings within reach of a Sunday-afternoon jaunt. Many parks like the San Diego Wild Animal Park, in which the photographs on these pages were taken, are located in hospitable climates with ample space and large breeding herds.

In these preserves, it is the people who are caged—in buses, trucks or monorail trains—while the animals run free. Because of this restriction on camera location, a medium-length zoom lens—one that adjusts from about 80 to 200mm in focal length—is a big help in composing pictures. The best shots are often made early or late in the day, when the light is most interesting and the animals are less distracted by visitors than at midday.

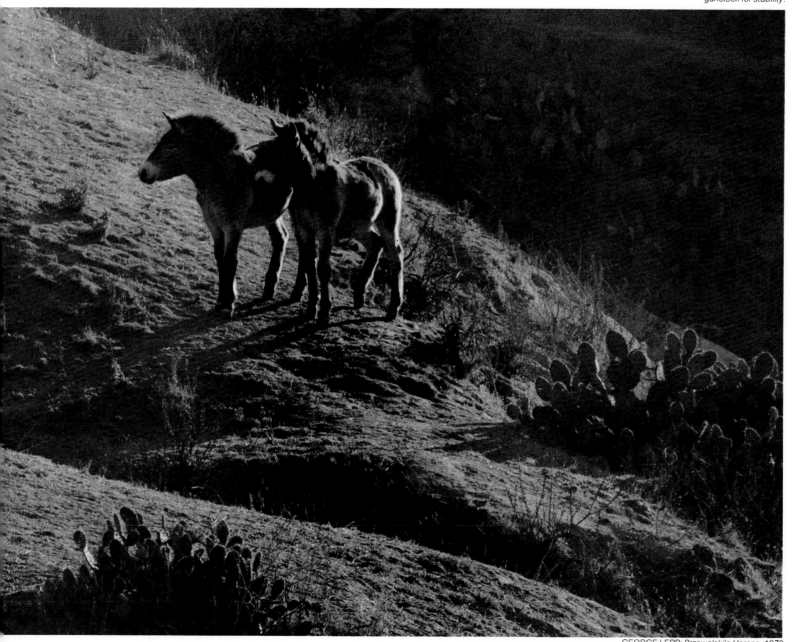

Against the background of a preserve hillside, these rare horses — native to Mongolia, where the species is now considered extinct — look much as they would if they could be found in their natural habitat. The photograph, taken from a monorail that runs through the preserve, was shot with a 35mm SLR and a 400mm lens, mounted on a gunstock for stability.

GEORGE LEPP: *Przewalski's Horses,* 1979

NINA LEEN: *Emerald Boa,* 1962

194

Looking through a Glass Darkly

The shallow glass-fronted niches in which zoos display some creatures provide good views for the casual visitor but special problems for the photographer. The light in such spaces is at best flat, usually dim, and sometimes red—a device that fools nocturnal animals into thinking it is nighttime. (When real darkness comes, the animals are put to sleep under bright lights that simulate daytime.)

The photographer can add light to show the animal's shape or texture, but he must be careful not to place it so that there is a glare on the film, a shadow on the wall behind the animal, or—worst of all—a reflection of the cameraman and his camera on the glass. For this reason Nina Leen, who shot the pictures on these pages, takes the precaution of wearing black clothes, even black gloves, and she frequently shrouds herself and her camera in a portable black tent to block out everything behind her.

◀ *The scaly texture of this South American tree snake (actually a gentle creature) stands out under floodlight illumination pouring down from one side of a glass cage at the Philadelphia Zoo. The intensity of the sidelight also plunges the glass-enclosed niche into darkness.*

Despite the fact that this slow loris in the San Diego Zoo is nocturnal and exhibited in a weak light, the photographer was able to get a good portrait without extra lighting because it is a placid creature. She set her camera shutter at 1/60 second and opened the aperture to f/4.

NINA LEEN: *Slow Loris*, 1962

A Tender Studio Portrait Outdoors

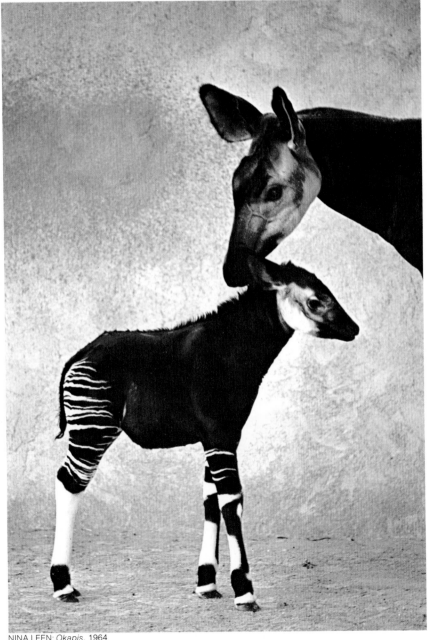

For all that modern zoos have done to simulate natural environments, some animals are still kept in old-fashioned enclosures. That is not entirely bad from the photographer's point of view, for it allows him to get portraits under conditions almost as well controlled as those in his studio. This is a particular boon in the case of animals that are so skittish that men are seldom able to catch more than fleeting glimpses of them in the wild. Among the most easily frightened animals are the okapis, which are native to the Congo rain forest. A pair of them are shown at left in a stucco enclosure at the San Diego Zoo.

Nina Leen made no attempt to disguise the location. Instead, she used the neutral color of the stucco to set off the rich browns, velvety blacks and creamy white stripes of the okapis' coats. To avoid the harsh shadows that would have been thrown on the ground behind the animals by bright light, she waited until a cloud passed across the sun. Then she started shooting, being careful to frame her pictures to exclude the food pans, a water trough and any other cage equipment that might mar the simplicity of the setting. When the mother bent over her calf, Miss Leen captured the attitudes of the two animals — the one protective, the other docile — that give this picture its emotional appeal. □

Okapi mothers are so nervous that they have been known to kick their offspring to death when startled by photographers' flashes. To get the picture at left, photographer Leen used a long 180mm lens that let her stay approximately 45 feet away from her subjects — far enough so they never knew she was there. The mother's easy nuzzling of her calf indicates that they were undisturbed.

NINA LEEN: *Okapis*, 1964

The Art of Landscape Photography 6

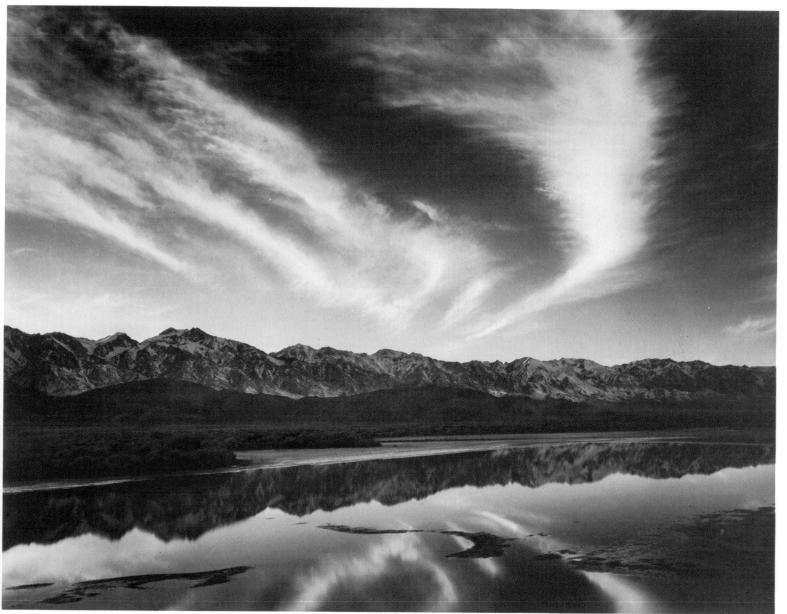

ANSEL ADAMS: *Evening Clouds, Sierra Nevada*, c. 1960

Getting the Grandeur onto the Film

Nothing seems easier, to a person who has never tried it, than photographing a landscape. The beauty is all there to start with—the bright flowers, the rich forest greens, the clear or cloud-studded sky, the gently rolling fields and hills. Surely all the photographer needs to do is point his camera and click away. And surely nothing is more exasperating than the pallid snapshots that usually result. Where is the panoramic sweep, so clearly remembered, of those rolling hills? The wild flowers seem barely visible in the finished print, and the groves of trees have turned flat and colorless. How did those telegraph wires get into the picture? And the little blue bump on the horizon—could that be the distant mountain that looked so majestic to the eye? What went wrong?

Almost everyone, after shooting his first casual landscape, faces such a moment of truth. For landscape photography is no casual matter, but a skill that requires time and patient effort. Ansel Adams, devoting his life to it, called it "the supreme test of the photographer—and often the supreme disappointment." Scores of variables must be considered. Each hour of the day, each change of weather, the slightest shift in viewpoint, can radically affect the way a picture will look.

A range of mountains that looms dramatically in the dawn light, with the oblique rays of the early sun casting each spur and pinnacle into bold relief, may shrink into insignificance under the hard vertical light of noon. A field that seems visually exciting when dappled with the shadow patterns of clouds may turn drab and monotonous under a clear sky. Yet all these pitfalls may be avoided by applying a few basic principles.

One reason many landscape pictures fail is that the camera and the human eye do not see the same thing. Stand on the top of a tall building, or on one of those mountain lookout points that offer a broad, uninterrupted vista. The eye sweeps across the land, from side to side and toward the horizon and back, sending hundreds of different visual messages to the brain. Together they add up to a composite impression. But the camera takes just a single segment of the total view. Unless the segment is well chosen, it will fail to convey the sense of spaciousness that is perceived by the eye and the brain. A picture that includes only distant countryside, for example, defeats the very concept of distance that the photographer wants to illustrate. This is because it offers no point of reference, no contrasting object in the foreground or middle ground. The eye without the camera picks out such reference points by shifting alternately from near objects to far ones. To give the same sense of depth with its single view, the camera must show both in the same photograph, so that the distant hills may be compared with, and contrasted to, some foreground object: a rock formation, the branch of a tree or even a bit of turf.

Film also registers images differently from the way they normally appear to the eye. No emulsion yet devised has the capacity to respond simultaneously to the range of dark and light tones that the human retina accepts as a matter of course. The photographer must frequently make a choice: to shoot for the highlights, in which case the shadows may turn completely black, or to show detail in the shadows, which may turn the highlights into areas of flat, undifferentiated white.

Another built-in weakness of many scenic snapshots is that the photographer made no real effort to study his subject, or to determine exactly how he wanted to portray it. Return again to the mountaintop observation post. Take a hard analytical look at each of the visual elements that contribute to making the scene so impressive, and decide which is most important. Is it the color of autumn foliage on nearby hills seen against the hazy blue backdrop of distant mountains? Clearly the photographer must include both, perhaps using a telephoto lens to bring individual trees closer to the camera. Mist rising from a river may be the most interesting element, in which case the best plan might be to return the following morning when the mist is even thicker and presumably more expressive. A beam of sunlight breaking through storm clouds may add a note of drama to the scene. Many photographers relish such dramatic lighting effects, and habitually venture out in stormy weather to find them.

Professional landscape photographers, in fact, will take endless trouble and go to almost any lengths to achieve unusual effects. The Swiss photographer Toni Hagen repeatedly went back to one area in the Himalayas over an eight-year period in order to take a particular photograph of a 26,000-foot peak with blossoming rhododendrons in the foreground. (Rhododendrons bloom in the spring when mist usually obscures the mountaintops.)

Not all landscapes demand such perseverance on the part of the photographer. Nor must all landscapes be exotic or dramatic panoramas. A well-executed photograph of a single maple tree may say more about the beauty of autumn than an entire forest. A cluster of rocks in the foreground of a picture may evoke the feeling of the out-of-doors more powerfully than an overall view of the field itself. But in each case the photographer has been successful if he has decided what effect he wants to create, and has emphasized the visual elements that help him create it.

Landscape photography, then, involves two fundamental steps. The first is a seeing process, in which the photographer perceives what he wants to convey. The second step is implementation — in which he decides how to convey through his camera what he has perceived.

The time-honored tool of the professional landscape photographer is the versatile view camera. All the great 19th Century landscapists used view

cameras, carting them into the wilderness in wagons or on pack mules; in 1898, photographer Wallace Nutting declared that the ideal equipment for picture-taking excursions into the countryside was a large camera, a small carriage and a smaller wife. Today many landscape photographers still prefer large format cameras. Though heavy and cumbersome, they allow the photographer to control his pictures in ways that small hand-held cameras do not. With a view camera securely mounted on a tripod, the photographer has the leisure to study each square centimeter of the ground glass to determine exactly what will appear in the final picture. There is little danger that stray beer cans and candy wrappers will intrude into the corners. Because the various parts of a view camera can be moved independently of each other— shifted up or down or pivoted—the photographer can manipulate the shape and location of images in his negative. And because the images the view camera produces are large, some photographers feel that the details of each leaf and grass blade can be rendered with unmatched clarity and precision.

One advocate of the carefully controlled, crystal-clear view-camera school of landscape art is George Tice, who took the pictures on pages 217 and 219. On a typical excursion into the field, Tice loads his car with close to 50 pounds of photographic equipment: an 8 x 10 view camera weighing 12 pounds, a dozen black-and-white film holders, a lens of medium focal length, a wide-angle lens, a lens shade, a tripod, a dark cloth, a small magnifier for reading fine focus on the ground-glass viewing screen, a reflected-light meter, two cable releases, a notebook for jotting down exposure details— plus waterproof boots for wading through streams and a bag of fruit to give him the energy to carry all this equipment around. This is a bare minimum. Many other photographers also pack a special camera-back for Polaroid Land film to make test exposures, and a set of filters— yellow to darken shadows, orange to bring out the shapes of clouds, red for even stronger cloud and shadow effects, green to lighten foliage, ultraviolet to cut through haze, and polarizing to eliminate glare and reflections.

Tice usually sets out before dawn and is on location by sunrise. The slanting early morning light is almost always the best for casting the soft, long shadows that bring out the shapes of rocks and hills. Normally Tice knows beforehand where he is going and precisely what scenes he will photograph. To avoid toting his gear unnecessary distances, he scouts the terrain a day ahead of time, planning in his mind's eye where he will set up his camera. When he photographs remote areas he often uses a compact 2¼ x 3¼ view camera— less unwieldy than the 8 x 10 and almost as effective in rendering detail. Still, Tice does not hesitate to carry his largest camera into the wilds, occasionally at great risk to life and limb. Once, while photographing

in Colorado he found his way blocked by a mountain river. Though it was only six feet wide, it ran 30 feet below him at the bottom of a steep, narrow gorge. Undaunted, he tucked camera and tripod under his arm, took a running start—and leaped. On the other side, he proceeded with unruffled poise to take his picture.

The precisely detailed view-camera approach has not entirely appropriated the field. Some photographers, striving for more quickly glimpsed views that reveal a general sense of place and atmosphere, rely on the 35mm single-lens reflex camera. It is the most practical camera for particularly arduous shooting situations—scrambling up a mountain face, for example. Harald Sund took the dramatic picture of a desert dawn on page 229 with a 35mm camera because he preferred the colors produced by Kodachrome film, which is not available for larger format cameras. A famous *Life* picture essay that captured the varying moods of the world's oceans was photographed by Leonard McCombe, a photojournalist who usually takes pictures of people with small cameras. McCombe spent half a year voyaging through the seven seas, carrying only two 35mm cameras, an assortment of wide-angle and telephoto lenses and a tripod, which he used only once. "I wanted to evoke a feeling, a general sense of place," he said. "It's very hard for me to get the same kind of spontaneity with a 4 x 5 camera."

Thus armed, with large camera or small, the good landscape photographer concentrates on his goal: to record the look of the land in a memorable and evocative way. He studies the character of the landscape—the grandeur of cliffs and mountain ranges, the intimacy of forest glades, the crispness of grasses and wild flowers. He searches for the unusual effects of light or atmosphere—sunshine pouring through foliage or sparkling on the ripples of a lake, the pattern of shadows cast by furrows in a plowed field, mist enveloping a valley at dawn. In each case, the good photographer relies on a keen, sensitive eye to refresh his vision of the countryside, and a thorough knowledge of equipment and technique to capture that vision on film. ☐

Creating a Scenic View

In this comparatively open view of a woodland pond, the eye is led by the foreground ripples across the water to the opposite bank, which it follows to a vanishing point near the picture's left side. Two subtle compositional devices help frame the picture: the strong vertical line on the left, formed by a tree trunk and its reflection, and two crossed tree stumps in the water at the right.

The first problem for every landscape photographer seems deceptively simple: deciding what to show. But nearly any landscape presents more than a single photograph can include, and so the photographer must select from the general scene. He must, in effect, compose his own landscape within his camera's viewfinder.

Unlike a studio photographer, who controls composition by rearranging subject matter, a scenic photographer must take his subject as he finds it, with only minor exceptions *(pages 210-211)*. His basic method of composing is to move his camera until he finds an angle that pleases him. But even the slightest shift in a camera position can radically change a photograph. The two pictures shown here, though worlds apart in composition, differ only because the photographer stepped back a few feet when he took the second one.

The problem of composition has al-

ways preoccupied landscape photographers. One method at the turn of the century divided all landscapes into four sections: foreground, middle ground, background and sky. While these divisions may seem arbitrary, they can be useful in analyzing the relationships between the different elements in a picture. A sense of distance, for example, can be created by catching the viewer's eye with a foreground detail, and then directing it into the background by

means of a winding road or riverbank. Another device is to use a foreground object such as an outcropping of rock to put a frame around a faraway view. Filling an expanse of empty sky can be another tough compositional problem. One trick is to elevate the camera and then aim it downward to include more ground. A preference for such lofty viewpoints often impels many professionals, such as Ansel Adams, to set up their tripods on the roofs of their cars.

Both subject and composition change abruptly when the photographer moves back to include a fallen tree, probably felled by beavers. The huge foreground image completely dominates the picture, preventing the eye from traversing the water, and producing a more intimate, closed-in effect. The picture now shows that this is not only a woodland pond; it is a beaver pond.

How Different Lenses Change the Composition

One way the photographer can change his composition without moving his camera is simply to change his lens. A telephoto lens, for example, not only makes distant objects seem closer; it also acts as a cropping device: by enlarging part of a scene so that it fills the picture frame, the lens allows the photographer to exclude whatever periph-eral images he may not want. Con-versely, a wide-angle lens, by shrinking the size of the images, allows the pho-tographer to squeeze an immense ex-panse of trees and hills into the limited confines of his negative. Shifting the camera itself closer or farther away will not produce exactly the same effect, since the sizes of the objects would then change in relation to each other.

Wide angle lenses supply another valuable effect. Because they can en-compass both distant horizons and the grass under foot, they provide a subtle kind of framing. In the picture at left, above, the large white stone in the fore-ground acts as a framing device that contrasts with the distant trees.

The same scene photographed through four different lenses has produced four different landscapes, each with its own composition. A sweeping sense of spaciousness characterizes the picture at far left, shot with an extremely wide-angle 18mm lens. In the picture next to it, a 35mm lens produced a less pronounced sweep from nearby grass to distant trees and hills; it also allowed the photographer to crop out the rock in the foreground. At top right, a 50mm lens preserved the relationship of size and distance that the photographer saw with his eye. And at right below a 100mm lens offered a close, intimate view that eliminated all but the six central trees. Each picture was taken from the same spot, with the same 35mm camera.

Sharpening the Focus

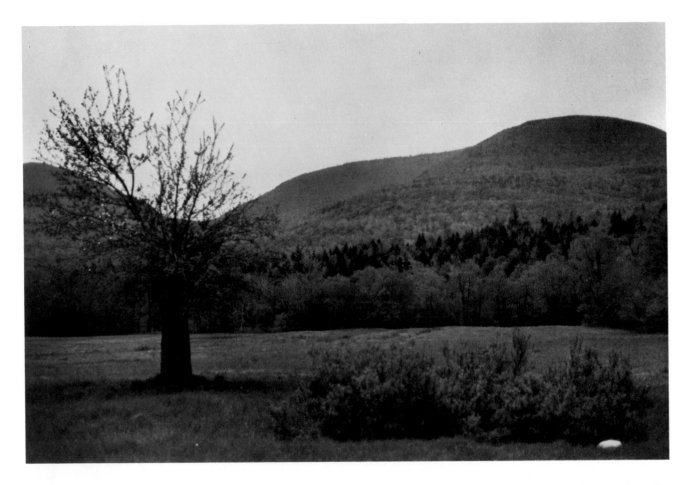

Foreground blur in the picture above resulted from at least two mistakes. An aperture of f/4 allowed only a limited area of focus, as indicated by the brackets on the lens's depth-of-field scale (above). And with focus set at infinity the photographer lost most of the area of sharpness.

One of the most frustrating technical problems in landscape photography is that of keeping the whole scene in focus. Impressionistic images can sometimes create fascinating effects, but most landscapes are more appealing when you can see everything. Complete clarity can be hard to achieve, because the distance between foreground and background in landscapes is usually so great. The photographer must use a depth of field broad enough to include the nearby rocks as well as the distant mountains.

The most obvious way to increase depth of field is to use a small aperture. Closing down the diaphragm means that a longer exposure time will be needed, of course. But unless a high wind is blowing, 1/125 second is usually fast enough, and on a still day exposures can be far longer.

The next rule of thumb for sharp focus is to use *all* the available depth of

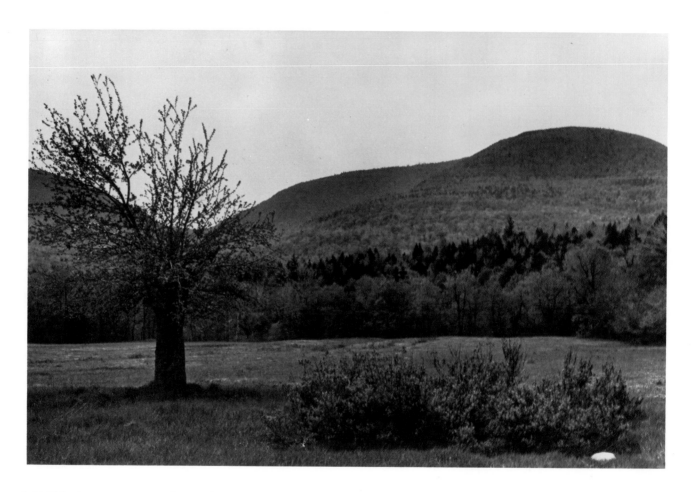

field. This does not mean setting the focus at infinity, even for the most distant landscapes. When a lens is focused at a particular point, the depth of field extends twice as far behind that point as it does in front of it. A setting at infinity, therefore, wastes two thirds of the available depth of field—which is exactly why so much of the picture at left is out of focus. To make the most of the available depth of field, set your camera at a point called the hyperfocal dis-

tance. This is done by consulting the depth-of-field scale engraved on most lenses. First determine the aperture setting; then adjust the focus so the infinity mark on the focusing scale coincides with the appropriate aperture mark on the depth-of-field scale *(lens at far right)*. The area of sharp focus will then extend from infinity back toward the camera with nothing wasted, allowing the wide range of clarity that distinguishes the picture above.

Now the photographer has increased the depth of field by using an aperture of f/8 (brackets on lens at left). And by aligning the infinity mark on the focusing scale with the f/8 mark on the depth-of-field scale (lens at right), he has brought the sharp focus even closer—down to almost 15 feet.

Reshaping Nature with the View Camera

A photographer enjoys little of the painter's freedom to reshape reality. The painter can move trees, change the outlines of rocks, even shift the course of a river. The photographer can accomplish only a few of these miracles —and then only if he has a view camera and uses the various adjustments available with it. Because the view camera's lens and film plane can each be moved independently, the photographer can slide and pivot them to control the shape and placement of its images, and thus achieve an apparent viewpoint that otherwise is physically impossible.

One way a view camera can reshape images is illustrated by the two photographs of a New Hampshire forest at right. When the photographer stood on the forest floor and simply aimed his camera upward, the trees all seemed to tilt backward. This was because the film in the back of the camera was no longer parallel with the tree trunks. With an ordinary camera, the only way to keep the film parallel and still include the treetops would be to take the picture from a greater distance. But in the cramped space of the locale this was impossible. With a view camera, however, the photographer could adjust both the back of the camera, to keep the film parallel with the trees, and the front of the camera, to include all of the tree *(diagrams at right, below).*

Other view camera adjustments can correct other types of distortion, alter the position of boulders or sharpen focus. The two-step manipulation on the right-hand page changed the camera's depth of field so that the close-up of the rock, the tree trunk and the leaves of the sapling in the background were all recorded with the same sharpness.

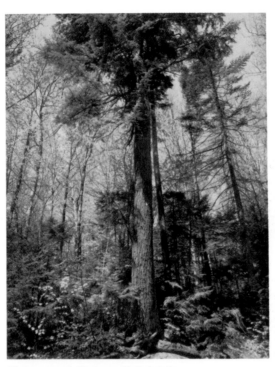

When a camera is tilted upward to include the treetops, the film is no longer parallel with the tree trunks. The result is a distorted perspective, which makes the tips of the trees seem to merge together toward a vanishing point in the sky.

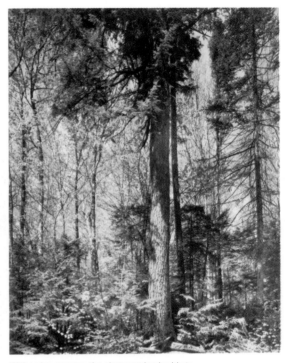

With a view camera, the photographer is able to prevent distortion by keeping the film parallel with the trees. In order to include the image of the entire tree, he simply raises the camera's front (the lens) in relation to its back (the film).

This closely glimpsed woodland scene has been carefully framed in the view camera's ground-glass screen to give it a pleasing composition. But the camera's lens and film plane are not parallel to the plane of the subjects (the tree, rock and sapling), so most of the picture is out of focus.

Swiveling the back and the front of the camera brings both lens and film parallel with the subjects so the area of sharp focus encompasses most of the scene to be recorded. But now the composition is slightly askew—chopped off at the right with unwanted space at the left.

To restore the original composition, the film plane (the back of the camera) is shifted so that the unwanted gray space no longer registers on the film and the area at right does. The photograph now combines the desired composition plus sharp focus on the tree, the rock and the sapling.

Filtering the Light

filter	physical effect	practical use
Filters for photographing with black-and-white film		
yellow	Absorbs ultraviolet and blue-violet rays.	Darkens blue sky to bring out clouds. Lightens foliage and grass. Keeps natural tones in sand or snow scenes when photographed in sunlight and blue sky.
dark yellow	Absorbs ultraviolet, violet and most of the blue rays.	Lightens yellow and red subjects such as flowers. Darkens water in marine scenes and blue sky to emphasize foreground objects or clouds. Increases contrast and texture in sand or snow scenes with sunlight and blue sky.
red	Absorbs ultraviolet, blue-violet, blue and green rays.	Lightens red and yellow subjects; darkens blue water and sky. Cuts haze and increases contrast in landscapes.
dark red	Absorbs ultraviolet, blue-violet, blue, green and yellow-green rays.	Produces almost black sky and bleached white clouds.
green	Absorbs ultraviolet, violet, blue and red rays.	Lightens foliage, darkens sky.
blue	Absorbs red, yellow, green and ultraviolet rays.	Lightens blue subjects, enhances aerial haze and fog.
Color correcting filters modify the color of transparencies and color negatives.		
yellow	Absorbs blue.	If the color in the transparency does not match the visual effect desired, a filter can correct the results. This alteration can be achieved by placing one or more color-correction filters over the transparency on a light box until one or more are found that give a more natural effect. If the picture is then to be reshot, the filter used on the lens should be the same color but one half the density of the filter that gives best correction over the transparency. This is because a filter used over the lens when exposure is made has about twice the effect of one used over the finished transparency.
magenta	Absorbs green.	
cyan	Absorbs red.	
red	Absorbs blue and green.	
green	Absorbs blue and red.	
blue	Absorbs red and green.	
Light balancing filters balance the light instead of controlling the color response of the transparency or color negative.		
yellowish	Lowers color temperature of the light.	Produces warmer colors.
bluish	Raises the color temperature of the light.	Produces cooler colors.
Other filters		
neutral density	Stops a portion of all visible colors. Since the color of the light is not affected, this filter can be used with color film as well as black and white.	Useful in reducing exposure when photographing a bright scene in sunlight with high-speed film.
polarizing	Eliminates reflections and unwanted glare.	Useful in taking pictures of water. Also darkens sky and lightens clouds when sun is not directly overhead.
ultraviolet	Stops ultraviolet light.	Eliminates haze. Generally used to obtain sharper results.
skylight	Reduces excess of blue. Use only with daylight type color-slide film.	Useful when photographing in open shade or on heavily overcast days.

Even when he takes a landscape with black-and-white film, a photographer has to control color. This is because subjects that stand out vividly in color sometimes lose all contrast when rendered in tones of gray. Red and green, for example, photograph in virtually identical shades of gray, so that apples in a tree become almost indistinguishable from the surrounding leaves. The photographer can make one of them seem darker than the other by using a colored filter—green to darken the apples or red to darken the leaves.

Filters can also bring out the clouds in the sky. Since most black-and-white film reacts more quickly to blue light than to light of any other color, the blue sky becomes as bright as the clouds, and the clouds disappear, as in the picture at top, near right. To put back the clouds, the photographer needs a yellow or red filter that will remove some of the blue light but let most of the white light from the clouds pass through.

Other filters can be used with color film to give a scene warmer tones or cooler ones, and a polarizing filter can eliminate glare. The table at left lists the most common filters both for black-and-white and for color film and gives their uses. Instructions for exposure compensation, included with each filter, should be followed carefully.

A succession of increasingly powerful filters has ▶ progressively darkened the sky and brought out the clouds in these four pictures. Without a filter, the sky registers as a uniform white (near right, top). A yellow filter blocks out enough blue sky light so that the shapes of clouds begin to appear (top, far right), restoring the balance of tones that would normally have been seen by the eye. But with a red filter (bottom right) the sky is darkened, giving a rich, dramatic effect that is intensified (bottom, far right) when a polarizing filter is added to eliminate glare.

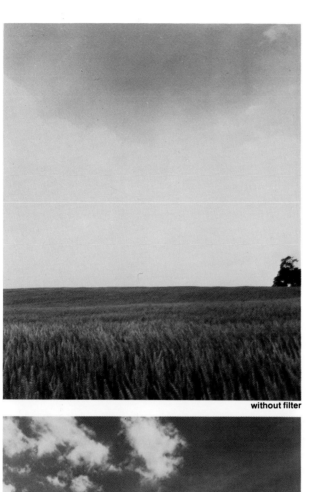

without filter

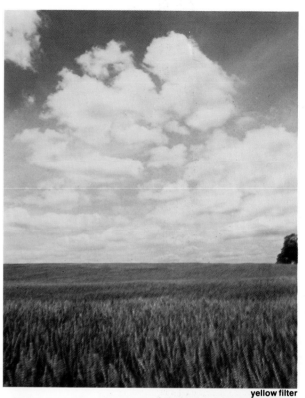

yellow filter

red filter

red filter and polarizer

213

Strengthening Colors

If light strikes an object at an angle that makes it skim the surface, all its waves are reflected, bouncing off as from a mirror, instead of being partly absorbed and partly reflected as they normally are. The result is glare—bright white light that dilutes the true colors of an image. There is a way to control glare because its waves, in glancing off the object, are altered in a special way. They all vibrate at one angle rather than at many angles, as do most light waves, and a so-called polarizing fil-ter can be set to block waves vibrating at a particular angle. The filter contains submicroscopic crystals that are aligned like pickets in a fence to pass waves of one angle of vibration and stop others.

A polarizing filter can also darken the sky. Light coming directly from the sky is polarized as it is scattered by particles in the atmosphere. With a polarizing filter, a sky that would be washed out by polarized sky light is transformed into a deep, brilliant blue *(opposite)*.

The glare of sharply reflected sunlight on a broad valley in the Colorado Rockies, photographed on a cloudless day without a filter, dulls and dilutes colors. Details, such as the roofs in the town at the base of the mountains, are also obscured.

Shooting the same scene at the same time of day
through a polarizing filter reveals the vista in greatly
enhanced color and detail. The filter largely
screens out the polarized light causing the glare,
and it also darkens the sky.

The Necessity for a Theme

The landscape photographer might well take a hint from the late Winston Churchill, who was never known to take a photograph but who had a flair for the direct, vivid statement. When finishing off a meal at a London restaurant one evening, he was served a dessert so bland that it was virtually tasteless. "Pray take away this pudding," he growled. "It has no theme." Many landscape pictures fail for exactly the same reason. They have no theme, no definite point of view that distinguishes them from thousands of other landscape pictures. Unlike Churchill's succinct observation, they deliver no clear, concise idea of what the photographer is trying to express.

The themes of the pictures on the following pages are as various as the shifting weather and changing moods of the land itself, and as different as the sensibilities of the photographers who took them. Some are detailed views, carefully singled out from the natural scene and lovingly rendered to reveal each nuance of shape and shading. Others open out into broad vistas, especially when a wide-angle lens has been used to accentuate the feeling of spaciousness and depth.

In some of the photographs, the photographer has employed a telephoto lens to flatten perspective, so that the point of the picture becomes the rhythmic patterns formed by overlapping hills or tree trunks. Occasionally the subject is simply the light itself—the way the setting sun transforms the colors of the desert or silhouettes the branches of a tree. But in each case, the photographer had a definite idea to express, and in each case he found exactly the right techniques to convey it best.

A fresh, delicate beauty distinguishes George Tice's picture of an oak tree on the opposite page. Its impact comes not from any dramatic effects of lighting or composition, but from its profusion of clearly rendered details—the finely etched reeds in the foreground, the textured bark of the oak, the young leaves reproduced so precisely that the viewer can almost count them. Tice used the camera that he believed was best suited for showing such clarity and detail—an 8 x 10 view camera mounted on a tripod. Because of the generous size of the negative, no enlargement is needed in making a print, and therefore no clarity is lost.

But a view camera presents difficult technical problems. Because a normal lens on an 8 x 10 camera has a focal length of 12 inches it allows very little depth of field, except at an extremely small aperture setting. To get sharpness throughout, Tice stopped down to f/45—which required an exposure time of one second. But at long exposures the motion caused by even the slightest breeze is enough to blur the leaves. Tice had to watch the wind and anticipate the very second between gusts when the leaves were almost completely at a standstill.

He needed a long exposure for another reason: He took the picture at dusk. To preserve the picture's delicate gray tones, Tice had to eliminate all strong shadows and highlights. A preliminary exposure that he had made under bright sunlight was so riddled with harsh, distracting contrasts that he waited until the sun had set before he took the final picture. The early evening light gave the picture exactly the soft quality that Tice was striving for.

A combination of soft tones, rich detail and gently contrasting textures gives an understated impact to this stately oak tree, photographed in late spring before the leaves had grown thick enough to obliterate the gnarled branches. Every effect is low key, including the compositional device that holds the picture together—two parallel diagonal lines, one formed by the tops of the reeds in the foreground, and the other by the tops of the trees in the wooded area behind the oak.

216

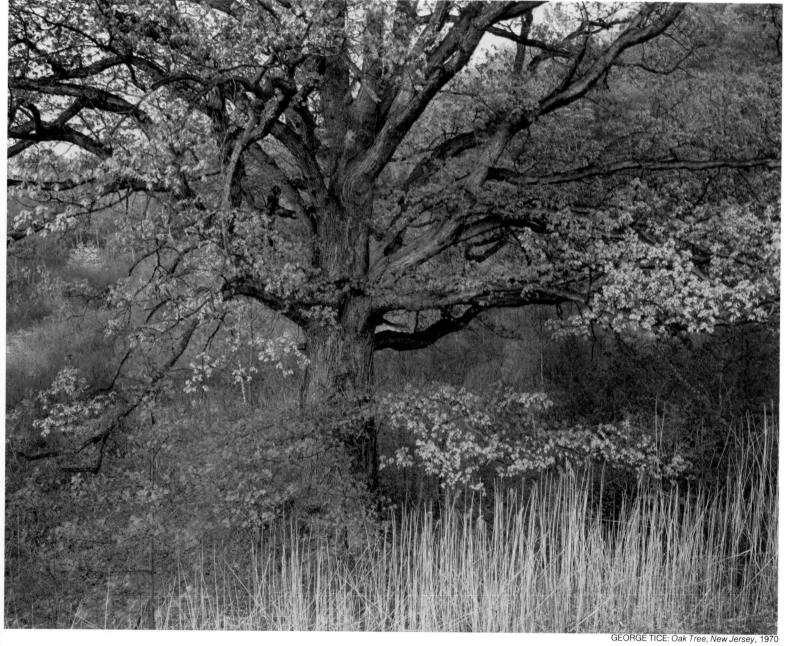

GEORGE TICE: *Oak Tree, New Jersey,* 1970

The View Camera's Expressive Eye for Detail

WOLF von dem BUSSCHE: *Rock Pool*, 1970

The peculiar problem for the landscape photographer is that, while his subject may stretch off over the horizon, his photograph cannot be any bigger than the four edges of the picture frame. So his ability to pick out isolated segments from the overall scene is often his best creative tool. And many landscapists, when closing in on the countryside's evocative details, rely on the instrument that they believe captures details most clearly—the view camera, with its large-sized film.

In addition to clarity, the view camera has another virtue: It swings and tilts, making possible a final degree of perfection in the landscape close-up. The picture at right was taken with an 8 x 10 view camera aimed down at an angle of approximately 45° to the surface of the field. By itself, a small diaphragm opening of f/45 would not produce a broad enough depth of field to bring both the closest flowers and the farthest grasses into sharp focus. But by tilting his lens a little closer to the horizontal, the photographer achieved clarity throughout.

Aiming his 4 x 5 view camera almost straight down between the rocks into a pool of clear water at Point Lobos, in California, the photographer has created an almost abstract composition of forms and textures. He used a 75mm wide-angle lens and stopped down to f/22, to give sharp focus throughout to the rough texture of the nearest rock ledge, to the ripples on the water, to the stones at the bottom of the pool.

GEORGE TICE: *Grasses with Iris*, 1968

*Wild iris that looked to the photographer like a
flock of darting butterflies inspired this exquisitely
detailed close-up of a field, taken on a late
afternoon in spring with an 8 x 10 view camera.
Gentle backlighting from the low-lying sun
contributed to the picture's delicacy and softness.*

Motion: Free-flowing and Frozen

JOHN CHANG McCURDY: *Dogwoods in Early Spring, Teatown, New York,* 1973

The landscape photographer has an advantage over a person who photographs animals or birds; his subject does not run away. But neither does it always sit completely still. Flowers sway in the breeze, treetops flutter, water flows. On a breezy day, for a shot into the middle distance, a shutter speed of 1/125 second is needed to stop the motion of foliage. In a high wind, 1/500 second is required. And the closer the subject to the camera, the faster the shutter must be.

But total stillness can sometimes ruin a picture. The beauty of a windswept hillside comes, in part, from its motion. To convey this sense of fluidity, photographers often use slow shutter speeds that create a slightly blurred effect.

The opposite method—using ultrafast shutter speeds that freeze the action in mid-course—can also capture the dynamic force of water in motion. To record the cresting wave at right, caught so precisely that every droplet can be clearly seen, the photographer set his shutter at 1/1,000 second, providing an instant profile of a choppy sea.

In a sun-dappled suburban forest, a light breeze stirs the leaves and blossoms of dogwood trees. To suggest the gentle spring wind, the photographer used a relatively slow shutter speed, about 1/15 second, to achieve a slight blur. An even slower speed would have destroyed the effect altogether by blurring the trees beyond recognition.

To catch the bow wave of a Chesapeake Bay ferry at the moment when a gust of wind blew spume from its top, the photographer set his shutter at 1/1,000 second. To gauge exposure to shoot the wave against the sun, he took a meter reading from the water to the left of the wave.

NICK FOSTER: *Wave*, 1971

JIM BRANDENBURG: *Canadian Rockies,* 1979

The Wide-Angle Lens to Enhance Nature

Nothing expands a landscape photographer's repertoire of effects like a wide-angle lens. By opening up the boundaries of a picture, it can give a feeling of spaciousness and panorama. The lens's extreme depth of field allows the photographer to focus with equal clarity on a rock in the foreground and a mountain in the distance. And by providing a different perspective from that seen by the eye, it makes near objects seem close and distant ones seem far, creating a dramatic sense of depth.

But with these advantages comes an increase in distortion. Objects may vary dramatically from their normal size and so may distances. Straight lines may appear curved. The edges of a photograph may seem to fall away. And distortion increases as focal length shortens.

Some extra-wide-angle lenses, called fisheye lenses, can cover an immense field of view, but without careful framing the edges of the image appear round. Freelance photographer Jim Brandenburg used one—a 16mm lens with a viewing angle of 180°—to record a massive glacier in Alaska.

Brandenburg wanted the widest possible range to depict the grandeur of the terrain but was careful to place the horizon across the center of his lens: This precaution, plus the absence of straight lines in the subject, made distortion at the edges of the frame less obvious.

The Columbia ice field majestically grinds its way toward the horizon in Alberta, Canada, in this picture taken from a helicopter. To embrace the 300-square-mile panorama, a 35mm SLR was fitted with a 16mm fisheye lens having a 180° field of view. But some distortion inevitably occurs in a fisheye lens of this focal length: Straight lines appear curved at the edge of the frame. Although the photographer minimized the effect by placing the horizon at the center of the picture, some distortion remains. He felt that the slight curve of the horizon line made the picture more dramatic.

The Long Lens for Bringing the Subject In

Since time out of mind, an ability to move mountains has been considered the ultimate in miracle-working; even the Prophet Muhammad, in the well-known parable, could not make the mountain come to him. But the landscape photographer of today has just the tool to perform this marvel. By using the magnifying properties of a telephoto lens, he can reach out into the distance and make the mountain appear, at least, to come a good part of the way to him.

Besides giving the photographer the ability to bring distant things closer, long lenses can conjure up another intriguing creative effect. Because they flatten perspective, they can reduce the sense of three dimensions in a scene, and transform a three-dimensional landscape into a strong, graphic pattern of two-dimensional shapes. In the picture at far right, which was shot with a powerful 500mm telephoto lens, the distant trees at the upper left-hand corner are almost as large as the nearest ones in the lower right corner. To the eye, therefore, they appear to be equally close to the viewer. As a result, the picture becomes a visual tapestry of dark evergreens set in diagonal rows against a light green field.

JOHN DEEKS: *Desert Divide*, 1970

Like flat paper cutouts, overlapping peaks of the San Bernardino Mountains become in this photograph a study of patterns. A 105mm long lens, combined with backlighting from the rising sun that turned the mountains into silhouettes, created the two-dimensional effect shown above.

A mountainside in Jasper National Park was ▶ *transformed into a pattern of green on green when shot through a powerful 500mm telephoto lens. Because the day was overcast, shadows were too subdued to show much modeling of forms —thus further removing the sense of three dimensions.*

MICHAEL FOSTER: *Trees on Mountainside,* 1967

Unique Views from the Air

There is no better vantage point from which to behold the lay of the land and to record it on film than from the air. Most aerial photographers shoot from small airplanes, although some have used helicopters, balloons and blimps. Normally, they photograph through an open window or door to avoid the glare and distortion caused by an extra thickness of glass—with the fastest possible shutter speed and a lens of a focal length no greater than 150mm. Longer lenses are seldom useful aloft because the plane's vibration makes them almost impossible to keep steady.

After equipment, the most important element in aerial photography is the quality of the light. Crosslighting enhances the salient details of the terrain below by etching them in shadows. Thus the best shooting is often accomplished in early morning and late afternoon. Some landscapes, however, such as the one at right, shot straight down, need the harsh, flat light of midday.

More than a mile below the camera, a small plane skims the chemically rich bed of a lake near Mount Kilimanjaro in Tanzania, casting a tiny shadow on the honeycombed surface. The lake bottom is stained red by bacteria, and the geometric pattern is white sodium carbonate—the compound used for washing soda—seeping up from underground. The plane at lower left was hired to fly beneath the photographer's plane to indicate scale in the picture, one of nearly a thousand shot for a German magazine.

UWE GEORGE: *Lake Natron, Tanzania,* 1977
227

A Changing Spectacle

The soft, indirect light of dawn floods a glen in Vermont. Early-morning fog scattered the light and prevented shadows from forming. A tripod was needed to shoot at the long shutter speed, ½ second, required by the dim light.

RICHARD BROWN: *Stevenson's Woods,* 1973

Light—the most essential tool of a landscape photographer—is the element he can least control. Unlike a studio photographer with his flood lamps or an animal photographer with his strobes, the landscapist must take his light as he finds it or wait until it changes.

The changes can, however, produce spectacular effects. The slightest turn in the weather transforms the look of the land. In the scene above, the muted light of an overcast daybreak brought out subtle gradations of tones and colors that sunlight would have overpowered.

Besides choosing his time, the landscape photographer can shift position in relation to the light. For the scene at right, the photographer positioned himself to take advantage of raking sunlight and strong shadows; an overcast sky would have resulted in a disappointing picture.

Just after daybreak, sunlight etches with shadows the furrows of wind-rippled sand in Monument Valley, Arizona, near the Colorado border. A low camera angle and the cross-lighting of the sun create a dramatic setting for the lone butte on the horizon.

HARALD SUND: *Desert,* 1977

ELIOT PORTER: *Ice Cave, Hut Point Peninsula*, 1975

230

Light Colored by Air and Ice

On Hut Point Peninsula in Antarctica, an ice cave glows with an eerie pale emerald fire, while a nearby cave, photographed at about the same time, came out blue. Although both color effects are caused by the filtering of light waves by water frozen into snow or ice, the results differ because of differences in the physical structure of the filtering medium.

After sunset the Arizona desert becomes a world without shadows, painted in varying tones of pink and purple by indirect light still lingering in the sky when the sun sinks below the horizon. Light fades so quickly after sundown that it is difficult to judge exposures. For this picture Dean Brown bracketed his exposures widely; the best one (below) was taken at f/8 and 1/15 second.

DEAN BROWN: *Desert Twilight*, 1969

Stunning pictures can result when light changes color as it passes through a translucent medium, such as the earth's atmosphere. It scatters the short wavelengths of light (blue and green) more than long ones (red and yellow). The more atmosphere light goes through, the more its color changes.

Thus toward sunset, when the sun's rays travel obliquely through the atmosphere, most of the blue is sifted out. Objects assume a warm cast, although their shadows, which take color from reflected sky light, remain bluish. But the minute the sun goes down the light changes dramatically. A landscape like the desert above is suffused with blues and purples reflected from the sky and clouds.

With water, another translucent medium, it is absorption of light, not scattering that makes light passing through it change color. Since water absorbs long red-orange wavelengths, water appears blue-green. This effect is especially noticeable when water is in the form of snow or ice, and it probably accounts for the striking green hue of the ice cave at left.

231

Showing the Sun and Moon

An orange sun dominates this moody vista of an English pasture on a late afternoon in winter. A 135mm telephoto lens brought the sun and background closer. By exposing for the sunset colors in the sky, the photographer reduced the trees in the middle ground to a bleak, wintry silhouette, and transformed the cattle in the foreground into dark, ghostlike presences.

STEPHEN GREEN-ARMYTAGE: *Winter Sunset*, 1963

Among the most spectacular landscape photographs are those that include the scene's extraterrestrial light source—the sun or the moon. Putting it into the picture raises tricky problems of exposure, different for each.

Shooting directly into the sun requires a delicate trade-off of exposures, for a sun that is part of the picture can overpower and bleach out the rest of the frame. To avoid this, deliberately underexpose by at least two f-stops; vigorous

foregound silhouettes will then be formed against the bright background.

The moon, on the other hand, is so dim that it needs several compensation techniques. In-camera meters may not be sensitive enough to register the faint illu-

HARALD SUND: *Moonrise Over Nooksack Ridge*, 1972

mination of a moonlit scene and a more sensitive hand-held meter may be required. Exposures will usually be long, and surprising color shifts may occur because of the way film emulsions react to weak light *(page 103)*. To avoid this color distortion, called reciprocity failure, photograph the moon just after sunset, when the sky is dark enough to create dramatic contrast, but is still casting enough light to give adequate exposure at a shutter speed of a second or less *(right)*.

A Fresh View of a Familiar Spectacle

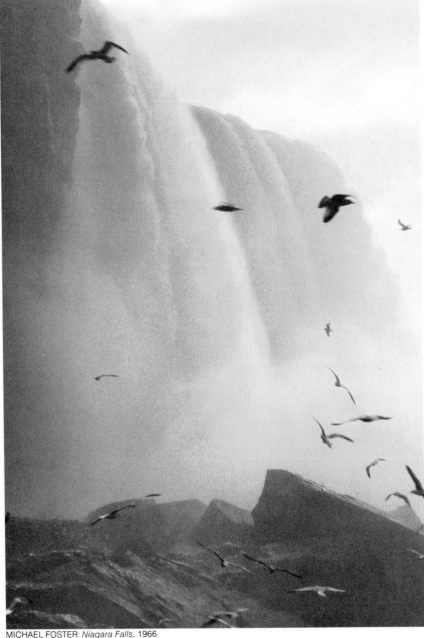

One of the most difficult challenges a landscape photographer faces is to find an original approach to a well-known, frequently photographed scene. It was easier for the itinerant landscape photographers of the 19th Century. In those days each picture was a revelation. Few people had ever glimpsed such vertiginous gorges, such awesome mountains or such breathtaking waterfalls. But after the viewer has seen his first dozen pictures of the Grand Canyon, the scene begins to lose its impact.

Still, the best photographers do find ways to bring a fresh eye to familiar settings. Many veterans of landscape photography invariably shoot several throwaway rolls of film "to get the clichés out." Other photographers make a few practice runs, clicking the shutter without film in the camera, until they get the feel of their subject. Michael Foster spent a day wandering around Niagara Falls, looking for new moods and perspectives, before hitting upon the mist-drenched view at left. "The best way to photograph a landscape," said Foster, "is to let the atmosphere of the place guide the camera." □

This photograph of Niagara Falls probably could not have been made anywhere else in the world. Taken on a slightly overcast day, it shows the falls in a fresh light—with mist from the cascading water softening the shapes of birds and rocks in the foreground, and enveloping the entire scene in a delicate pearly gray.

MICHAEL FOSTER: *Niagara Falls,* 1966

Bibliography

General

Dalton, Stephen, *The Miracle of Flight*. McGraw-Hill, 1977.
Faulkner, Douglas, and C. Lavett Smith, *The Hidden Sea*. Viking Press, 1970.
Feininger, Andreas:
The Focal Encyclopedia of Photography. Focal Press, 1960.
Successful Color Photography. Prentice-Hall, 1968.
Gerster, Georg, *Flights of Discovery: The Earth from Above*. Paddington Press, 1978.
Holmåsen, Ingmar, *Nature Photography*. Ziff-Davis Publishing Company, 1976.
Kinne, Russ, *The Complete Book of Nature Photography*. Amphoto, 1971.
Moore, Tui De Roy, *Galapagos, Islands Lost in Time*. Viking Press, 1980.
Nuridsany, Claude, and Marie Pérennou, *Photographing Nature*. Oxford University Press, 1976.
Porter, Eliot, *Antarctica*. E. P. Dutton, 1978.
Stix, Hugh and Marguerite, and R. Tucker Abbott, *The Shell: Five Hundred Million Years of Inspired Design*. Abrams, 1968.

History

Gernsheim, Helmut and Alison, *The History of Photography*. McGraw-Hill, 1969.
Jackson, William H., and Howard R. Driggs, *The Pioneer Photographer: Rocky Mountain Adventures with a Camera*. World Book Company, 1929.
Johnson, Martin:
Lion. Putnam, 1929.
Over African Jungles. Harcourt Brace, 1935.
Kearton, Richard, *Wild Life at Home: How to Study and Photograph It*. Cassell and Company, 1901.
*Taft, Robert, *Photography and the American Scene*. Dover, 1964.
Wallihan, Allen:
Camera Shots at Big Game. Doubleday, 1901.
Hoofs, Claws and Antlers of the Rocky Mountains. Frank S. Thayer, 1894.

Techniques

Adams, Ansel, *Camera and Lens*. Morgan & Morgan, 1970.
Croy, Otto R., *Camera Close-Up: Same Size and Larger than Life Photography*. Focal Press, 1961.
Eastman Kodak:
†*Close-up Photography & Photomacrography*. Eastman Kodak, 1977.
†*Filters for Black and White and Color Pictures*. Eastman Kodak, 1967.
Frey, Hank, and Paul Tzimoulis, *Camera Below: The Complete Guide to the Art and Science of Underwater Photography*. Association Press, 1968.
Lefkowitz, Lester, *The Manual of Close-Up Photography*. American Photographic Book Publishing Co., 1979.
Logan, Larry L., editor, *The Professional Photographer's Handbook*. Logan Design Group, 1980.
Mertens, Lawrence, *In-Water Photography*. John Wiley, 1970.
Owens, William J., *Close-Up Photography*. Petersen's Photo Publishing Group, 1975.
Papert, Jean, *Photomacrography: Art and Techniques*. Amphoto, 1971.
Schulke, Flip, *Underwater Photography for Everyone*. Prentice-Hall, 1978.
Tölke, Arnim and Ingeborg, *Macrophoto and Cine Methods*. Focal Press, 1971.

Field Guides

†Bean, L. L., *Hunting, Fishing and Camping*. L. L. Bean, 1969.
Bridges, William, *The Bronx Zoo Book of Wild Animals*. Golden Press, 1968.
Brockman, C. Frank, *Trees of North America*. Golden Press, 1968.
Conant, Roger, *A Field Guide to Reptiles and Amphibians*. Houghton Mifflin, 1958.
Klots, Alexander B., *A Field Guide to the Butterflies*. Houghton Mifflin, 1957.
Peterson, Roger Tory:
A Field Guide to the Birds. Houghton Mifflin, 1968.
A Field Guide to Western Birds. Houghton Mifflin, 1961.
Peterson, Roger Tory, and Margaret McKenny, *A Field Guide to Wildflowers of Northeastern and North-Central North America*. Houghton Mifflin, 1968.
†Sargent, Charles S., *Manual of the Trees of North America*. Dover, 1961.
Stebbins, Robert C., *A Field Guide to Western Reptiles and Amphibians*. Houghton Mifflin, 1966.
Urry, David and Kate, *Flying Birds*. Harper & Row, 1970.

Recordings

American Bird Songs, Volumes I and II. Cornell University, 1954.
A Field Guide to Bird Songs. Houghton Mifflin, 1959.
A Field Guide to Western Bird Songs. Houghton Mifflin, 1962.
Mexican Bird Songs. Cornell University, 1958.

* Also available in paperback
† Available only in paperback

Acknowledgments

The index for this book was prepared by Karla J. Knight. For their help in the preparation of this book, the editors thank the following: Ansel Adams, Carmel, Calif.; James Bryant, National Museum of Natural History, Smithsonian Institution, Washington, D.C.; Chip Clark, National Museum of Natural History, Smithsonian Institution, Washington, D.C.; William E. Congdon, South Glens Falls, N.Y.; Dr. J. A. L. Cooke, The American Museum of Natural History, New York City; Stuart Craig, New York City; Albert Detilla, U.S. Botanic Gardens, Washington, D.C.; Townsend Dickinson, New York City; Ruth Dugan, Los Angeles; David Epp, The Sierra Club, New York City; Les Falls, Arlington, Va.; Douglas Faulkner, Summit, N.J.; Dr. Hank Frey, New York City; Ken Froehly, The Sierra Club, New York City; Lynn Hamlin, New York City; Karl Heitz, New York City; Nancy Henderson, New York City; Frederick A. Hetzel, Director, Univ. of Pittsburgh Press, Pa.; Martha Hill, Picture Editor, *Audubon Magazine,* New York City; Gene Hosansky, New York City; Robert B. Inverarity, Director, Philadelphia Maritime Museum, Pa.; Gene Jeffers, The American Red Cross, Washington, D.C.; Jeff Karp, Garden City, N.Y.; Karl Kleinen, Rockleigh, N.J.; Eve Kloepper, New York City; Cyril Laubscher, Orpington, Kent, England; Nina Leen, New York City; Leica Technical Service, E. Leitz Inc., Rockleigh, N.J.; George Lepp, Los Osos, Calif.; Leonard McCombe, New York City; Thomas W. Martin, New York City; Pat Maye, New York City; Linda Morrissey, *Audubon Magazine,* New York City; Robert Noonan, Baltimore, Md.; Rayma Overton, U.S. Botanic Gardens, Washington, D.C.; Tom Perazella, Woodside, N.Y.; Dr. and Mrs. Roger Tory Peterson, Old Lyme, Conn.; Coles H. Phinizy, Senior Editor, *Sports Illustrated,* New York City; Kjell B. Sandved, National Museum of Natural History, Smithsonian Institution, Washington, D.C.; Mary G. Smith, Senior Assistant Editor, *National Geographic* magazine, Washington, D.C.; George A. Tice, Colonia, N.J.; Julie Twombly, Santa Monica, Calif.; Paul Tzimoulis, Los Angeles; John B. Wall, Falls Church, Va.; Bradford Washburn, Director, The Museum of Science, Boston; Sally Wilson, Santa Monica, Calif.; Craig Wineman, Arlington, Va.

Picture Credits
Credits from left to right are separated by semicolons, from top to bottom by dashes.

Index
Numerals in italics indicate a photograph, painting or drawing.